The Digital Photography Book

The step-by-step secrets for how to make your photos look like the pros'! **Book**

Scott Kelby

The Digital Photography Book, part 1

The Digital Photography Book, part 1 Team

CREATIVE DIRECTOR
Felix Nelson

ART DIRECTOR
Jessica Maldonado

TECHNICAL EDITORS
Kim Doty
Cindy Snyder

EDITORIAL CONSULTANT
Bill Fortney

PRODUCTION MANAGER
Dave Damstra

PHOTOGRAPHY
Scott Kelby

STUDIO AND
PRODUCTION SHOTS
Brad Moore

PUBLISHED BY

Peachpit Press

©2013 Scott Kelby

Composed in Myriad Pro (Adobe Systems Incorporated) and LCD (Esselte) by Kelby Media Group Inc.

Trademarks
All terms mentioned in this book that are known to be trademarks or service marks have been appropriately capitalized. Peachpit Press cannot attest to the accuracy of this information. Use of a term in the book should not be regarded as affecting the validity of any trademark or service mark.

Photoshop, Elements, and Lightroom are registered trademarks of Adobe Systems, Inc.
Nikon is a registered trademark of Nikon Corporation.
Canon is a registered trademark of Canon Inc.
Sony is a registered trademark of Sony Corporation.

Warning and Disclaimer
This book is designed to provide information about digital photography. Every effort has been made to make this book as complete and as accurate as possible, but no warranty of fitness is implied.

The information is provided on an as-is basis. The author and Peachpit Press shall have neither the liability nor responsibility to any person or entity with respect to any loss or damages arising from the information contained in this book or from the use of the discs or programs that may accompany it.

ISBN 13: 978-0-321-93494-9

ISBN 10: 0-321-93494-6

15 14 13 12 11 10 9 8 7 6 5 4 3 2 1

Printed and bound in the United States of America

www.peachpit.com
www.kelbytraining.com

Dedicated to the amazing
Dr. Stephanie Van Zandt
for her excellent advice, for taking
such good care of my wife, and
for delivering the sweetest
little baby girl in the whole world.

Acknowledgments

Although only one name appears on the spine of this book, it takes a team of dedicated and talented people to pull a project like this together. I'm not only delighted to be working with them, but I also get the honor and privilege of thanking them here.

I've written more than 50 books, and in each book I write, I always start by thanking my amazing, wonderful, beautiful, hilarious, and absolutely brilliant wife Kalebra. She probably stopped reading these acknowledgments 30 or more books ago because I keep gushing on and on about her, and despite how amazingly beautiful, charming, and captivating she is, she's a very humble person (which makes her even more beautiful). And even though I know she probably won't read this, I just have to thank her anyway because not only could I not do any of this without her, I simply wouldn't want to. She's just "it." It's her voice, her touch, her smile, her heart, her generosity, her compassion, her sense of humor, and the way she sneaks around behind the scenes trying to make sure my life is that much better, that much more fun, and that much more fulfilling—you just have to adore someone like that. She is the type of woman love songs are written for, and as any of my friends will gladly attest, I am, without a doubt, the luckiest man alive to have her as my wife. I love you madly, sweetheart!

I also want to thank my crazy, fun-filled, wonderful 16-year-old son Jordan. He won't read this either, because as he says, "It embarrasses him." And since I know he won't read it (or even let me read it to him), I can safely gush about him, too. Dude, you rock! You are just about the coolest son any dad could ask for—you dig Bon Jovi, you're always up for a game of *Black Ops*, you play drums (just like your dad), you love to go to the movies with me, and you get as excited about life as I do. You are nothing but a joy, and I'm so thrilled to be your dad (plus, you're such a great big brother to your little sister). I am very, very proud of you little pal (which is a relative term, since you're 6'1" now).

I also want to thank my beautiful, hilarious daughter Kira, who is the best-natured, happiest little girl in the whole wide world. You're only seven years old, and you've already been reflecting your mom's sweet nature, her beautiful smile, and her loving heart for many years now. You're too young to really know what an amazing mother you have, but before long, just like your brother, you'll realize that your mom is someone very special, and that thanks to her you're in for a really fun, exciting, hug- and adventure-filled life.

Also, thanks to my big brother, Jeff. Brothers don't get much better than you, and that's why Dad was always so proud of you. You are truly one of the "good guys" and I'm very, very lucky to have you in my life.

My personal thanks to my friend and fellow photographer Brad Moore, who shot most of the product shots for this edition of the book and worked as first assistant on many of the shots I took throughout the book. You're absolutely invaluable and an awful lot of fun.

Special thanks to my home team at Kelby Media Group. I love working with you guys and you make coming into work an awful lot of fun for me. I'm so proud of what you all do—how you come together to hit our sometimes impossible deadlines, and as always, you do it with class, poise, and a can-do attitude that is truly inspiring. I'm honored to be working with you all.

Thanks to my Editor Kim Doty, who is just the greatest editor ever, and I couldn't imagine doing these books without her. Also, thanks to Jessica Maldonado (my awesome book designer and our newest co-host on *Photoshop User TV*) for giving the book such a tight, clean layout, and for all the clever little things she adds that make the book that much better. Thanks to my in-house Tech Editor Cindy Snyder, who puts everything through rigorous testing and tries to stop me from slipping any of my famous typos past the goalie.

Thanks to my best buddy Dave Moser, whose tireless dedication to creating a quality product makes every project we do better than the last. Thanks to Jean A. Kendra for her steadfast support, and an extra special thanks to my Executive Assistant Susan Hageanon for keeping everything running smoothly while I'm out traveling and writing books (and for making sure I actually have the time I need to write books in the first place).

Thanks to my publisher Nancy Aldrich-Ruenzel, my way cool Editor and friend Ted Waitt (BT), marketing maverick Scott Cowlin, and marketing gunslinger Sara Jane Todd, along with the incredibly dedicated team at Peachpit Press. It's a real honor to get to work with people who really just want to make great books. Also, thanks to the folks at iStockphoto.com for enabling me to use some of their wonderful photography in this book when I didn't have the right image to illustrate my point.

I owe a special debt of gratitude to my good friend Bill Fortney for helping tech edit the first edition of this book, and it's infinitely better because of his comments, ideas, and input. Bill is just an amazing individual, a world-class photographer, a testament to how to live one's life, and I'm truly honored to have gotten the chance to work with someone of his caliber, integrity, and faith.

My sincere and heartfelt thanks to all the talented and gifted photographers who've taught me so much over the years, including Moose Peterson, Vincent Versace, Bill Fortney, David Ziser, Jim DiVitale, Helene Glassman, Joe McNally, Anne Cahill, George Lepp, Cliff Mautner, Kevin Ames, David Tejada, Frank Doorhof, Eddie Tapp, Jack Reznicki, and Jay Maisel. Thank you for sharing your passion, ideas, and techniques with me and my students.

Thanks to my mentors whose wisdom and whip-cracking have helped me immeasurably, including John Graden, Jack Lee, Dave Gales, Judy Farmer, and Douglas Poole.

Most importantly, I want to thank God, and His Son Jesus Christ, for leading me to the woman of my dreams, for blessing us with such amazing children, for allowing me to make a living doing something I truly love, for always being there when I need Him, for blessing me with a wonderful, fulfilling, and happy life, and such a warm, loving family to share it with.

Other Books by Scott Kelby

The Digital Photography Book, parts 2, 3 & 4

Professional Portrait Retouching Techniques for Photographers Using Photoshop

*Light It, Shoot It, Retouch It: Learn Step by Step How to Go from Empty Studio
to Finished Image*

The Adobe Photoshop Lightroom Book for Digital Photographers

The Adobe Photoshop Book for Digital Photographers

The Photoshop Elements Book for Digital Photographers

It's a Jesus Thing: The Book for Wanna Be-lievers

The iPhone Book

About the Author

Scott is Editor, Publisher, and co-founder of *Photoshop User* magazine, is Publisher of *Light It!* digital magazine, and is co-host of the weekly videocasts *The Grid* (a photography talk show) and *Photoshop User TV*.

He is President of the National Association of Photoshop Professionals (NAPP), the trade association for Adobe® Photoshop® users, and he's President of the software training, education, and publishing firm Kelby Media Group.

Scott is a photographer, designer, and an award-winning author of more than 50 books, including *The Digital Photography Book*, parts 1, 2, 3, & 4, *The Adobe Photoshop Book for Digital Photographers*, *Professional Portrait Retouching Techniques for Photographers Using Photoshop*, *The Adobe Photoshop Lightroom Book for Digital Photographers*, *Light It, Shoot It, Retouch It: Learn Step by Step How to Go from Empty Studio to Finished Image*, and *The iPhone Book*.

For the past three years, Scott has been honored with the distinction of being the world's #1 best-selling author of books on photography. His books have been translated into dozens of different languages, including Chinese, Russian, Spanish, Korean, Polish, Taiwanese, French, German, Italian, Japanese, Dutch, Swedish, Turkish, and Portuguese, among others.

Scott is Training Director for the Adobe Photoshop Seminar Tour, and Conference Technical Chair for the Photoshop World Conference & Expo. He's featured in a series of training DVDs and online courses, and has been training photographers and Adobe Photoshop users since 1993. He is also the founder of Scott Kelby's Annual Worldwide Photowalk, the largest global social event for photographers, which brings tens of thousands of photographers together on one day each year to shoot in over a thousand cities worldwide.

For more information on Scott, visit him at:

His daily blog: **www.scottkelby.com**
Twitter. **http://twitter.com/@scottkelby**
Facebook: **www.facebook.com/skelby**
Google+: **Scottgplus.com**

CHAPTER FIVE 91

Shooting Sports Like a Pro
Better Bring Your Checkbook

CHAPTER NINE

Taking Travel & City Life Shots Like a Pro
Tips for Travel Photography

CHAPTER TEN

How to Print Like a Pro and Other Cool Stuff
After All, It's All About the Print!

Chapter Eleven *197*

Ten Things I Wish Someone Had Told Me
When I First Started Out in Photography

CHAPTER TWELVE *211*

Photo Recipes to Help You Get "The Shot"
The Simple Ingredients That Make It All Come Together

SHUTTER SPEED: 1/200 SEC F-STOP: F/32 ISO: 200 FOCAL LENGTH: 70mm | PHOTOGRAPHER: SCOTT KELBY

Chapter One
Pro Tips for Getting Really Sharp Photos
If Your Photos Aren't Sharp, the Rest Doesn't Matter

Having photos that are sharp and in focus is so vitally important to pro photographers that they actually have coined a term for them. They call them "tack sharp." When I first heard that term tossed around years ago, I naturally assumed that it was derived from the old phrase "sharp as a tack," but once I began writing this book and doing some serious research into its history, I was shocked and surprised at what I found. First of all, it's not based on the "sharp as a tack" phrase at all. Tack sharp is actually an acronym. TACK stands for Technically Accurate Cibachrome Kelvin (which refers to the color temperature of light in photographs), and SHARP stands for Shutter Hyperfocal At Refracted Polarization. Now, these may seem like highly technical terms at first, but once you realize that I totally made them up, it doesn't seem so complicated, does it? Now, you have to admit, it sounded pretty legitimate at first. I mean, I almost had ya, didn't I? Come on, you know I had you, and I'll bet it was that "color temperature of light" thing I put in parenthesis that helped sell the idea that it was real, right? It's okay to admit you were fooled, just like it's okay to admit that you've taken photos in the past that weren't tack sharp (just in case you were wondering, the term "tack sharp" is actually formed from the Latin phrase *tantus saeta equina* which means "there's horsehair in my tantus"). Anyway, what's really important at this point is whatever you do, keep your spotted palomino away from anything with a sharp, pointy end used to attach paper to a bulletin board. That's all I'm saying.

The Real Secret to Getting Sharp Photos

Hey, before we get to "The Real Secret to Getting Sharp Photos," I need to let you in on a few quick things that will help you big time in getting the most from this book (sorry about duping you with "The Real Secret to Getting Sharp Photos" headline, but don't worry—that subject and more are coming right up, but first I have to make sure you totally understand how this book works. Then it will all make sense and we can worry about sharp photos). The idea is simple: You and I are out on a photo shoot. While we're out shooting, you have lots of questions, and I'm going to answer them here in the book just like I would in real life—straight and to the point, without teaching you all the technical aspects and behind-the-scenes technology of digital photography. For example, if we were out shooting and you turned to me and said, "Hey Scott, I want to take a shot where that flower over there is in focus, but the background is out of focus. How do I do that?" I wouldn't turn to you and give you a speech about smaller and larger apertures, about how exposure equals shutter speed plus aperture, or any of that stuff you can read in any book about digital photography (and I mean any book—it's in every one). In real life, I'd just turn to you and say, "Put on your zoom lens, set your aperture at f/2.8, focus on the flower, and fire away." That's how this book works. Basically, it's you and me out shooting, and I'm giving you the same tips, the same advice, and the same techniques I've learned over the years from some of the top working pros, but I'm giving it to you in plain English, just like I would in person, to a friend.

The Other Most Important Secret

JOEY WRIGHT

Again, ignore that headline. It's just a cheap come-on to get you to keep reading. Anyway, that's the scoop. Now, here's another important thing you need to know: To get the kind of quality photos I think you're looking for, sometimes it takes more than changing an adjustment in the camera or changing the way you shoot. Sometimes, you have to buy the stuff the pros use to shoot like a pro. I don't mean you need to buy a new digital camera, but instead, some accessories that the pros use in the field every day. I learned a long time ago that in many fields, like sports for example, the equipment doesn't really make that big a difference. For example, go to Wal-Mart, buy the cheapest set of golf clubs you can, hand them to Tiger Woods, and he's still Tiger Woods—shooting 12 under par on a bad day. However, I've never seen a field where the equipment makes as big a difference as it does in photography. Don't get me wrong, hand Jay Maisel a point-and-shoot camera and he'll take point-and-shoot shots that could hang in a gallery, but the problem is we're not as good as Jay Maisel. So, to level the playing field, sometimes we have to buy accessories (crutches) to make up for the fact that we're not Jay Maisel. Now, I don't get a kickback, bonus, or anything from any of the companies whose products I recommend. I'm giving you the same advice I'd give you if we were out shooting (which is the whole theme behind this book). This is *not* a book to sell you stuff, but before you move forward, understand that to get pro results sometimes you have to use (and that means buy) what the pros use.

Perhaps Even More Important Than That!

Still a fake headline. Don't let it throw you. Now, although we want pro-quality photos, we don't all have budgets like the pros, so when possible, I break my suggestions down into three categories:

 I'm on a budget. These are denoted with this symbol. It simply means you're not loose with money (meaning you're probably married and have kids).

 I can swing it. If you see this symbol, it means photography is your passion and you don't mind if your kids have to work a part-time job once they get to college to buy books. So you're willing to spend to have some better-than-average equipment.

 If you see this symbol, it means you don't really have a budget (you're a doctor, lawyer, venture capitalist, U.S. Senator, etc.), so I'll just tell you which one I would buy if I was one of those rich bas*%$#s. (Kidding. Kind of.)

To make things easy, I put up a webpage at **kelbytraining.com/books/vol1gear** with direct links to these goodies if you're so inclined. Again, I don't get a red cent if you use these links or buy this stuff, but I don't mind because I made such a killing on you buying this book. Again, I kid. Now, where do these links actually go? (See next page.)

If You Skip This, Throw Away Your Camera

Hey, how do you like that grabber of a headline? Sweet! Totally a scam, but sweet nonetheless. Now, those links on the webpage lead to one of two places: (1) to the individual manufacturer who sells the product, if they only sell direct, or (2) to B&H Photo's website. So, why B&H? Because I trust them. I've been buying all my personal camera gear from them for years (so do all my friends, and most of the pros I know) and since you're now going to be one of my shooting buddies, this is where I would tell you to go without a doubt. There are three things I like about B&H, and why they have become something of a legend among pro photographers: (1) They carry just about every darn thing you can think of, no matter how small or insignificant it may seem. Lose your Nikon brand lens cap? They've got 'em in every size. Lose your neck strap with Canon stitched on it? They've got them, too. Lose that tiny little cap that covers the input for your remote shutter release? They've got it. (2) When you call them, you talk to a real photographer, and my experience is that they give you the real straight scoop on what to buy. I've called up with something in mind, and have had their reps tell me about something better that's cheaper. That's rare these days. And finally (3), their prices are very, very competitive (to say the least). If you're ever in New York City, make it a point to drop by their store. It is absolutely amazing. It's like Disneyland for photographers. I could spend a day there (and I have). Anyway, they're good people. Now, does the headline scam thing continue on the next page? You betcha.

If You Do This Wrong, It Will Lock Up

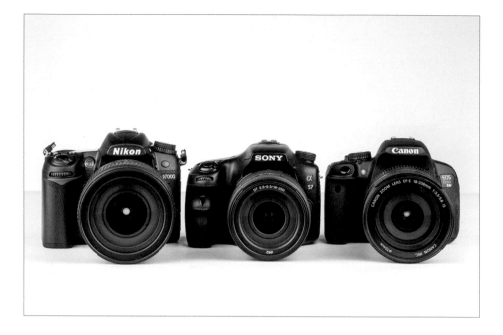

It's not as good as the last fake headline, but we're only one more page away from the real chapter content, so I'm backing it off a little. Now, once you turn the page you'll notice lots of photos of Nikon, Canon, and Sony cameras, and it might make you think that I'm partial to these three brands. It's not just me. Apparently most of the world is partial to these three brands, so you'll see lots of shots of them. Now, what if you don't shoot with a Nikon, Canon, or Sony camera? No sweat—most of the techniques in this book apply to any digital SLR camera, and many of the point-and-shoot digital cameras as well, so if you're shooting with an Olympus or a Sigma, don't let it throw you that a Nikon, Canon, or Sony is pictured. This book is about taking dramatically better photos, not about how to set up your Nikon, Canon, or Sony, even though since most people are shooting with one of these, I usually show one of these cameras or menus (but mainly only tell you how to set things up on a Nikon or Canon). So, if I'm talking about white balance, and I'm show-ing the Canon white balance menu, but you're not shooting with a Canon, simply breathe deeply and say to yourself, "It's okay, my [insert your camera name here] also has a white balance setting and it works pretty much like this one." Remember, it's about choosing the right white balance, not exactly which buttons to push on your camera, because if we were really out shooting together, we might not have the same brand of camera.

It's Time to Get Serious

Chapter Three
Shooting Weddings
Like a Pro
There Is No Retaking Wedding Photos.
It's Got to Be Right the First Time!

If you're living your life and you think to yourself, "Ya know, I've got it pretty easy," then it's time to shoot a wedding. Don't worry, this isn't something you're going to have to go looking for—if you've got even one long lens (200mm or longer), it will find you. That's because in a lot of people's minds, if you have a long lens, you're a serious photographer. It's true. Seriously, try this: show up at an event with a 200mm to 400mm lens on your camera and people will literally get out of your way. They assume you've been hired by the event and that you're on official photography business, and they will stand aside to let you shoot. It's the equivalent of walking into a factory with a clipboard—people assume you're legit and they let you go about your business. Add a photographer's vest and it's like having an official press pass to anything (try this one—you'll be amazed). Anyway, if you have a long lens, before long someone you know will get married but they won't have a budget for a professional photographer (like your cousin Earl). He'll ask, "Can you shoot our wedding photos?" Of course, you're a nice person and you say, "Why sure." Big mistake. You're going to work your butt off, miss all the food, drinks, and fun, and you'll experience stress at a level only NORAD radar operators monitoring North Korea ever achieve. A wedding ceremony happens once in real time. There are no second takes, no room for mess-ups, no excuses. Don't make Earl's bride really mad—read this chapter first.

I have good news: Not only are we at the end of this "fake headline" thing, you'll also be happy to know that from here on out, the rest of the book isn't laced with the wonderfully inspired (lame) humor you found on these first few pages. Well, the intro page to each chapter has more of this stuff, but it's only one page and it goes by pretty quickly. My books have always had "enlightened" chapter intros (meaning I wrote them when I was plastered) and the chapter names are usually based on movies, song names, or band names (the actual chapter name appears below the fake chapter name). The other reason I do it is because I need a chance to write something that doesn't use any of the terms shutter, aperture, or tripod. In a book like this, there's not much room to interject personality (if you want to call it that), and since the rest of the book is me telling you just what you need to know, there's little time for my brand of humor. In fact, in life there's little time for my brand of humor, so I sneak it in there. I have so little. Anyway, as you turn the page, keep this in mind: I'm telling you these tips just like I'd tell a shooting buddy, and that means oftentimes it's just which button to push, which setting to change, and not a whole lot of reasons why. I figure that once you start getting amazing results from your camera, you'll go out and buy one of those "tell me all about it" digital camera books. In all seriousness, I truly hope this book ignites your passion for photography by giving you some insight into how the pros get those amazing shots, and showing you how to get results you always hoped you'd get from your digital photography. Now pack up your gear, it's time to head out for our shoot.

Getting "Tack Sharp" Starts with a Tripod

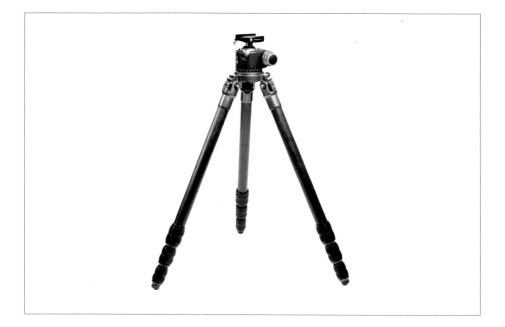

There's not just one trick that will give you the sharp photos the pros get—it's a combination of things that all come together to give you "tack sharp" shots. (Tack sharp is the term pro photographers use to describe the ultimate level of sharpness. Sadly, we aren't the best at coming up with highly imaginative names for things.) So, while there are a number of things you'll need to do to get tack-sharp photos, the most important is shooting on a tripod. In fact, if there's one single thing that really separates the pros from the amateurs, it's that the pros always shoot on a tripod (even in daylight). Yes, it's more work, but it's the key ingredient that amateurs miss. Pros will do the little things that most amateurs aren't willing to do; that's part of the reason their photos look like they do. Keeping the camera still and steady is a tripod's only job, but when it comes to tripods, some do a lot better job than others. That's why you don't want to skimp on quality. You'll hear pros talking about this again and again, because cheap tripods simply don't do a great job of keeping your camera that steady. That's why they're cheap.

Scott's Gear Finder

Oben AC-2310LA 3-Section Tripod (around $115)

Manfrotto 458B NeoTec Pro Tripod (around $375)

Gitzo GT3541L Series 3 Mountaineer Tripod (around $745)

A Ballhead Will Make Your Life Easier

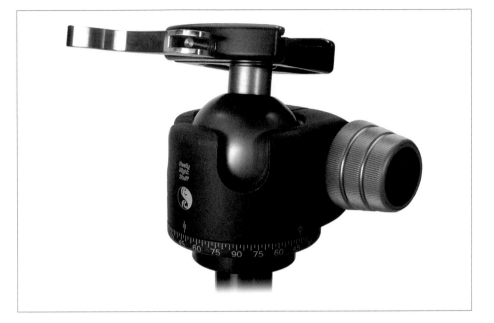

Here's the thing: when you buy a pro-quality tripod, you get just the tripod. It doesn't come with a tripod head affixed like the cheap-o tripods do, so you'll have to buy one separately (by the way, this ballhead thing isn't necessarily about getting sharp images, but it is about keeping your sanity, so I thought I'd better throw it in). Ballheads are wonderful because with just one knob they let you quickly and easily aim and position your camera accurately at any angle (which you'll find is a huge advantage). Best of all, good ballheads keep your camera locked down tight to keep your camera from "creeping" (slowly sliding one way or the other) after you've set up your shot. Like tripods, a good ballhead isn't cheap, but if you buy a good one, you'll fall in love with it.

Scott's Gear Finder

Manfrotto 498RC4 Midi Ballhead (around $110)

Oben BC-2 Ballhead (around $180)

Really Right Stuff BH-40 LR Ballhead ($375)

Don't Press the Shutter (Use a Cable Release)

Okay, so now you're lugging around a tripod, but your photos are looking much sharper. Not tack sharp yet, but much sharper. What will take you to the next level of sharpness? A cable release. This is simply a cable that attaches to your digital camera (well, to most semi-pro or high-end consumer DSLRs anyway) and it has a button on the end of it. That way, when you press this button on the end of the cable, it takes the photo, but without you actually touching the shutter button on the camera itself. So, why is this such a big deal? It's because, believe it or not, when you press the shutter button on the camera, it makes the camera move just enough to keep your photos from being tack sharp. I know, it sounds like a little thing, but this one is bigger than it sounds. Using it is easier than you might think, and these days most cameras support wireless remotes too, and they're fairly inexpensive, as well. Now your photos are just that much sharper.

Forgot Your Cable Release? Use a Self Timer

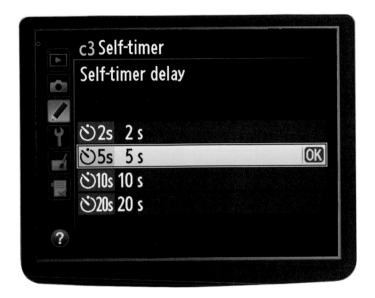

If you don't want to spring for a cable release (or wireless remote), or if you're out shooting and forgot yours (which has happened to me on numerous occasions), then the next best thing is to use your digital camera's built-in self timer. I know, you normally think of using this so you can run and get in the shot real quick, but think about it—what does the self timer do? It takes the shot without you touching the camera, right? Right! So, it pretty much does the same job of keeping your camera from moving—you just have to wait about 10 seconds. If you hate waiting (I sure do), then see if your camera allows you to change the amount of time it waits before it shoots. I've lowered mine to just five seconds (see the Nikon menu above). I press the shutter button and then five seconds later, the shot fires (I figure that five seconds is enough time for any movement caused by my pressing the shutter release to subside).

A BETTER CABLE RELEASE

If you're thinking of getting a cable release to reduce vibration, you're better off getting an electronic cable release rather than one that actually presses the shutter button with a plunger-style wire. Because, even though it's better than you pressing the button with your big ol' stubby vibration-causing finger, it doesn't compare with an electronic (or wireless) version that doesn't touch the camera at all.

Getting Super Sharp: Mirror Lock-Up

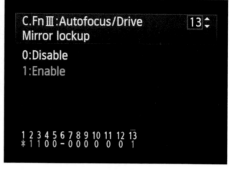

Nikon Canon

All right, we're starting to get a bit obsessed with camera shake, but that's what this chapter is all about—removing any movement so we get nothing but the sharpest, cleanest photo possible. The next feature we're going to employ is called Exposure Delay Mode on a Nikon or Mirror Lockup on a Canon. What this essentially does is locks your camera's mirror in the up position, so when you take the shot, the mirror does not move until after the exposure is made—limiting the movement inside your camera during the exposure, and therefore giving you that much sharper a photo. How much does this matter? It's probably second only to using a solid tripod! So, you'll need to find out where the mirror lock-up control is for your camera (most of today's DSLR cameras have this feature because you also use this to clean your sensor). Once you set your camera to mirror lock-up, on a Nikon you now have to press the shutter release button (on your remote or cable release) once, on a Canon you have to press it twice—once to lift the mirror, and then a second time to actually take the shot. Now, this technique sounds a bit nitpicky. Does it make that big a difference? By itself, no. But add this to everything else, and it's another step toward that tack sharp nirvana.

Turn Off Vibration Reduction (or IS)

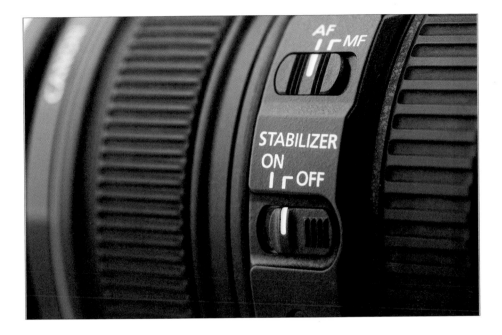

The big rage in digital lenses these days are the Vibration Reduction (VR) lenses from Nikon and the Image Stabilization (IS) lenses from Canon, which help you get sharper images while hand-holding your camera in low-light situations. Basically, they let you hand-hold in more low-light situations by stabilizing the movement of your lens when your shutter is open longer, and honestly, they work wonders for those instances where you can't work on a tripod (like weddings, some sporting events, when you're shooting in a city, or just places where they simply won't let you set up a tripod). If you're in one of those situations, I highly recommend these VR or IS lenses, but depending on which one you use, there are some rules about when you should turn them off. For example, we'll start with Nikon. If you are shooting on a tripod with a Nikon VR lens, to get sharper images, turn the VR feature off (you do this right on the lens itself by turning the VR switch to the Off position). The non-technical explanation why is that these VR lenses look for vibration. If they don't find any, they'll go looking for it, and that looking for vibration when there is absolutely none can cause (you guessed it) some small vibration. So just follow this simple rule: When you're hand-holding in anything but bright daylight (where your shutter speeds will already be really fast), turn VR or IS on. When you're shooting on a tripod, for the sharpest images possible, turn VR or IS off. Now, there are some Nikon VR lenses and some older Canon IS lenses that can be used on a tripod with VR or IS turned on. So, be sure to check the documentation that came with your VR or IS lens to see if yours needs to be turned off.

Shoot at Your Lens' Sharpest Aperture

Another trick the pros use is, when possible, shoot at your lens' sharpest aperture. For most lenses, that is about two full stops smaller than wide open (so the f-stop number you use will go higher by two stops). For example, if you had an f/2.8 lens, the sharpest apertures for that lens would be f/5.6 and f/8 (two full stops down from 2.8). Of course, you can't always choose these apertures, but if you're in a situation where you can (and we'll talk about this later in the book), then shooting two stops down from wide open will usually give you the sharpest image your lens can deliver. Now, that being said, this isn't true for all lenses, and if that's not the case with your lens, you'll find your lens' sweet spot (its sharpest aperture) in short order if you keep an eye out for which aperture your sharpest images seem to come from. You can do that by looking at your photos' EXIF data (the background information on your shots embedded by your digital camera into the photos themselves) in Photoshop by going under Photoshop's File menu and choosing File Info. Then, click on Camera Data. It will show the aperture your shot was taken at. If you find most of your sharpest shots are taken with a particular aperture, then you've found your sweet spot. However, don't let this override the most important reason you choose a particular aperture, and that is to give you the depth of field you need for a particular shot. But it's just nice to know which f-stop to choose when your main concern is sharpness, not controlling depth of field.

Good Glass Makes a Big Difference

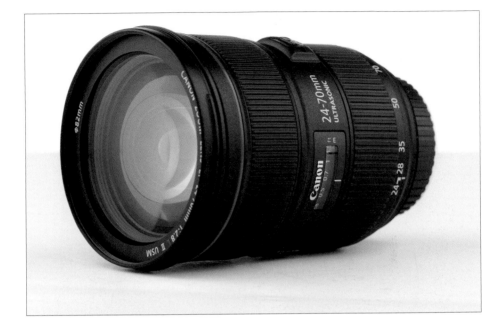

Does buying a really good lens make that big a difference in sharpness? Absolutely! I went shooting with a friend in Zion National Park in Utah. He had just bought a brand new Canon EF 24–70mm f/2.8L II, which is a tack-sharp lens. It's not cheap, but like anything else in photography (and in life), the really good stuff costs more. His other lens was a fairly inexpensive telephoto zoom he had been using for a few years. Once he saw the difference in sharpness between his new, good quality lens and his cheap lens, he refused to shoot with the telephoto again. He had been shooting with it for years, and in one day, after seeing what a difference a really sharp lens made, he wouldn't shoot with his old lens again. So, if you're thinking of buying a zoom lens for $295, sharpness clearly isn't your biggest priority. A quality lens is an investment, and as long as you take decent care of it, it will give you crystal clear photos that inexpensive lenses just can't deliver.

Scott's Pro Speak TRANSLATOR

When talking about the quality of lenses, we don't use the word "lens." It's too obvious. Instead, we say stuff like, "Hey, Joe's got some really good glass," or, "He needs to invest in some good glass," etc. Try this the next time you're at the local camera store, and see if the guy behind the counter doesn't get that "you're in the club" twinkle in his eye.

Avoid Increasing Your ISO on a Tripod

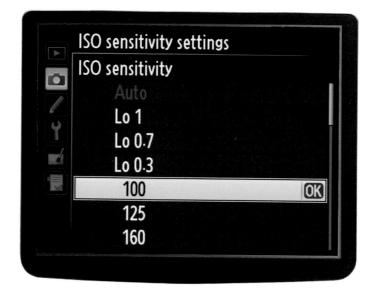

When you're shooting on a tripod, even in very dim or low light, don't increase your ISO (your digital equivalent of film speed). Keep your ISO at the lowest ISO setting your camera allows (ISO 200, 100, as shown on the Nikon menu above, or 50, if your camera's ISO goes that low) for the sharpest, cleanest photos. Raising the ISO adds noise to your photos, and you don't want that (of course, if you're hand-holding and have no choice, like when shooting a wedding in the low lighting of a church, then increasing the ISO is a necessity, but when shooting on a tripod, avoid high ISOs like the plague—you'll have cleaner, sharper images every time).

BREAKING THE RULES

So what do you do if you can't use a tripod (e.g., the place where you're shooting won't allow tripods)? In this case, if there's plenty of light where you're shooting, you can try using very fast shutter speeds to minimize hand-held camera shake. Set your camera to shutter priority mode and choose a speed that matches or exceeds the focal length of your lens (a 180mm lens means you'll shoot at 1/200 of a second).

Zoom In to Check Sharpness

Nikon

Canon

Here's a sad fact of digital photography—everything looks sharp and in focus when you first look at the tiny LCD screen on the back of your digital camera. When your photo is displayed at that small size, it just about always looks sharp. However, you'll soon learn (once you open your photo on your computer) that you absolutely can't trust that tiny little screen—you've got to zoom in and check the sharpness. On the back of your camera there's a zoom button that lets you zoom in close to see if the photo is really in focus. Do this right on the spot, right after you take the shot, so you still have a chance to retake the photo if you zoom in and find out it's blurry. The pros always check for sharpness this way, because they've been burned one too many times.

CUSTOM QUICK ZOOM SETTINGS

Some of today's digital SLR cameras have a quick zoom option, where you can set a particular amount you want your zoom to zoom in to. Check your owner's manual to see if your digital camera has a custom quick zoom setting.

Sharpening After the Fact in Photoshop

If you've followed all the tips in this chapter thus far, and you've got some nice crisp photos, you can still make your photos look even that much sharper by adding sharpening in either Adobe Photoshop (the software darkroom tool the pros use) or Adobe Photoshop Elements (the semi-pro version). Now, which photos need to be sharpened using Photoshop? All of them. We sharpen every single photo we shoot using Photoshop's Unsharp Mask filter. Okay, it sounds like something named "unsharp" would make your photos blurry, but it doesn't—the name is a holdover from traditional darkroom techniques, so don't let that throw you. Using it is easy. Just open your photo in Photoshop, then go under Photoshop's Filter menu, under Sharpen, and choose Unsharp Mask. When the dialog appears, there are three sliders for applying different sharpening parameters, but rather than going through all that technical stuff, I'm going to give you five sets of settings that I've found work wonders.

(1) **For people:** Amount 150%, Radius 1, Threshold 10

(2) **For cityscapes, urban photography, or travel:** Amount 65%, Radius 3, Threshold 2

(3) **For general everyday use:** Amount 120%, Radius 1, Threshold 3

(4) **For super-sharpening** (for sports photos, landscapes, stuff with lots of details): Amount 95%, Radius 1.5, Threshold 1

(5) **For images I've already made smaller and lower resolution,** so I can post them on the web: Amount 85%, Radius 1, Threshold 4

Did You Resize That for the Web?
Then Resharpen!

If you take a shot, open it in Photoshop (or Photoshop Elements), and apply the Unsharp Mask filter to it (see the previous page), and then you lower the image size and resolution so you can post it on the web, you need to apply the Unsharp Mask filter again with just a little bit of sharpening. Here's why: when you lower the image size and resolution, it loses some of its sharpness during that resize, so I always go back and apply a tiny bit of sharpening to bring back what I just lost. I generally use this Unsharp Mask setting as a starting place: Amount: 70%, Radius: 1.0, Threshold: 10, but before I click the OK button, I simply look at the photo to make sure that it doesn't look oversharpened. If it looks a bit too sharp now, just lower the Amount to 50 and see how that looks. Still too sharp? Drop it down to 40, or even 30 (I've never gone below 30, but this is a call only you, as the "sharpener," can make).

Hand-Held Sharpness Trick

Anytime you're hand-holding your camera in anything but nice direct sunlight, you're taking your chances on getting a sharply focused photo because of camera shake, right? Well, the next time you're hand-holding in less than optimal light, and you're concerned that you might not get a tack-sharp image, try a trick the pros use in this sticky situation— switch to continuous shooting (burst) mode and hold down the shutter release to take a burst of photos instead of just one or two. Chances are at least one of those dozen or so photos is going to be tack sharp, and if it's an important shot, it can often save the day. I've used this on numerous occasions and it has saved my butt more than once. (Sony's continuous shooting mode button is pictured above. See Chapter 5 for more on shooting in continuous [burst] mode with both Nikon and Canon cameras.)

Getting Steadier Hand-Held Shots

I picked up this trick from photographer Joel Lipovetsky when we were out on a shoot and I saw him hand-holding his camera with his camera strap twisted into what he called "The Death Grip." It's designed to give you extra stability and sharper shots while hand-holding your camera by wrapping your camera strap around your arm (just above the elbow), then wrapping it around the outside of your wrist (as shown above) and pulling the strap pretty tight, which makes your camera more stable in your hand. You can see how it wraps in the photo above, but the pose is just for illustrative purposes—you still would hold the camera up to your eye and look through the viewfinder as always. Thanks to Joel for sharing this surprisingly cool tip.

LEAN ON ME!

Another trick the pros use (when they're in situations where they can't use a tripod) is to either: (a) lean themselves against a wall to help keep themselves steady—if they're steady then the camera's more steady, or (b) lean or lay their lens on a railing, a fence, or any other already stationary object as kind of a make-shift tripod. Keep an eye out for these tripod substitutes whenever you're without yours—it can make a big difference.

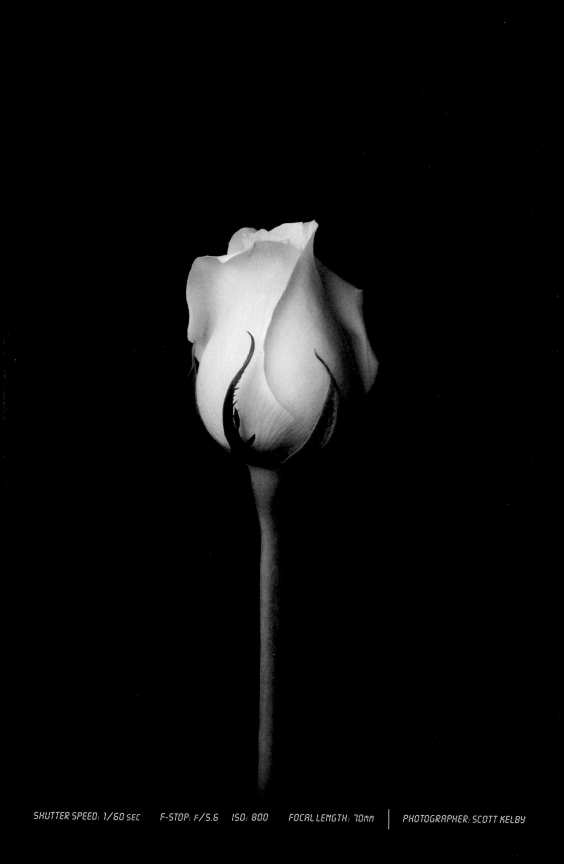

SHUTTER SPEED: 1/60 SEC F-STOP: F/5.6 ISO: 800 FOCAL LENGTH: 70mm │ PHOTOGRAPHER: SCOTT KELBY

Chapter Two

Shooting Flowers Like a Pro

There's More to It Than You'd Think

You're probably surprised to see a chapter in here about shooting flowers because flowers seem like they'd be easy to shoot, right? I mean, they're just sitting there—not moving. They're colorful. They're already interesting, and people love looking at them. It should be a total no-brainer to get a good flower shot. But, ya know what? It's not. It's a brainer. It's a total brainer. Ya know why? It's because of pollination. That's right, it's the pollination that naturally occurs in nature that puts a thin reflective film over flowers that can't normally be seen with the naked eye, but today's sensitive CMOS and CCD digital camera sensors capture this reflectance and it appears as a gray tint over our images. Not only does it turn the photos somewhat gray (which causes flowers to lose much of their vibrant color), you also lose sharpness as well. Now, there is a special photographic filter (called the Flora 61B from PhotoDynamics) that can help reduce the effects of this pollination and both bring back the sharpness and reduce the graying effect, but because of U.S. trade sanctions imposed by the Federal Trade Commission, we can no longer buy this filter direct. Especially because I totally made this whole thing up. I can't believe you fell for this two chapters in a row. Seriously, how are you going to get good flower photos if you're falling for the old Flora 61B trick? Okay, I'm just teasing you, but seriously, getting good flower shots is an art, and if you follow the tips I'm laying out in this chapter, the very next flower shots you take will be that much better (especially if you don't mind the graying and loss of sharpness caused by pollination). See, there I go again. It's a sickness.

Don't Shoot Down on Flowers

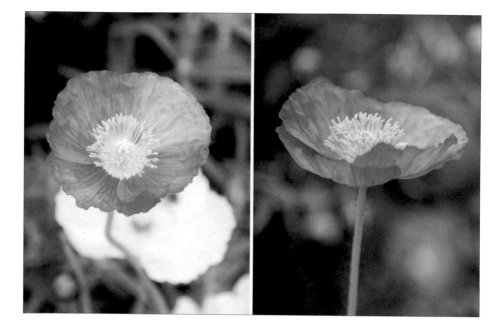

On an average day, if you were to walk by some wildflowers in a field, or along a path in a garden, you'd be looking down at these flowers growing out of the ground, right? That's why, if you shoot flowers from a standing position, looking down at them like we always do, your flower shots will look very, well…average. If you want to create flower shots with some serious visual interest, you have to shoot them from an angle we don't see every day. That usually means not shooting down on them, and instead getting down low and shooting them from their level. This is another one of those things the pros routinely do and most amateurs miss. Hey, if you're going to shoot some great flower shots, you're going to have to get your hands dirty (well, at least your knees anyway). The shots above show the difference: on the left, the typical "shooting down on flowers" shot; on the right, the same flower in the same light using the same focal length lens shot 30 seconds later, but I shot it from the side (down on one knee) instead of shooting down on it. You can see the difference shooting a non-typical angle makes. So, to get great flower shots, start by not shooting down on them. By the way, while you're down there, try getting really low (down below the flowers) and shoot up at them for a fascinating angle you rarely see!

Shooting Flowers with a Zoom Lens

You don't have to have a macro (close-up) lens to take great flower shots—zoom lenses work just great for shooting flowers for two reasons: (1) you can often zoom in tight enough to have the flower nearly fill the frame, and (2) it's easy to put the background out of focus with a zoom lens, so the focus is just on the flower. Start by shooting in aperture priority mode (set your mode dial to A or Av), then use the smallest aperture number your lens will allow (in other words, if you have an f/5.6 lens, use f/5.6). Then try to isolate one flower, or a small group of flowers that are close together, and focus on just that flower. When you do this, it puts the background out of focus, which keeps the background from distracting the eye and makes a stronger visual composition.

SAVE YOUR KNEES WHEN SHOOTING FLOWERS

If you're going to be shooting a lot of flowers, there's an inexpensive accessory that doesn't come from the camera store, but you'll want it just the same—knee pads. They will become your best friend. Find them at Home Depot, Lowe's, or any good gardening store.

Use a Macro Lens to Get Really Close

If you've ever wondered how the pros get those incredibly close-up shots (usually only seen by bees during their pollination duties), it's with a macro lens. A macro lens (just called "macro" for short) lets you get a 1:1 view of your subject and reveal flowers in a way that only macros can. A macro lens has a very shallow depth of field—so much so that when photographing a rose, the petals in the front can be in focus and the petals at the back of the rose can be out of focus. I'm not talking about an arrangement of roses in a vase—I'm talking about one single rose. By the way, you *must* (see how that's set off in italics?), must, must shoot macro on a tripod. When you're really in tight on a flower, any tiny bit of movement will ruin your photo, so use every sharpening technique in Chapter 1 to capture this amazing new world of macro flower photography.

TURN YOUR ZOOM LENS INTO A MACRO ZOOM

It's easy—just add a close-up lens (like we talk about on the next page) onto your regular zoom lens. As I mention, these close-up lenses (also called two-element close-up diopters) are cheaper than buying a full-blown macro lens, plus adding it to your zoom gives you zoom capability, as well. You can buy single-element close-up filters, but they're generally not as sharp at the edges, but for flowers the edges usually aren't as important anyway.

Can't Afford a Macro? How 'bout a Close-Up?

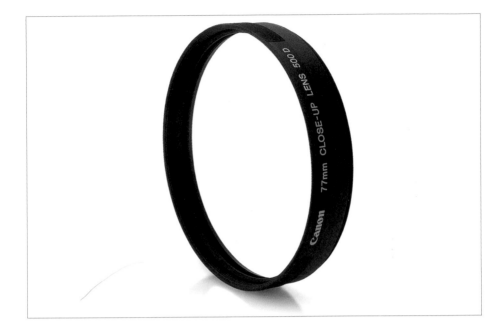

I learned about this from my buddy (and famous wildlife and nature photographer) Moose Peterson, and what it lets you do is turn your telephoto zoom lens into a macro lens for 1/4 of the price, and 1/10 the weight and size. It looks just like a thick filter (it's about 1" thick), and it screws onto both Canon and Nikon lenses just like a traditional filter, but it turns your zoom lens into a macro zoom. What's great about this little close-up lens is that:

(1) it takes up so little room in your camera bag;

(2) it weighs just a few ounces;

(3) and best of all—it's pretty inexpensive (well, compared to buying a decent macro lens, which would run you at least $500).

It's called the Canon Close-Up Lens (even though it's from Canon, you can get a version that screws onto a Nikon lens. It's the only thing I know of from Canon that's designed for Nikon cameras. I use the Canon Close-Up Lens 500D to attach to my 70–200mm Nikon VR lens [it's 77mm], and it works wonders). So, how much is this little wizard? Depending on the size of the lens you're going to attach it to, they run anywhere from about $75 to $145. That ain't bad!

When to Shoot Flowers

©ISTOCKPHOTO/ANTONY SPENCER

There are three ideal times to shoot flowers:

(1) **On cloudy, overcast days.** The shadows are soft as the sun is hidden behind the clouds, and the rich colors of the flowers aren't washed out by the harsh direct rays of the sun. That's why overcast days are a flower photographer's best friend. In fact, there's probably only one other time that's better than shooting on an overcast day, and that is…

(2) **Just after a rain.** This is a magical time to shoot flowers. Shoot while the sky is still overcast and the raindrops are still on the petals (but of course, to protect your digital camera [and yourself], don't actually shoot in the rain). If you've got a macro lens, this is an amazing time to use it. While you're shooting macro, don't forget to shoot the raindrops on leaves and stems as well, while they're reflecting the colors of the flowers (of course, don't forget to shoot on a tripod if you're shooting macro).

(3) **If you shoot on sunny days**, try to shoot in the morning and late afternoon. To make the most of this light, shoot with a long zoom lens and position yourself so the flowers are backlit, and you'll get some spectacular (but controlled) back lighting.

Don't Wait for Rain—Fake it!

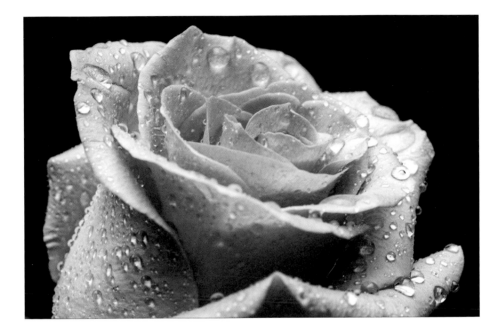

This one may sound cheesy at first, but you'll be shocked at how well this works. Instead of waiting for a rainy day to shoot, take a little spray bottle with you, fill it with water, and spray the flowers with water yourself. I found a nice little spray bottle in Walgreens' beauty section (I know what you're thinking, "Walgreens has a beauty section?" Believe it or not, they do) for a couple of bucks, and it works wonders. Just a couple of quick spritzes with the spray bottle and you've got some lovely drops of water on your petals, and no one will ever know you didn't wait patiently for Mother Nature to intervene. Get a small enough bottle and you can carry it in your camera bag (empty, of course). By the way, I've used this spray bottle technique to shoot some yellow roses I bought for my wife, and by using a macro lens you'd swear I was shooting on the White House lawn after a spring shower. Try this once—you'll become a believer.

TIP THAT DOESN'T BELONG IN THIS BOOK

There's another hidden benefit of carrying a small spray bottle in your camera bag: getting wrinkles out of clothes. Just give your shirt, blazer, photographer's vest, etc., a couple of spritzes before bed and when you wake up in the morning, the wrinkles are gone. I know, this has little to do with photography, but I had this empty space at the bottom here, so I figured I'd pass this on.

Flowers on a Black Background

One of the most dramatic compositions for shooting flowers is to position a single flower on a black background. You can add a black background in Photoshop, but in most cases that is just way too much work. Instead, do what the pros do—put a black background behind your flower when you shoot it. My buddy Vincent Versace, one of the leading nature photographers (and instructors) in the business, told me his trick—he wears a black jacket while out shooting flowers, and if he sees a flower he wants on a black background, he has his assistant (or a friend, or his wife, or a passerby, etc.) hold the back of his jacket behind the flower. I know, it sounds crazy—until you try it yourself. If you're shooting flowers indoors (I shoot nearly every arrangement I buy for my wife, or that we receive from friends), buy a yard of either black velvet or black velour (velvet runs around $10–15 per yard; velour runs around $5–10 per yard) and literally put it behind your flowers. You can prop it up on just about anything (I hate to admit it, but I've even propped up my velour background by draping it over a box of my son's Cookie Crisp cereal). Leave a few feet between your flowers and the black background (so the light falls off and the black looks really black) and then shoot away. Now, what kind of light works best? Keep reading to find out.

Flowers on a White Background

Another popular look for a flower photographer is to shoot on a white background. You could buy a seamless roll of paper from your local camera store (it's pretty cheap), but it's usually much wider than you need. Plus, unless you're shooting flowers for a florist, you're usually not going to want to see the vase. That's why I go to Office Depot and buy two or three 20x30" sheets of white mounting board (it looks like poster board, but it's much thicker and stiffer). I usually position one behind the flowers (in a vase), and then use the other to reflect natural light (from a window with indirect sunlight) back onto the white background so it doesn't look gray. Again, put about 3 feet between your flowers and the background, and use that natural light to capture your flowers on what appears to be a solid white background you added in Photoshop, but it was even easier because you did it in the camera.

PUT THAT SHOWER CURTAIN TO WORK

If you buy the white shower curtain mentioned in the tip on the next page, here's another way to stretch your shopping dollar—use it as your white background. As long as you're using a shallow depth of field, you'll never know that white background is a shower curtain. Just don't shoot at f/11 or f/16 or people will say things like, "Hey, nice shower curtain," or, "Did you shoot that in the bathroom?"

The Perfect Light for Indoor Flower Shots

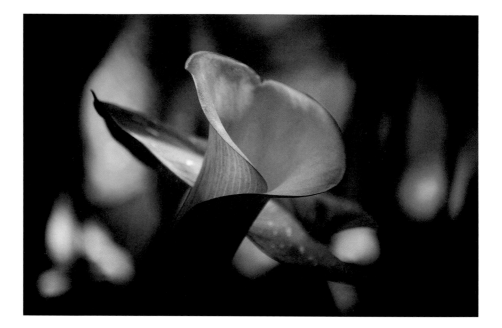

If you're shooting flowers indoors, you don't have to buy an expensive lighting rig (finally, something you don't have to spend a bunch of money on), because flowers love diffused natural light. By diffused, I mean that it's not getting direct sunlight, so any soft light coming in from a window works just great. If your window is really, really dirty, that's even better because it makes the light even more diffuse. So look for a window in your house, studio, office, etc., that has non-direct sunlight coming in. Then set your flowers near that window, and position them so you're getting side lighting (if the natural light hits the flowers head on, they'll look kind of flat—you need that extra dimension that side lighting brings). Set up your tripod so you're shooting the flowers at eye level (remember, don't shoot down on flowers). Now you're ready to shoot in some beautiful, soft light, and you didn't spend a dime (at least on lighting, anyway).

HOW TO CREATE THE PERFECT NATURAL LIGHT BY CHEATING

If you're faced with nothing but harsh direct sunlight through your open window, you can cheat—just go to Wal-Mart, Kmart, or Target and buy two things: (1) a frosted white shower curtain (or shower curtain liner), and (2) some tacks or push pins. Go back to your harsh light window, tack up your frosted shower curtain, and enjoy the best diffused natural light you've seen. Don't worry—I won't tell anybody.

Where to Get Great Flowers to Shoot

©ISTOCKPHOTO/BRIGIDA SORIANO

This may sound like the "Duh" tip of the book, but I can't tell you how many times I've told a photographer about this and they say, "Gee, I never thought of that." To get some really great flowers to shoot, just go to a local florist and buy them (see, there's that "duh" part). You can pick exactly which individual flowers you want (I like shooting roses, calla lilies, and daisies myself), and chances are the flowers you're getting are in great shape (they're fresh). You can reject any flower they pull out that has brown spots or is misshapen (I love that word, "misshapen"), and you don't have to pay to have them arranged. You can often walk out for less than 10 bucks with some amazing-looking subjects to shoot at the height of their freshness (though sometimes you have to wait a day or so until your roses are in full bloom).

Stopping the Wind

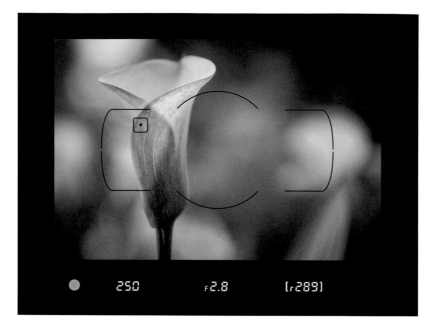

If you're shooting flowers outdoors, you're bound to run into the natural enemy of flower photography—wind. There's nothing more frustrating than standing there, tripod set, camera aimed and focused, and you're waiting for the wind to die down enough to get the shot. This is especially bad if you're shooting macro, where the slightest movement spells disaster (well, not disaster, but a really blurry photo). You can try the old use-your-body-to-block-the-wind trick (which rarely works, by the way), but you're actually better off letting the camera fix the problem. Switch to shutter priority mode (where you control the shutter speed and your camera takes care of adjusting the rest to give you a proper exposure), then increase the shutter speed to at least 1/250 of a second or higher. This will generally freeze the motion caused by wind (unless it's hurricane season). If the higher shutter speed doesn't do the trick, then you have to go to Plan B, which is making the wind the subject. That's right, if you can't beat 'em, join 'em—use a very slow shutter speed so you see the movement of the flowers (you'll actually see trails as the flower moves while your shutter is open), and in effect you'll "see" the wind, creating an entirely different look. Give this seeing-the-wind trick a try, and you might be surprised how many times you'll be hoping the wind picks up after you've got your regular close-ups already done.

Consider Just Showing One Part

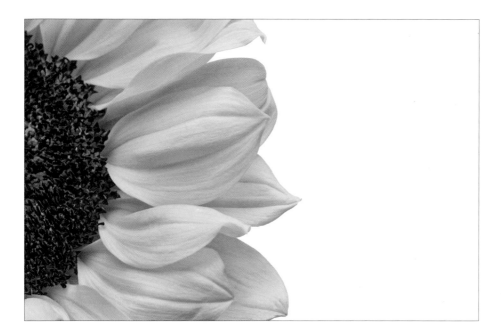

Although most of the time we'll be capturing one or more flowers in our frame, you can create flower images with a lot of impact by zooming in really tight and just showing part of a flower. One single petal (if it's a larger flower) or 1/3 or 1/2 of the flower can really create a dynamic-looking image. One of the reasons why these images are so interesting is because this close-up view of flowers is one we normally don't see. This doesn't take any special technique—you just have to zoom in really close (and if you have a macro lens, it's even easier getting in really tight on just part of the flower).

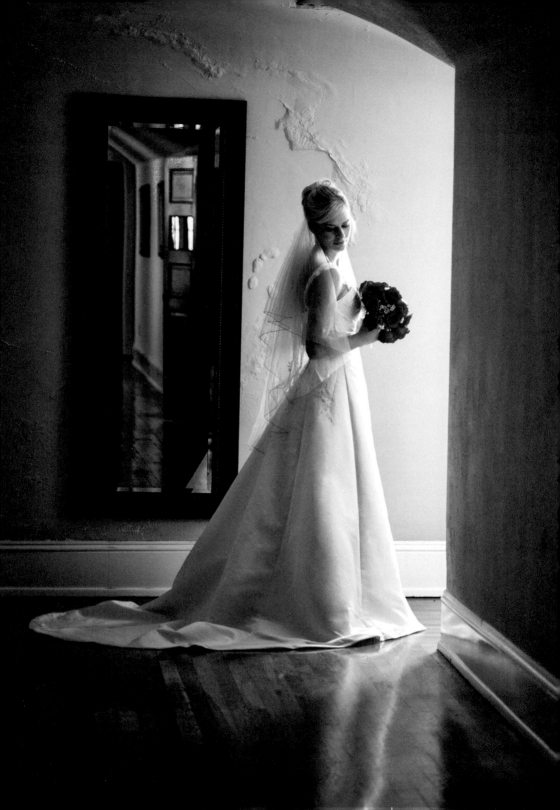

SHUTTER SPEED: 1/25 SEC F-STOP: F/2.8 ISO: 1000 FOCAL LENGTH: 82mm | PHOTOGRAPHER: SCOTT KELBY

Chapter Three
Shooting Weddings Like a Pro
There Is No Retaking Wedding Photos. It Has Got to Be Right the First Time!

If you're living your life and you think to yourself, "Ya know, I've got it pretty easy," then it's time to shoot a wedding. Don't worry, this isn't something you're going to have to go looking for—if you've got even one long lens (200mm or longer), it will find you. That's because in a lot of people's minds, if you have a long lens, you're a serious photographer. It's true. Seriously, try this: show up at an event with a 200mm to 400mm lens on your camera and people will literally get out of your way. They assume you've been hired by the event and that you're on official photography business, and they will stand aside to let you shoot. It's the equivalent of walking into a factory with a clipboard—people assume you're legit and they let you go about your business. Add a photographer's vest and it's like having an official press pass to anything (try this one—you'll be amazed). Anyway, if you have a long lens, before long someone you know will get married but they won't have a budget for a professional photographer (like your cousin Earl). He'll ask, "Can you shoot our wedding photos?" Of course, you're a nice person and you say, "Why sure." Big mistake. You're going to work your butt off, miss all the food, drinks, and fun, and you'll experience stress at a level only NORAD radar operators monitoring North Korea ever achieve. A wedding ceremony happens once in real time. There are no second takes, no room for mess-ups, no excuses. Don't make Earl's bride really mad—read this chapter first.

Tricks for Low-Light Shooting in a Church, Part 1

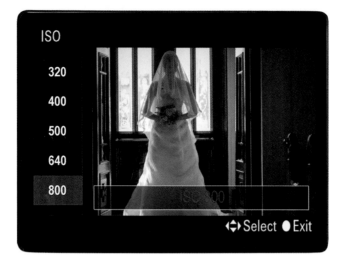

Although you usually should use a tripod when shooting the formals (the group shots after the ceremony with the bride, groom, family members, etc.), when shooting the wedding ceremony in a low-light situation like a church, you'll probably need to hand-hold your shots. This is a problem because hand-holding in low-light situations is almost a guarantee of having blurry photos. Here's why: When there's low lighting, your camera compensates for it by slowing down the shutter speed to take in more light so it can make a proper exposure. So, your exposure will still be right, but chances are your photos will wind up being blurry because the shutter speed isn't fast enough. Any tiny little movement on your part equals blurry photos. So, how do the pros get those crisp low-light shots in a setting like a church? Well, one thing they do is increase their digital camera's ISO setting, which raises the camera's shutter speed (you generally need a shutter speed of at least 1/60 of a second for non-blurry photos). Luckily, today's DSLR cameras let you shoot at high ISOs with little visible noise. So, how high can you go? At least ISO 800, but you can usually get away with as high as ISO 1600 in most situations (or more, depending on your camera model—generally, the more expensive the camera, the less noise you'll see shooting at high ISOs). So, now that you know what to do, here's how to do it: Aim at the low-light scene you want shoot, press your shutter button halfway down, and look in your viewfinder to see what your shutter speed will be. If it's slower than 1/60 of a second, you're going to need to crank up the ISO until you see your shutter speed hit at least 1/60 of a second or faster (then hold your camera very steady).

Tricks for Low-Light Shooting in a Church, Part 2

The second trick wedding pros use to shoot in low-light situations is to shoot with a fast lens to let in more light (by that, I mean a lens where the largest available f-stop is something like f/1.4 or f/1.8, or maybe f/2.8—lower numbers are better). Once you have one of these lenses, shooting at these fast f-stops (let's use f/1.8, for example) lets a lot more light in, which gives you faster shutter speeds so you don't have to raise your ISO nearly as much (or at all). Since we know that raising our ISO adds at least some noise to our photos, if we have a choice, we'd rather use a fast lens than crank up our ISO. Now, depending on how dark it is where you're shooting, you might still have to increase the ISO amount, even when using one of these fast lenses at it's wide-open (lowest number) setting, but you'll have to raise it less, which means less noise.

Do You Really Need the f/1.4 Lens?

So, now you know that wedding pros use fast lenses to shoot in lower light with less noise, so having one of these in your wedding shoot camera bag makes a lot of sense. However, how fast of a lens do you really need? The two most popular fast lens sizes for wedding photographers these days are probably the 50mm prime and the 85mm prime (prime means it's not a zoom lens, it's stuck at that one focal length). Okay, so now do you need the f/1.4 or the f/1.8? This I can help with: At the time this book was published, a Nikon 50mm f/1.8 lens sold for around $125 (over at B&H). However, to get just 2/3 of a stop more light, the Nikon 50mm f/1.4 sold for around $330 (nearly triple the price). Besides the obvious price difference, you need to be more accurate with your focus shooting at f/1.4 than you do shooting at f/1.8 (shooting a close object with either is going to create a very shallow depth of field. For example, if you shoot a close-up portrait at f/1.4, the tip of your subject's nose could be in focus, but then their eyes would be a bit out of focus, and their hair would be way out of focus). For that reason, I'm personally more likely to shoot at f/1.8 (it gives me a little more latitude, and a little more area in focus). As for quality, there's a lot of debate as to whether anyone can really see the quality difference between the f/1.4 or the f/1.8, so for most folks, I recommend going with the less expensive f/1.8 lens (so, who would I recommend buy the f/1.4 model? That's easy—rich doctors).

Getting Soft, Diffused Light with Flash, Part 1

If you're shooting your weddings with a flash indoors, you're likely to get harsh shadows and unflattering, flat light, but it doesn't have to be that way. The trick for getting soft, diffused light is to get a flash diffuser of some sort. One of the most popular ones these days is the Westcott Micro Apollo Softbox (shown above), which runs around $30. Another popular flash diffuser is Gary Fong's Lightsphere Collapsible, which sells for around $45. Both attach over your flash unit, and do a great job of softening the light and dispersing it evenly. This will make a big difference in the quality of the light that falls on your bride, groom, and bridal party, and you'll get much more professional results for a very small investment.

WAY COOL TIP

If you're shooting in very high ISOs, you'll want to know about a popular Photoshop plug-in for wedding photographers called Dfine 2.0 (from Nik Software). Besides reducing noise, a happy side effect is that it also smooths skin.

Getting Soft, Diffused Light with Flash, Part 2

The other method of getting soft, diffused, and better yet, directional light using a flash (the key word here is directional, because it keeps your flash shots from looking flat) works if you're using an external flash unit (and not the built-in flash on your camera, which is pretty limited, as you'll soon see). The advantage of an external flash unit is that you can change the angle and direction of the flash. The reason this is cool is that instead of aiming your flash right into your subject's face (which gives the most harsh, flat light you can imagine), you can bounce the light off one of two places: (1) The ceiling. If the room you're shooting in has a white ceiling (and chances are the ceiling is white), then you can aim your flash head up at the ceiling at a 45° angle (as shown above, and provided that the ceiling isn't more than 10 feet tall) and the ceiling will absorb the harsh light, and what will fall on your subject is much softer, smoother light and, best of all, it won't cast hard shadows behind your subject. Instead, your soft shadows will cast on the ground (and out of your frame). Now, want to take this up another notch? Then instead of aiming at the ceiling, (2) have an assistant (a friend, relative, etc.) hold a reflector on your left or right side, slightly above shoulder height, and angle your flash head into that. So now, the reflector eats up the harsh light, but better yet, since the reflector is at an angle, it casts soft directional light on an angle, too. This puts soft shadows on one side of the bride's (groom's, bridesmaid's, etc.) face, giving a more pleasing and less flat lighting effect (think of it as side lighting).

Use Your Flash at Outdoor Weddings

One trick that wedding photographers have been using for years is to use fill flash outdoors on sunny days. I know, it sounds crazy to use a flash when the sun is bright in the sky, but wedding photographers add flash to these daylight shots to help eliminate those hard, harsh shadows in their subjects' faces, and make the bride and groom look more natural under these undesirable lighting conditions (plus it usually adds nice catchlights in the eyes of your subjects, as well). Always check the results in your LCD monitor to make sure your light is properly balanced. Here's a shot of me taken while shooting a recent wedding. Notice the flash doesn't fire straight into the wedding party's faces. Instead, the head is rotated to the right (or left) and tilted 45°, so the flash fills in the shadows yet doesn't have that harsh look you'd get by aiming the flash straight at your subjects. As long as you're not more than 8 or 10 feet away from your subject, don't worry—the flash will still be effective, even though it's not aiming straight on.

ANOTHER COOL FLASH TIP

Here's another tip that will make your flash seem less "flashy" when shooting outdoors: use your camera's flash exposure compensation button and change the flash exposure compensation to –1 (it works the same way regular exposure compensation works, but for flash exposures). Your flash will still help lift out the shadows, but now without being so obvious.

Finding That Perfect Bridal Light

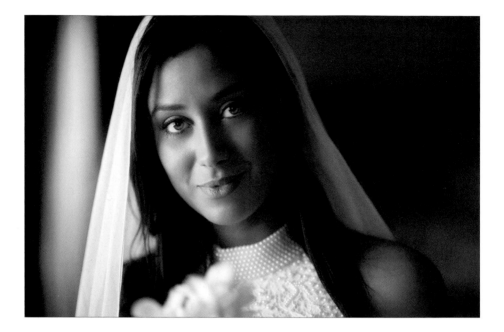

At most weddings there is a spot with really spectacular light just waiting for you to walk over and find it, but once you find it, you have to know how to use it. That light, of course, is natural light coming in through a window (it's hard to make a photo look bad in that light). Look for a window that doesn't have direct sunlight (a window facing north usually works well to provide some soft, diffused light). So, once you find this wonderful natural side light coming in from a window, where do you place the bride? Ideally, about 6 to 8 feet from the window, so the light falls evenly and softly upon her (almost sounds like a song, doesn't it?). This is a great spot for shooting some pre-wedding shots of the bride alone, the bride with her mother, and the bride with her father.

Don't Spend Too Much Time On the Formals

SCOTT KELBY AND ©ISTOCKPHOTO/ALEKSANDR LOBANOV

A very famous wedding photographer gave me some great advice one day about shooting the formals (the posed group portraits, usually taken after the ceramony, of the bride and groom posed with the wedding party, with just the bridesmaids, just the groomsmen, just the bride's parents, just the groom's parents, and so on). He said, "Get the formals over fast. You have to do them, but nobody cares about them." They don't usually include a special or touching moment and they're rarely photos anybody talks about after the wedding (unless, of course, you forget to do them). So, get everybody together, knock those shots out, and move on to the important job of capturing the moments that do matter.

Formals: Who to Shoot First

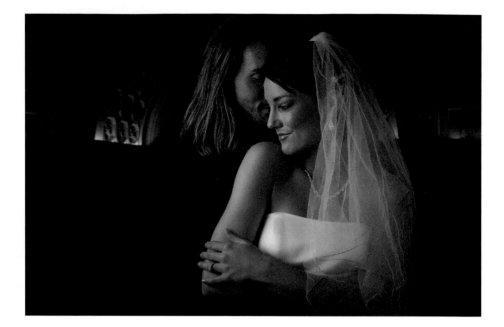

After the ceremony, in most cases you'll shoot the formal portraits of the bride and groom posed with everyone from bridesmaids to grandparents. The hard part is rounding up all the people you'll need to shoot with the bride and groom at the exact time you need them. This can take 30 minutes or three hours—it's up to you and how organized you are. Here's a tip to make things move as quickly as possible: gather everyone that will appear in any shot together right from the start. While they're all sitting there, shoot the formal bride and groom portraits first (you'll see why in just a moment). Once you've got those out of the way, shoot the largest groups of people (the huge family portraits), and then once you're done with a group (like the grandparents for example), send them off to the reception. So, in short—start with everyone, and then as you shoot them, release them to go to the reception until you're left with just the bride and groom again. If you don't do it this way, you'll wind up standing around for long periods of time waiting for Uncle Arnie, who's somewhere in the reception hall. The reason you shoot the bride and groom first is that the pressure to get the bride and groom to the reception hall increases exponentially as time goes by, because generally they hold the meal until the bride and groom have arrived. So, everyone is sitting in the reception hall waiting on you—the photographer. You then wind up rushing the most important portraits of them all (the ones the couple will actually buy—their formal portraits). Make your life easy—start big, then get small.

Formals: Build Off the Bride and Groom

©ISTOCKPHOTO/TRIGGERPHOTO

There's a popular format for creating all your formals—have the bride and groom in the center, and have them stay put. They don't move—instead you have groups of other people (bridesmaids, groomsmen, the best man, maid of honor, parents, grandparents, etc.) move in and out around them. Use the bride and groom as building blocks and everything will be much easier (well, as far as posing your large groups goes anyway).

How to Pose the Bride with Other People

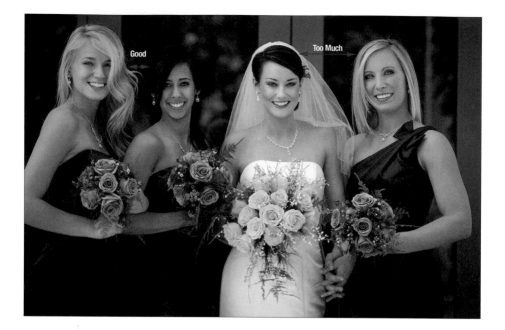

When you're posing other people with the bride, including the groom, to create the level of closeness you'll want in your photos, be sure to position the heads of the bride and the other person very close to each other. This doesn't sound like it would be a problem, until you actually start posing people. When they fall into what feels like a natural pose, they leave way too much room between their head and the bride's head. While this may look perfectly natural in person, the photos will lack a closeness that will be really obvious. I've seen this again and again, and I constantly have to remind people, even the groom, to move their head in very close to the bride's. To them, it just feels unnatural being that close while posing, but if they don't do it, your shots will look stiff and unnatural. Keep an eye out for this on your next wedding shoot and you'll be amazed at how the level of closeness between your subjects goes up, giving you much more powerful images.

The Trick to Keeping Them from Blinking

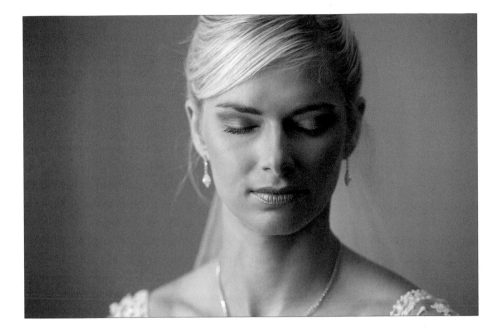

If you shoot a group of five people or more, it's almost guaranteed that one or more people will have their eyes shut. It's another natural law of wedding photography, but you're not going to have to worry about that very much, because you're about to learn a great trick that will eliminate most, if not all, instances of people blinking or having their eyes closed. When you're ready to shoot the shot, have everybody close their eyes, and then on the count of three have them all open their eyes and smile. Then, wait one more count before you take your shot. When I'm shooting these groups, here's what I say, "Okay, everybody close your eyes. Now open them on 3-2-1…open!" Then I wait one count after they open their eyes before I take the shot. It works wonders.

Formals: Where to Aim

When shooting large groups for the formal portraits, you'll want to make sure that you use an aperture setting that keeps everyone in focus. Try f/11 for a reasonable depth of field for groups. Now, where do you focus? If you have more than one row of people deep, the old rule (which still stands true today) is to focus on the eyes of the people in the front row. You have more depth behind than in front, so make sure you focus on them, and the rest should be okay, but if that front row is out of focus, the whole shot is a bust.

Formals: How High to Position Your Camera

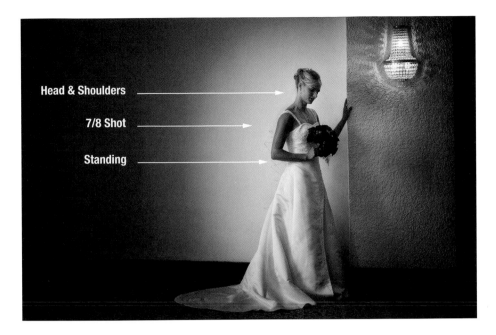

When you're shooting your formal shots, the height that you position the camera is actually very important, because if it's not positioned correctly, your subject's body can look distorted or some parts can look larger than normal (in general, this is just not good stuff). So, finding the right height for professional portraits is critical. Here are a few guidelines to help you get the pro look:

Standing, Full-Length Portrait: Position your camera (on your tripod) at the bride's waist height (yes, you'll have to squat down/bend over, etc., but the final result will be worth it). Keep your lens straight (don't aim up toward the bride's face).

7/8 Shots (from the Calf Up): Position your camera (on your tripod) at the bride's chest level and shoot with your lens straight from there.

Head and Shoulders Shots: Position your camera (on your tripod) either at the bride's eye level or slightly above.

Formals: Don't Cut Off Joints

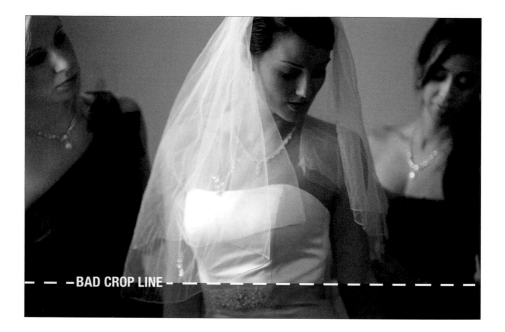

When you're framing your formals in your viewfinder, for a more professional look, be careful not to cut off anyone at the joints (in other words, don't let the bottom of the frame cut anyone off at the elbow or knee. On the side of the frame, don't cut anyone off at the wrist or elbow either). Basically, stay away from the joints. If you have to crop an arm or leg off, try to do it as close to the middle of the arm or leg as possible, staying clear of the joints. 'Nuf said.

Formals: The Trick to Great Backgrounds

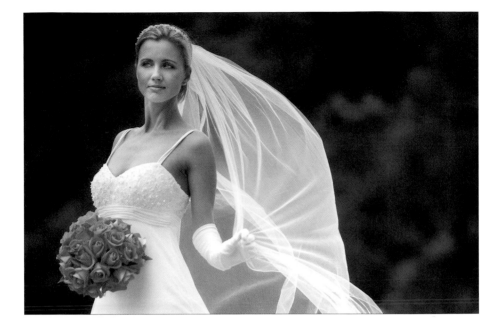

In formal portraits, the backgrounds are just that—backgrounds. And the key to a great background is using a very simple one. The simpler, the better. So don't look for an outdoor shot with a waterfall, 36 different kinds of plant life, and flowers blossoming from hanging vines, etc. Look for simplicity or it will greatly distract from your portraits, and give your formals an uncomfortable look (yet nobody will know why). Plus, if for any reason you have to retouch the background later in Photoshop, the less busy the background, the easier your retouch will be.

BACKGROUND TIP

Here's another good tip: vary your background for your formals. It may not seem like a big deal at the time, but when you see the same background over and over and over again in the final wedding album, it can become really tedious. Once you've shot a few sets on one background, if there's another simple background nearby, try it in order to keep the album from looking like a cookie cutter.

Reception Photos: Making Them Dance

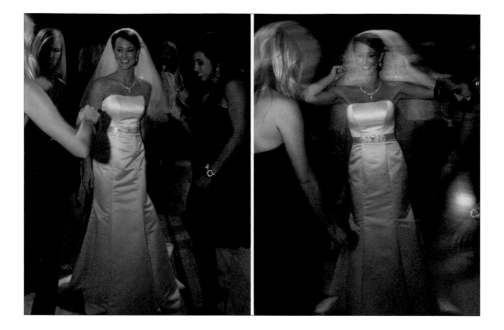

There's a problem with taking photos of people dancing. If you shoot them with a flash (and most likely you will), it will freeze their movement, so they'll look like they're just standing still, but in somewhat awkward poses. It still amazes me how people doing a line dance can be pictured as people in a police lineup—the camera just doesn't capture motion, unless you tell it to. There are really two techniques: The first is in the camera. Use a slow shutter speed so the people have a motion blur, which makes them look like (you guessed it) they're dancing. (If you want the main person in your shot, like the bride, to be in focus, you can use panning, where you take the camera and follow their move-ment.) If you didn't remember to employ this technique during your reception shoot, then you can add this motion blur in Photoshop. The first step is to duplicate the Background layer. Then go under the Filter menu, under Blur, and choose Motion Blur. Set the Angle to 0°, then increase the Distance until things look like they're really moving. If you want to keep one person in focus, get the Eraser tool, choose a really big, soft-edged brush (like the soft round 200-pixel brush) and erase over the person you're focusing on (like the bride, etc.) so that person appears in focus, while everyone else is dancing and moving around having a good time.

Your Main Job: Follow the Bride

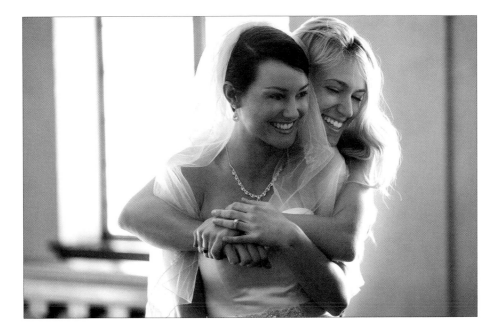

The main focus at any wedding is the bride, so make darn sure your main focus at the pre-wedding, the ceremony, the formals, and the reception is the bride. Follow the bride just like you would follow the quarterback if you were shooting a football game. Especially if you're going to be selling these photos, as it will be the bride (either directly or indirectly) who will be buying the prints. So, make darn sure that she's the clear star of the show (photos of Uncle Arnie at the reception don't sell well, if you get my drift).

Shooting the Details (& Which Ones to Shoot)

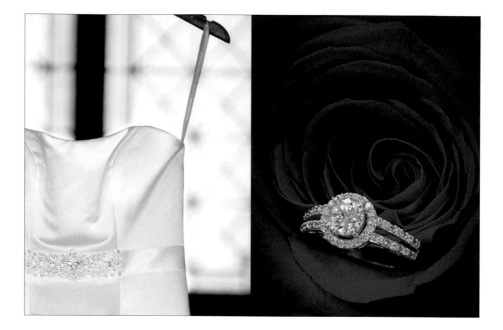

The photojournalism style of wedding photography is very big right now (where you tell the story of the wedding in photos as if you were covering it for a newspaper or magazine). One of the cornerstone elements of this technique is to make sure to photo-graphically capture the tiny details of the wedding, especially behind the scenes before the wedding. Here's a list of things you might want to capture (shoot), which can either stand alone in the wedding album or be used as backgrounds for other photos:

- The bride's shoes

- The bride's dress hanging on a hanger

- The bride's tiara, necklace, etc.

- The wedding invitation

- The sheet music played at the wedding

- The guestbook (once a few people have signed it)

- Their champagne glasses

- Name cards at the reception

- Their wedding rings (perhaps posed on the invitation with some rose petals casually placed nearby)

- The airline tickets for their honeymoon

- The sheet music, or CD jewel case, to the music for their first dance

- The groom's boutonniere

- The bride's bouquet

- Any fine detail in her dress

Change Your Vantage Point to Add Interest

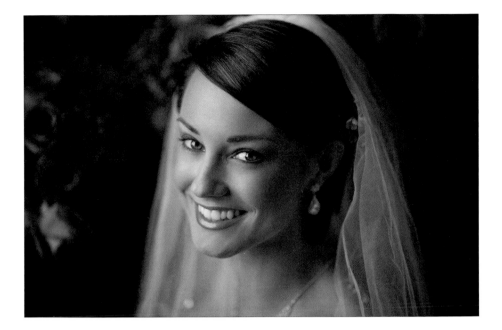

Want to create a shot everyone will remember? Shoot it from a high vantage point (look for a second story window you can shoot down from, or a balcony on the second floor, a bridge, etc.). If you can't find an existing high vantage point, then you can always create your own by bringing (or borrowing) a ladder to shoot from. Of course, be careful, because being on a ladder with expensive camera equipment is the stuff Hollywood comedies are made of. This high vantage point trick is ideal for shooting bridesmaids, groomsmen, the bride and groom, and even the bride alone (as shown here, where I shot the bride while standing on a ladder).

What to Shoot with a Wide-Angle Lens

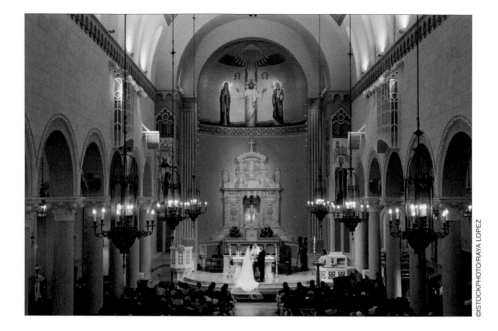

©ISTOCKPHOTO/RAYA LOPEZ

At weddings, there are three things you're definitely going to want to shoot with a wide-angle lens. One is the rice throwing (of course, they don't actually throw rice anymore). You'll want to shoot this with a wide-angle lens so you get the bride, groom, and—just as important—the crowd throwing the rice (or birdseed, or blowing bubbles, etc.) behind and around them. Another thing you'll want a wide-angle lens for is shooting the interior of the church. The bride is going to expect a photo that takes it all in and your wide-angle lens will be your Get Out of Jail Free card when it comes to covering this all-important shot. Lastly, you'll want your wide-angle lens for shooting the bouquet toss and garter toss, so you can get both the tosser and the anxious crowd waiting to capture the prize (so to speak). Go wide, shoot from in front of the bride, and you'll get it all in one shot (but don't just take one shot—this is where a burst of shots will pay off).

Keep Backup Memory Cards on You

It's not unusual for a pro wedding photographer to shoot 750 shots in one wedding, covering the four major parts of a wedding (the pre-wedding shots, the ceremony, the formals, and the reception), so it's likely you'll be shooting a similar amount (maybe less, maybe more, but it will be literally hundreds of shots). The last thing you want to happen is to run out of film (in other words—you don't want to fill up your digital camera's memory card unless you have an empty backup card ready to step right in so you can keep shooting). The trick here is to keep a spare backup memory card physically on you at all times. Keep one right there in your pocket (or purse) so the moment your card reads full, you're just seconds away from continuing your shoot. It's a natural law of wedding photography that your memory card will become full at the most crucial moment of the ceremony, and if you have to stop to go find your backup card (in your camera bag across the room, in the car, or in the reception hall), you're going to miss the most important shot of the day (I learned this the hard way). So always keep a backup physically on you, so you're only 10 seconds away from shooting again.

Back Up Your Photos Onsite

COURTESY OF SANHO

A wedding happens once. You don't get a redo, so make sure that backing up your photos on location is a part of your workflow. If you fill a memory card, and pop in a new one, the next thing you should be doing is backing up that full card to a hard drive, like the Sanho 250-GB HyperDrive ColorSpace UDMA2 Multimedia Player/Storage Device (shown above), which lets you pop a CompactFlash card directly into the unit and back up your photos onto it without having a computer nearby. As soon as you fill a card, pop it into the Sanho HyperDrive and hit the copy button. In just a few minutes, your memory card (with those irreplaceable photos) is backed up. Also, as soon as you return to your studio, immediately copy all the photos on the backup drive onto a removable hard drive, so now you have two backups of the wedding photos. This backing up is so important—without a backup, you're placing a lot of faith in those memory cards. Imagine how you'd feel having to tell a bride and groom that your memory card somehow became corrupted and you lost the shots of their ceremony. You can sidestep that crisis (and a potential lawsuit) by making one or two simple backups.

Scott's Gear Finder

The 250-GB Sanho HyperDrive (around $370)

The 750-GB NEXTO DI Photo Storage Portable Backup Drive (around $450)

If Shooting JPEGs, Use a Preset White Balance

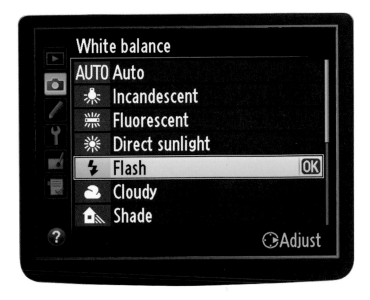

If you're shooting with your digital camera set to RAW format, you don't need to worry about the white balance (leave it set at Auto White Balance, you can always change it later, in Photoshop), but if you're like many pro wedding photographers, you're shooting in JPEG Fine format (so you can take more shots and write to the memory card faster). If that's the case, then you're better off choosing a preset white balance in the camera that matches the lighting situation you're shooting in (that way, the overall color of your photo looks balanced for the light). If you don't set the right white balance, your photos can look too yellow or too blue. Luckily, choosing a white balance is easier than you'd think, and it will save you loads of time later when you're processing your photos in Photoshop. Just go to the menu on your digital camera, scroll to the white balance control, and choose Incandescent if you're shooting in a standard reception hall, or Daylight if you're shooting an outdoor wedding. If you're using a flash, set your white balance to Flash. It's that easy to get your color in line.

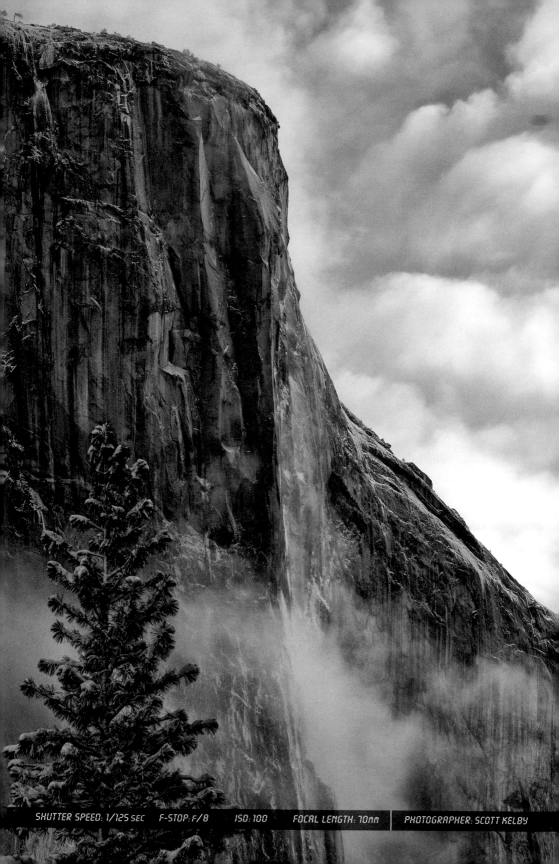

SHUTTER SPEED: 1/125 SEC F-STOP: F/8 ISO: 100 FOCAL LENGTH: 70mm PHOTOGRAPHER: SCOTT KELBY

Chapter Four
Shooting Landscapes Like a Pro
Pro Tips for Capturing the Wonder of Nature

If you ever get to shoot in some truly amazing outdoor locations, like the Grand Canyon or Yosemite National Park, it's really a very humbling photographic experience. The reason why is you're looking at this amazing vista, at the sheer grandeur of it all, and it looks so awe inspiring you'd figure a chimp could even take a great photo of it. I mean, it's just so spectacular, how could you mess it up? Then you set up your tripod, look in your viewfinder, and it happens—you begin to silently sob. You're sobbing because you bought all this expensive camera gear, with multiple camera bodies and lenses that cost more than a Toyota Prius hybrid, you've got more filters than a Ritz Camera store, and your camera bag weighs approximately 54 lbs. You saved all year, took your two-week vacation from work, bought round-trip airfare, and rented a huge SUV big enough to haul you, your family, and all your expensive gear out into the sweltering summer heat of the canyon. Now you're looking through your viewfinder and what you see doesn't look half as good as the stinkin' postcards in the park's gift shop that sell for $1.25 each. Tears begin to stream down your face as you realize that you're not going to get the shot you came for. And whose fault is all this? Ansel Adams—that's who. He screwed up the Grand Canyon, Yosemite, and a dozen other locations for us all. But even though we're not Ansel Adams, we can surely get better photos than the ones in the gift shop, right? Well, it starts with reading this chapter. Hey, it's a start.

The Golden Rule of Landscape Photography

LOCATION: MONTEREY, CA

There's a golden rule of landscape photography, and you can follow every tip in this chapter, but without *strictly* following this rule, you'll never get the results the top pros do. As a landscape photographer, you can only shoot two times a day: (1) Dawn. You can shoot about 15 to 30 minutes before sunrise, and then from 30 minutes to an hour (depending on how harsh the light becomes) afterward. The only other time you can shoot is (2) dusk. You can shoot from 15 to 30 minutes before sunset, and up to 30 minutes afterward. Why only these two times? Because that's the rule. Okay, there's more to it than that. These are the only times of day when you get the soft, warm light and soft shadows that give professional quality lighting for landscapes. How stringent is this rule? I'll never forget the time I was doing a Q&A session for professional photographers. The other instructor was legendary *National Geographic* photographer Joe McNally. A man in the crowd asked Joe, "Can you really only shoot at dawn and dusk?" Joe quietly took his tripod and beat that man to death. Okay, that's an exaggeration, but what Joe said has always stuck with me. He said that today's photo editors (at the big magazines) feel so strongly about this that they won't even consider looking at any of his, or any other photographer's, landscape work if it's not shot at dawn or dusk. He also said that if he takes them a shot and says, "Look, it wasn't taken during those magic hours, but the shot is amazing," they'll still refuse to even look at it. The point is, professional landscape photographers shoot at those two times of day, and only those two times. If you want pro results, those are the only times you'll be shooting, too.

Become Married to Your Tripod

Okay, so now you know that as a pro landscape shooter your life is going to be like this: you get up before dawn, and you miss dinner about every evening (remember, there's no shame in coming to dinner late). If you're okay with all that, then it's time to tell you the other harsh reality—since you'll be shooting in low light all the time, you'll be shooting on a tripod all the time. Every time. Always. There is no hand-holding in the professional landscape photography world. Now, I must warn you, you will sometimes find landscape photographers out there at dawn some mornings shooting the same thing you are, and they're hand-holding their cameras. They don't know it yet, but once they open their photos in Photoshop, they are going to have the blurriest, best-lit, out-of-focus shots you've ever seen. Now, what can you do to help these poor hapless souls? Quietly, take your tripod and beat them to death. Hey, it's what Joe McNally would do. (Kidding. Kind of.)

TRIPODS: THE CARBON FIBER ADVANTAGE

The hottest thing right now in tripods is carbon fiber. Tripods made with carbon fiber have two distinct advantages: (1) they're much lighter in weight than conventional metal tripods without giving up any strength or stability, and (2) carbon fiber doesn't resonate like metal, so you have less chance of vibration. However, there's a downside: as you might expect, they're not cheap.

Shoot in Aperture Priority Mode

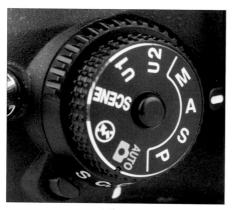

Nikon

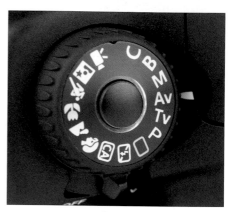

Canon

The shooting mode of pro outdoor photographers is aperture priority mode (that's the little A or Av on your digital camera's mode dial). The reason why this mode is so popular is that it lets you decide how to creatively present the photo. Here's what I mean: Let's say you're shooting a tiger with a telephoto zoom lens and you decide you want the tiger (who's in the foreground of the shot) to be in focus, but you want the background out of focus. With aperture priority mode, it's easy—set your aperture to the smallest number your lens will allow (for example, f/2.8, f/4, f/5.6, etc.) and then focus on the tiger. That's it. The camera (and the telephoto lens) does the rest—you get a sharp photo of the tiger and the background is totally out of focus. So, you just learned one of the three aperture tricks: low numbers (and a zoom lens) leave your subject in the foreground in focus, while the background goes out of focus. Now, what do you do if you want the tiger and the background to both be in focus (you want to see the tiger and his surroundings clearly)? You can move your aperture to either f/8 or f/11. These two settings work great when you just want to capture the scene as your eye sees it (without the creative touch of putting the background majorly out of focus). Far away backgrounds (way behind the tiger) will be a little bit out of focus, but not much. That's the second trick of aperture priority mode. The third trick is which aperture to use when you want as much as possible in focus (the foreground, the middle, the background—everything): just choose the highest number your lens will allow (f/22, f/36, etc.).

Composing Great Landscapes

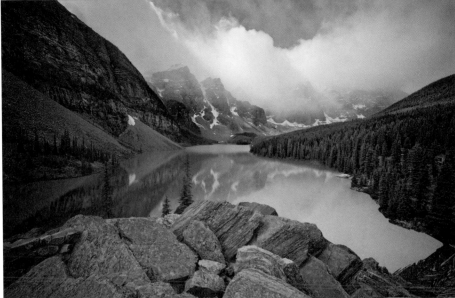

LOCATION: LAKE LOUISE, BANFF NATIONAL PARK, CANADA

The next time you pick up a great travel magazine that features landscape photography or look at some of the work from the masters in digital landscape photography, like David Muench, Moose Peterson, Stephen Johnson, Bill Fortney, and John Shaw, take a moment to study some of their wonderful, sweeping images. One thing you'll find that most have in common is that these landscape shots have three distinct things: (1) A foreground. If shooting a sunset, the shot doesn't start in the water—it starts on the beach. The beach is the foreground. (2) They have a middle ground. In the case of a sunset shot, this would be either the ocean reflecting the sun, or in some cases it can be the sun itself. And lastly, (3) they have a background. In the sunset case, the clouds and the sky. All three elements are there, and you need all three to make a really compelling landscape shot. The next time you're out shooting, ask yourself, "Where's my foreground?" (because that's the one most amateurs seem to forget—their shots are all middle and background). Keeping all three in mind when shooting will help you tell your story, lead the eye, and give your landscape shots more depth.

ANOTHER ADVANTAGE OF SHOOTING AT DAWN

Another advantage of shooting at dawn (rather than at sunset) is that water (in ponds, lakes, bays, etc.) is more still at dawn because there's usually less wind in the morning than in the late afternoon. So, if you're looking for that glassy mirror-like reflection in the lake, you've got a much better shot at getting that effect at dawn than you do at dusk.

The Trick to Shooting Waterfalls

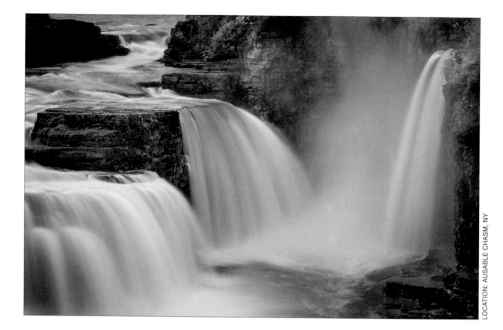

LOCATION: AUSABLE CHASM, NY

Want to get that silky waterfall or that stream effect you see in those pro photos? The secret is leaving your shutter open (for at least a second or two), so the water moves while everything else (the rocks and trees around the waterfall or stream) remains still. Here's what you do: switch your digital camera to shutter priority mode (the S or Tv on your camera's mode dial), and set the shutter speed to 1 or 2 full seconds. Now, even if you're shooting this waterfall on a bit of an overcast day, leaving your shutter open for a few seconds will let way too much light in, and all you'll get is a solid white, completely blown-out photo. That's why the pros do one of two things: (1) They shoot these water-falls at or before sunrise, or just after sunset, when there is much less light. Or they (2) use a stop-down filter. This is a special darkening filter that screws onto your lens that is so dark it shuts out most of the light coming into your camera. That way, you can leave the shutter open for a few seconds. Such little light comes in that it doesn't totally blow out your photo, and you wind up with a properly exposed photo with lots of glorious silky water. Now, if you don't have a stop-down filter and you run across a waterfall or stream that's deep in the woods (and deep in the shade), you can still get the effect by trying this: put your camera on a tripod, go to aperture priority mode, and set your aperture to the biggest number your lens will allow (probably either f/22 or f/36). This leaves your shutter open longer than usual (but that's okay, you're in deep shade, right?), and you'll get that same silky-looking water.

A Tip for Shooting Forests

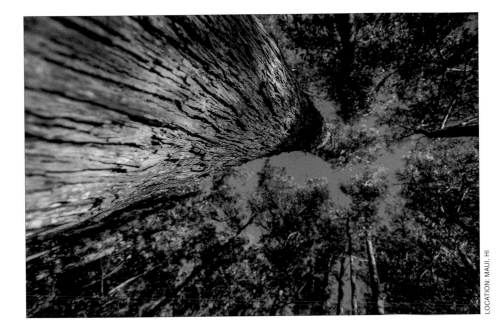

LOCATION: MAUI, HI

Want a great tip for shooting forest scenes? Don't include the ground in your shots. That's right, the ground in the forest is often surprisingly messy (with dead branches, and leaves, and a really cluttered look) and that's why so many pro forest shots don't include the ground—it distracts from the beauty of the trees. So, easy enough—frame your shots so they don't include the ground, and you're shooting better forest shots right off the bat. Now, if the ground looks good, then by all means include it, but if it's a mess, you've got a way to save the shot. Here's another forest shooting tip: overcast days are great for shooting forests because it's difficult to get a decent forest shot in bright, harsh sunlight. However, there is one exception to this rule: if there's "atmosphere" (fog or mist) in the forest on bright days, the sun's rays cutting through the fog or mist can be spectacular.

THIS ISN'T A FOREST TIP. IT'S FOR WATERFALLS

So why is this tip here instead of on the waterfalls page? I ran out of room on that page. The tip is this: when shooting waterfalls, if you don't have a stop-down filter, then you can try putting your polarizing filter on instead. This serves two purposes: (1) It cuts the reflections in the waterfall and on the rocks, and (2) since it darkens, it can eat up about two stops of light for you, so you can shoot longer exposures with it than you could without it. Also, choosing slower shutter speeds exaggerates the silky water effect, so try a few different shutter speeds (4 seconds, 6 seconds, 10 seconds, etc.) and see which one gives you the best effect for what you're currently shooting.

Where to Put the Horizon Line

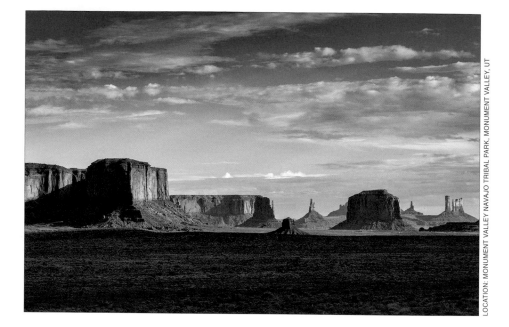

LOCATION: MONUMENT VALLEY NAVAJO TRIBAL PARK, MONUMENT VALLEY, UT

When it comes to the question of "Where do I place the horizon?" the answer is pretty easy. Don't take the amateur route and always place the horizon in the dead center of the photo, or your landscape shots will always look like snapshots. Instead, decide which thing you want to emphasize—the sky or the ground. If you have a great-looking sky, then put your horizon at the bottom third of your photo (which will give you much more emphasis on the sky). If the ground looks interesting, then make that the star of your photo and place the horizon at the top third of your photo. This puts the emphasis on the ground, and most importantly, either one of these methods will keep your horizon out of the center, which will give your shots more depth and interest.

REALLY BORING SKY? BREAK THE RULE

If you're shooting a landscape shot with a sky where nothing's really happening, you can break the 1/3 from the top horizon line rule and eliminate as much of the sky from view as possible. Make it 7/8 ground and 1/8 sky, so the attention is totally off the sky, and onto the more interesting foreground.

Getting More Interesting Mountain Shots

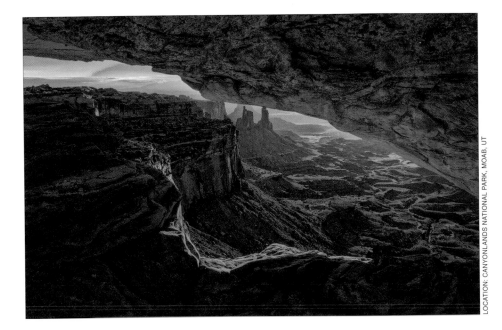

LOCATION: CANYONLANDS NATIONAL PARK, MOAB, UT

One theme you'll see again and again throughout this book is to shoot from angles we don't see every day. For example, if your subject is mountains, don't shoot them from the road at the bottom of the mountain. This is exactly how we see mountains every day when we drive by them on the interstate, so if you shoot them like that (from the ground looking up), you'll create shots that look very normal and average. If you want to create mountain shots that have real interest, give people a view they don't normally see—shoot from up high. Either drive up as high as you can on the mountain, or hike up as high as is safe, then set up your camera and shoot down on or across the mountains. (This is the same theory as not shooting down on flowers. We don't shoot down on flowers because that's the view we normally have of them. In turn, we don't shoot up at mountains, because we always see them from that same view. It's boring, regular, and doesn't show your viewer something they haven't seen a hundred times before.)

The Trick for Warmer Sunrises and Sunsets

Nikon *Canon*

Here's a trick I picked up from Bill Fortney for getting even warmer sunrises and sunsets: For Nikon shooters, go to your camera's Shooting menu and choose Cloudy as your white balance. Press the right arrow button to get the White Balance Cloudy submenu, and move the dot in the middle of the grid to the right three spots (to A3), and then click OK. This does an amazing job of warming these types of photos. If you're a Canon shooter, go to your camera's menu and choose Cloudy as your white balance. Go back to the menu, select WB SHIFT/BKT, move the dot in the middle of the grid to the right three spots (to A3), and then press the Set button. *Note*: Don't forget to turn this setting off when you're not shooting sunrises or sunsets. Okay, it wouldn't be the worst thing in the world (it won't ruin all your subsequent shots), but your world will be a little warmer.

Turn on "The Blinkies" to Keep More Detail

Okay, they're technically not called "the blinkies" (that's our nickname for them), they're actually called highlight warnings (or highlight alerts) and having this turned on, and adjusting for it, is a critical part of getting properly exposed landscape shots. This warning shows exactly which parts of your photo have been overexposed to the point that there's no detail in those areas at all. You'll be amazed at how often this happens. For example, even on an overcast day, clouds can blow out (turn solid white with no detail) easily, so we keep our camera's highlight warning turned on. Here's how it works: When the highlight warning is turned on and you look at the shot in your LCD monitor, those blown out areas will start to blink like a slow strobe light. Now, these blinkies aren't always bad— if you shoot a shot where the sun is clearly visible, it's going to have the blinkies (I don't mean sunlight, I mean the red ball of the sun). There's not much detail on the suface of the sun, so I'd let that go. However, if your clouds have the blinkies, that's a different story. Probably the quickest way to adjust for this is to use your camera's exposure compensation control (covered on the next page). For now, let's focus on making sure your highlight warning (blinkies) is turned on. If you have a Nikon camera, press the playback button so you can see the photos on your memory card. Now, push the down arrow button to see file information, then the right arrow button until the word Highlights appears below your photo on the LCD monitor. If you have a Canon camera, press the playback button to view your images and then press the Info button to see the blinkies.

How to Deal with the Dreaded Blinkies

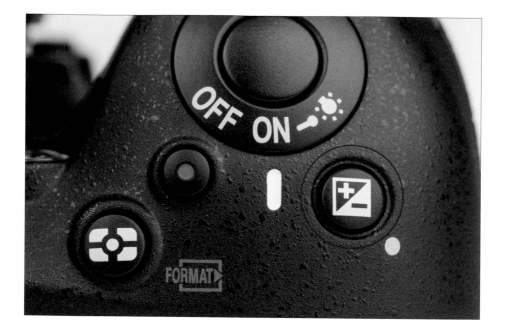

If you look on your camera's LCD monitor and you see the blinkies appearing in an area that's important to you (like in the clouds, or in someone's white shirt, or in the snow, etc.), then you can use your digital camera's exposure compensation control. Basically, you're going to lower the exposure until the blinkies go away. It usually takes a few test shots (trial and error) to find out how much you have to back down, but normally this only takes a few seconds. Here's how it works:

Nikon: Press the exposure compensation button that appears just behind your shutter button (as shown above). Then move the command dial until your exposure compensation reads −1/3 (that's minus 1/3 of a stop). Now take the same shot again and see if the blinkies are gone. If they're not, do the same thing, but lower the amount another 1/3, so it reads −2/3 of a stop, and so on, until the blinkies are gone.

Canon: Turn the mode dial to any creative zone mode except manual, turn the power switch to the quick control dial setting, then set the exposure compensation by turning the quick control dial on the back of the camera and using the settings mentioned above.

How to Show Size

©ISTOCKPHOTO/JIM VEILLEUX

If you've ever had a chance to photograph something like the California redwood trees or a huge rock formation out in Utah's Monument Valley, you've probably been disappointed that when you looked at those photos later, you lost all sense of their size. In person, those redwoods were wider around than a truck. In your photos, they could've been the regular pines in your backyard, because they lost their sense of size. That's why, when trying to show the size of an object, you need something in that shot to give the object a sense of scale. That's why many photographers prefer to shoot mountains with people in the scene (hikers, climbers, etc.) because it instantly gives you a frame of reference—a sense of scale that lets the viewer immediately have a visual gauge as to how large a mountain, or a redwood, or the world's largest pine cone really is. So, the next time you want to show the sheer size of something, simply add a person or a familiar object to your shot and you've got an instant frame of reference everyone can identify with. It'll make your shots that much stronger. (*Note*: By the way, this also works for things that are very small. Put the object in someone's hands, and it instantly tells the story.)

Don't Set Up Your Tripod. Not Yet

Okay, so you walk up on a scene (a landscape, a mountain range, a waterfall, etc.) and you set up your tripod and start shooting. What are the chances that you just happened to walk up on the perfect angle to shoot your subject? Pretty slim. But that's what most people do—they walk up on a scene, set up their tripod right where they're standing, and they start shooting. It's no big surprise that they wind up with the same shot every-body else got—the "walk-up" shot. Don't fall into this trap: before you set up your tripod, take a moment and simply walk around. View your subject from different angles, and chances are (in fact, it's almost guaranteed) that you'll find a more interesting perspective in just a minute or two. Also, hand-hold your camera and look through the viewfinder to test your angle out. Once you've found the perfect angle (and not just the most conve-nient one), you can then set up your tripod and start shooting. Now the odds are in your favor for getting a better than average take on your subject. This is one of the big secrets the pros use every day (legendary landscape photographer John Shaw has been teaching this concept for years)—they don't take the walk-up shot. They first survey the scene, look for the best angle, the best view, the interesting vantage point, and then (and only then) they set up their tripod. It sounds like a little thing (surveying the scene before you set up), but it's the little things that set the pros apart.

The Trick to Getting Richer Colors

One tool the pros use to get richer, more vivid colors is the polarizing filter. Of all the add-ons used by landscape pros, the polarizing filter is probably the most essential. This filter screws onto the end of your lens and it basically does two things: (1) it cuts the reflections in your photo big time (especially in water, on rocks, or on any reflective surface), and (2) it can often add more rich blues into your skies by darkening them and generally giving you more saturated colors throughout (and who doesn't want that?). Two tips: (1) polarizers have the most effect when you're shooting at a 90° angle from the sun, so if the sun is in front of you or behind you, they don't work all that well, and (2) you'll use the rotating ring on the filter to vary the amount (and angle) of polarization (it's also helpful so you can choose to remove reflections from either your sky or the ground). Once you see for yourself the difference a polarizing filter makes, you'll say something along the lines of, "Ahhhh, so that's how they do it."

POLARIZING TIP

If there's a lens the polarizing filter doesn't love, it's the super-wide-angle lens (like a 12mm or 10.5mm, etc.). Because the field of view is so wide, the sky winds up having uneven shades of blue, and because of that, many pros avoid using polarizers with super-wide-angle lenses. Also, when it comes to polarizers, it pays to buy a good one—that way it will be truly color balanced. It doesn't pay to scrimp here.

What to Shoot in Bad Weather

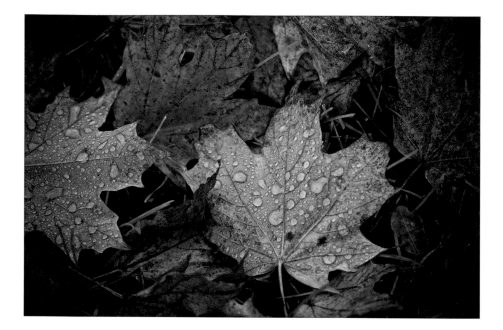

Okay, so you're thinking that it's an overcast or drizzly day, and you're going to spend the day inside working on your photos in Photoshop. That's not the worst idea in the world, but you'll miss some great shooting opportunities, like:

(1) Right after a rain, while it's still cloudy and dark, is the perfect time to shoot foliage, forests (the green leaves look more saturated and alive, even leaves on the ground look good, plus the water droplets on the leaves and flowers add interest), mossy rivers, and waterfalls (you can use slower shutter speeds while the sun is buried behind the overcast rain clouds).

(2) If it's storming, there's a good chance that right after the rain stops, and the clouds break, and the sun peeks through, there's a very dramatic shot coming. It may only last a couple of minutes, and it will either start storming again or clear up and just get really sunny (an outdoor photographer's enemy), so be ready for those few magical moments between storms. They're worth waiting for.

(3) Before the storm "lets loose," you can get some really amazing skies, with angry clouds and sometimes colorful light or strong light beams. Most people miss these shots, so be ready (just don't shoot in the rain, to protect you and your gear).

Atmosphere Is Your Friend

LOCATION: GREAT SMOKY MOUNTAINS NATIONAL PARK, TN

Besides just keeping us here on earth, the atmosphere (low-hanging clouds or fog) can make for some really interesting landscape photos (we're talking soft, diffused light heaven). In fact, some of my personal favorite shots are taken when the fog rolls in between mountains (but, of course, you need to shoot this from above the fog on a higher mountaintop). I've shot horses on the beach with the fog rolling in and it creates almost a Hollywood fantasy effect that looks great on film (digital film, anyway). Also, beams of light in the forest, beaming through moisture in the air, or through thick fog, can be just amazing. Get up early (or miss dinner) to make the most of these atmospheric effects.

PROTECT YOUR GEAR TIP

Fog and moisture are fancy names for water, and digital cameras flat out do not like water, so make sure your gear is not getting silently soaked. You can buy rain gear for your camera from B&H, but in a pinch, use the shower cap from your hotel room and put it around your camera—it's not pretty, but it works.

Getting Rid of Lens Flare—The Manual Way

Another great reason to wear a baseball cap when you shoot (besides the two obvious reasons: [1] it protects you from the harmful rays of the sun, and [2] it looks cool) is to help eliminate (or at the very least, reduce) lens flare. If you're using a lens hood on your camera, that can certainly help, but I've found that often it alone is not enough. That's where your ballcap comes in—just take it off and position it above the right or left top side of your lens (depending on where the sun is positioned). Then look through your camera's view-finder to see (1) right where to position your ballcap so it blocks the lens flare from the sun (it's easier than you think), and (2) to make sure your ballcap doesn't show up in your photo (I've had more than one photo with the edge of a ballcap in the frame. I guess that's why they make Photoshop—to remove silly stuff like that). I'm still surprised how well this totally manual technique for removing lens flare works.

The Landscape Photographer's Secret Weapon

So, earlier you learned about the polarizer and how essential that filter is. This filter, the neutral density gradient filter, isn't necessarily essential but it is the secret weapon of professional landscape photographers. It lets them balance the exposure between the ground and the sky to capture a range of exposure which, without it, their camera could never pull off (it's either going to expose for the ground or for the sky, but not both at the same time). For example, let's say you're shooting a landscape at sunset. If you expose for the sky, the sky will look great but the ground will be way too dark. If you expose for the ground, then the sky will be way too light. So, how do you get both the sky and the ground to look right? With a neutral density gradient filter (a filter that's dark at the top and smoothly graduates down to transparent at the bottom). What this essentially does is darkens the sky (which would have been overexposed), while leaving the ground un-touched, but the brilliance of it is the gradient—it moves from darkening (at the top of the filter) and then graduates smoothly down to transparent. That way it only darkens the sky, but it does so in a way that makes the top of the sky darker, and then your sky gradually becomes lighter until the filter has no effect at all by the time it reaches the ground. The result is a photo where both the sky and ground look properly exposed.

Keeping Your Horizons Straight

There is nothing that looks worse than a crooked horizon line. It's like when you don't get the fleshtone color right in a photo—it just jumps out at people (and people can't resist pointing this out. It doesn't matter if you've taken a photo with composition that would make Ansel Adams proud, they'll immediately say, "Your photo's crooked"). A great way to avoid this is by using the Virtual Horizon feature on your camera (if your camera has this feature, like the Nikon D600 shown above on the left) or with a double level—a simple little gizmo that slides into your flash hot shoe (that little bracket on the top of your camera where you'd attach an external flash). This double level gizmo has a mini-version of the bubble level you'd find at Home Depot and it lets you clearly see, in an instant, if your camera is level (and thus, your horizon line). The double level version works whether your camera is shooting in portrait or landscape orientation and is worth its weight in gold (of course, that's not saying very much, because I doubt the thing weighs even one ounce, but you get my drift). As luck would have it, they're more expensive than they should be— between $25 and $80—but still very worth it.

Shooting on Cloudy Days

LOCATION: TORC WATERFALL, KILLARNEY NATIONAL PARK, IRELAND

This is another one of those things that may initially elicit a "Duh" response, but I've been out shooting with more photographers than I can think of who didn't think of this simple concept when shooting on gray, overcast days—shoot to avoid the sky. I know, it sounds silly when you're reading it here, but I've heard it time and time again, "Ah, the sky is so gray today, I'm not going to shoot." Baloney. Just take shots that limit the amount of visible sky. That way, if you make a tonal adjustment later in Photoshop (that's a fancy way of saying, "I'm going to make the sky look bluer than it really was on that gray, over-cast day"), you won't have to work very hard. This just happened on my last shoot, where we'd have 20 minutes of blue sky and then an hour and a half of gray, overcast sky. I just really limited the amount of sky in my photos (I was shooting urban city photos), and then it took just seconds to fix in Photoshop. Here's what I did:

Step One: I opened one of the photos where the sky looked nice and blue, then took the Eyedropper tool (I), and clicked on the blue sky to make that my Foreground color.

Step Two: I then opened a photo with small amounts of gray, overcast sky and with the Magic Wand tool (W) clicked in the sky to select it (which took all of two seconds).

Step Three: I added a new blank layer above my Background layer and filled the selection with my Foreground color. That's it—my gray sky was blue.

Tips for Shooting Panoramas, Part 1

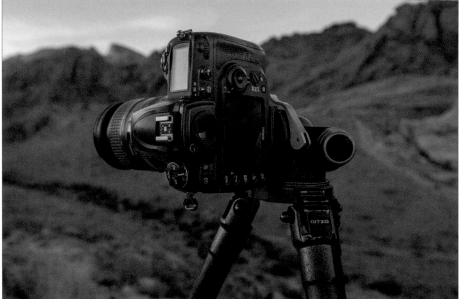

MIKE KUBEISY

There is something so fascinating about what happens when you stitch together five or six (or more) landscape photos into one long, single image. It's as close as you can get (with a photograph anyway) to recreating the experience of being there. Now, although this will take more than one page to describe, shooting panos right is easy, so if you're serious about panos, follow these rules. However, if you have Photoshop CS4 or higher (or Elements 6 or higher), Photomerge is so vastly improved, you can simply just overlap each shot by 20% when you shoot your pano.

(1) Shoot your pano on a tripod. (*Note:* Panos work best shot on a tripod, and if you're shooting at sunrise or sunset, they're a must. That being said, you can shoot hand-held if the light is bright enough, like if you're shooting in daylight or really bright cloudy light.)

(2) Shoot vertically (in portrait orientation) rather than horizontally (in landscape orientation). It'll take more shots to cover the same area, but you'll have less edge distortion and a better looking pano for your extra effort.

(3) Switch your camera's white balance to Cloudy. If you leave it set to Auto, your white balance may (will) change between segments, which is bad, bad, bad.

(4) There's more—go to the next page...

Tips for Shooting Panoramas, Part 2

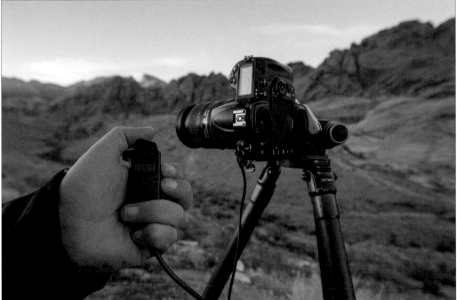

MIKE KUBEISY

(5) **Press your shutter button halfway down** to set your exposure, then look in your viewfinder and make note of the f-stop and shutter speed. Now switch your camera to manual mode and dial in that f-stop and shutter speed. If you don't, and you shoot in an auto exposure mode of any kind, your exposure may (will) change for one or more of the segments.

(6) **Once you focus on the first segment,** turn off auto focus for your lens. That way, your camera doesn't refocus as you shoot the different segments.

(7) **Overlap each segment by 20–25%.** That's right, make sure that about 1/4 of your first shot appears in the second shot. Each segment needs to overlap by at least 20% so Photoshop's stitching software can match things up. This is very important.

(8) **Shoot fairly quickly**—especially if clouds are moving behind your landscape. Don't be lollygagging for two minutes between each shot. Git 'er done, or something could change (lighting, clouds, etc.) in your pano, which will really mess things up.

(9) **Use a shutter release,** or at the very least a self timer, so you don't have any camera movement as you're shooting each segment. Nothing's worse than one segment that is blurry.

Tips for Shooting Panoramas, Part 3

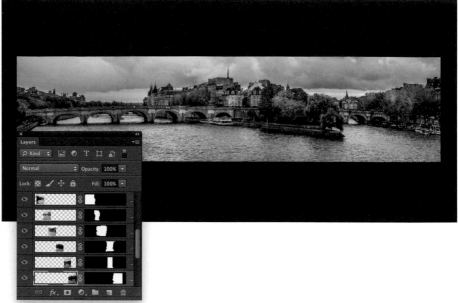

LOCATION: SEINE RIVER AND ÎLE DE LA CITÉ, PARIS, FRANCE

Now, if you followed the rules set out on the previous two pages, the rest is easy:

Step One: Open Photoshop and then go under Photoshop's File menu, under Automate, and choose Photomerge.

Step Two: In the resulting dialog, click the Browse button in the center, navigate to your pano photo segments, choose them all, and click Open.

Step Three: At the bottom of the Source Files section, make sure the Blend Images Together checkbox is turned on and turn on Vignette Removal. Leave the Layout set to Auto and click OK.

Step Four: Photoshop will then stitch the photos together into one seamless panorama (you may need to crop off any transparent areas). If you see a small seam at the top, between two segments, use the Clone Stamp tool (S) to cover it by pressing-and-holding the Option (PC: Alt) key and clicking in a nearby area of sky that looks similar to sample that area. Then, choose a soft-edged brush from the Brush Picker and clone (paint) over the little seam to hide it. If you still have some gaps in the corners, select them, then go under the Edit menu and choose Fill. In the Fill dialog, change the Use pop-up menu to Content-Aware and click OK. Use the Clone Stamp tool to clean up any problems.

Faking Panoramas

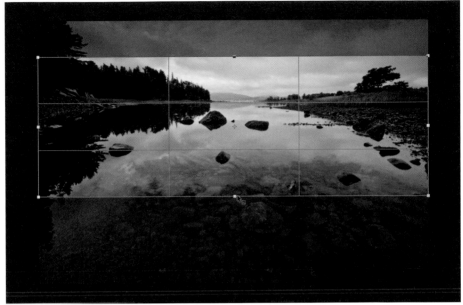

LOCATION: OUTSIDE BAR HARBOR, ME

If you have Photoshop or Photoshop Elements, there's a great way to create a fake panorama: crop the photo so it becomes a panorama. Just get the Crop tool (C) and click-and-drag so it selects only the center of your photo, cropping off the top and bottom (as shown above). Then press Return (PC: Enter) and the top and bottom are cropped away, leaving you with a wide panoramic crop of your original photo. Hey, don't knock it until you've tried it.

Why You Need a Wide-Angle Lens

If you're shooting landscapes, you've probably come back from a shoot more than once and been disappointed that the incredible vista you saw in person didn't transfer to your photos. It's really tough to create a 2D photo (which is what still photos are— two-dimensional) that has the depth and feeling of being there. That's why I recommend one of two things:

(1) **Don't try to capture it all.** That's right, use a zoom lens and deliberately capture just a portion of the scene that suggests the whole. These can often be much more powerful than trying to fit everything into one photo, which can lead to a photo without a clear subject, and with distracting images and backgrounds. This is why I often shoot with a 70–200mm lens—to get in tight on a portion of the scene.

(2) **Buy a super-wide-angle lens.** Not a fish-eye lens—a super-wide-angle lens (like a 12mm). If you're trying to capture it all, a super-wide-angle (sometimes called ultra-wide-angle) lens is often just the trick you need to take in the big picture. My favorite outdoor lens is my 14–24mm zoom lens (which is also a good sports shooting lens, by the way). I must admit, I rarely use the 24mm end, because I use this lens when I'm trying to get "the big picture," so I use the 14mm end most of the time. You'll love what it does to clouds, almost giving them a sense of movement along the edges.

Want to Take Things Up a Notch? Shoot Low

When you're setting up your tripod at some famous landscape location, look at all the other people setting up their tripods. What do they all have in common (take a look at the image on page 65 again)? They're all standing behind their tripods, right? So, what's about to happen? They're all about to take a shot with pretty much the same vantage point and perspective. So, how do you make yours have more impact and stand out? Shoot down low. That's right—rather than extending the legs of your tripod all the way out, set up your tripod fairly low to the ground, to where you'll be shooting either sitting down or kneeling down (in some situations you might even want to lay down). This will give you a different perspective and it will accentuate the foreground. These two will often give your images more impact. Remember, if you just do what everybody else is doing, your shots will pretty much look like those of everybody else shooting right beside you. This is one way to tip the scales in your favor.

WHAT TO DO IF THE COLOR IN YOUR SHOT DOESN'T LOOK GOOD

Okay, this one's an "if all else fails" tip, but if you have a landscape shot that is well composed, and otherwise looks good, but the color is kind of lame, consider converting the image to black and white (using Photoshop, Elements, Lightroom, etc.). This can sometimes save a shot that has a lot going for it photographically, but the color just isn't compelling. Hey, it's worth a try.

SHUTTER SPEED: 1/1600 SEC F-STOP: F/2.8 ISO: 200 FOCAL LENGTH: 400mm PHOTOGRAPHER: SCOTT KELBY

Chapter Five
Shooting Sports Like a Pro
Better Bring Your Checkbook

This is the one chapter in the book where you have a choice. Do you want to get much better at shooting sports using the tips the pros use, but pretty much use your own existing gear? Or, do you want to seriously shoot sports for a living? Here's why I mention this: we're going to conduct a brief, totally scientific test which will quickly determine which path you should take. Ready? Let's begin. Question 1: This book retails for $24.99. When you turned the book over to look at the price, how did you react? You thought: (a) $24.99, that's cheap enough—I think I'll buy it; (b) I dunno, it's $24.99—I hope this is worth it; (c) $24.99, that's pretty steep, but I really need to learn this stuff; or (d) $24.99! $24.99! I can't believe they're charging $24.99! Well, I'm not happy about it, but I have to have this book. Answer: If you answered a, b, c, or d, you're not ready to enter the world of professional sports photography, because professional sports photographers spend so much on their equipment that they would never even think of looking at the price of anything. Ever. They see something they want and they just take it to the checkout counter and buy it, never questioning its price, because they figure they've spent so much on their photography equipment, there's no way any book, or flat screen TV, or luxury car could ever cost anything close. So what are we mere mortals to do? We use the tricks in this chapter to get better shots with what we've got. Of course, a few accessories wouldn't hurt, right?

Pro Sports Shooting Is Dang Expensive

©ISTOCKPHOTO/SPXCHROME

Of all the photographic professions, professional sports photography is probably the most expensive, so if you think you want to go this route, better bring your checkbook. The main reason it's so expensive is because many sporting events are held indoors (or in domed stadiums) or at night, so you'll need the most expensive (fastest) lenses money can buy (well, only if you want to shoot at a professional level). For example, you're going to need some long telephoto lenses (ideally, a 400mm) and since you'll generally be shooting in lower-light situations, they'll need to be f/2.8 to f/4 lenses. If you haven't priced a 400mm f/2.8 lens lately, they're around $11,500 (Canon) and $9,000 (Nikon). Plus, you'll need a monopod (those lenses are too heavy to hand-hold), so figure another $300 for that. Also, you'll need at least two camera bodies, which both have to be able to shoot at high ISOs indoors with very low noise and, ideally, shoot at least 10 or more frames per second (which means, as a Canon shooter, you're going to spend around $6,800 for an EOS-1D X or, as a Nikon shooter, you're going to spend around $6,000 for a D4. Did I mention you need two?). By the time you add up two camera bodies, a fast long lens, a fast shorter lens (like a 70–200mm f/2.8), a monopod, a 1.4x tele-extender (to get your zoom in even closer), lots of very fast memory cards (plan on shooting well over 1,000 photos for a typical baseball or football game), and rolling cases to move all this gear, you're in the $25,000 and up range, just for starters.

Which Lenses to Use

TROY BREIDENBACH

When you're shooting sports, carrying a load of lenses and a big camera bag (even a camera backpack) will strain your back and just add to your frustration. Instead, go light with just two lenses:

(1) **A wide-angle zoom lens** (something that goes at least 24mm wide, like a 24–70mm). You'll need these wide angles to capture full stadium shots, full court shots, close-up group shots, etc.

(2) **A 300mm or 400mm telephoto lens** (or a 200–400mm zoom). At the very least, you'll need a 200mm lens, but plan on doing a *lot* of running because if the players aren't right in front of you, they'll be too far away to make pro-quality shots.

You're not going to want to change lenses, so ideally you'd put one lens on one camera body, and one lens on the other (more on this coming up). The only other thing you'll need to carry (besides extra memory cards and a backup battery) is a 1.4x teleconverter to get you even closer to the action (these magnify the amount of zoom, turning a 300mm telephoto into a 450mm). *Note:* Some pros advise against 2x teleconverters because they feel 2x photos are not as sharp and you lose up to two f-stops of light (it turns your f/2.8 into an f/5.6), making it harder to get the fast shutter speeds you need indoors. To move all this stuff around with the greatest of ease, try a Manfrotto Pro Photo Vest or a Think Tank Photo belt system, which is very popular with pro sports shooters.

This Lens Rocks for the Money

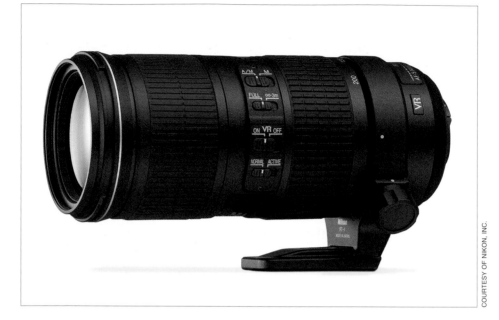

If you're just starting out shooting sports, I've got a great lens you might want to consider and both Canon and Nikon now make their own versions of this lens: it's the 70–200mm f/4. What's so great about this lens is (a) it has a great range for your first lens, and if you get a longer lens one day (like a 300mm or a 400mm), you can still use this lens on your second camera body, or when the play action gets close to you. Since it's an f/4 lens, rather than f/2.8, (b) the price is much better (the Canon 70–200mm f/4 IS is around $1,350 and the Nikon is around $1,400 [Sony doesn't make a 70–200mm f/4 at this time]. If that sounds kind of expensive, consider how much the same lens costs for the f/2.8 model—the Canon is $2,500 and the Nikon is around $2,400). Believe it or not, in the world of shooting sports, spending $1,400 for a good lens is actually considered a bargain. Don't shoot the messenger. Finally, (c) these weigh much less than their f/2.8 counterparts, which are fairly heavy (at least, that's what people always tell me when I hand them an f/2.8 lens to try). *Tip:* If you're primarily shooting in daylight, then you might want to also buy a 1.4x tele-extender to turn your 200mm reach into a 280mm (nearly a 300mm), but besides the price of it, there's another price you pay: you lose one stop of light (so your f/4 lens only lets you open it up to f/5.6 now). This is why I really only recommend getting a tele-extender for daylight sports shooters using an f/4 lens—at f/5.6 at night or indoors with that tele-extender, you'll have to crank your ISO a bunch (see page 99). Not that big a deal if you have an f/2.8 lens (because it becomes an f/4), but it kinda crosses the line for a lens that's already f/4.

Stability for Shooting Sports

DON JONES

Sports photographers don't generally use tripods for a number of reasons: (1) they're not mobile enough for the fast-action shooting that typifies sports photography, (2) many professional sports won't allow the use of tripods, and (3) having a tripod set up near the playing field (in football, basketball, etc.) has the potential to injure a player. That's why sports shooters, especially those shooting with long lenses, use monopods instead. These one-legged versions of tripods generally wind up supporting those long lenses (the lens attaches directly to the monopod itself for support and to keep the lens and camera still during the low-light situations many sporting events are played under). Monopods are easy to move (or to quickly move out of the way if need be), and many professional sports that ban tripods allow monopods. Carbon fiber monopods are the most popular because, while they can hold a lot of weight, they are surprisingly lightweight. Now, not surprisingly, they're not cheap (nothing in sports photography is).

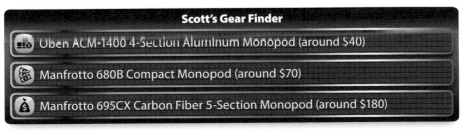

Scott's Gear Finder

Oben ACM-1400 4-Section Aluminum Monopod (around $40)

Manfrotto 680B Compact Monopod (around $70)

Manfrotto 695CX Carbon Fiber 5-Section Monopod (around $180)

Don't Plan on Changing Lenses

JEFF KELBY

Now, don't read this headline to mean you only need one lens for sports photography. It means just what it says, don't plan on changing lenses—plan on changing cameras. That's right, if you're really into sports photography, you'll miss "the shot" if you have to change lenses. That's why the pros have multiple camera bodies hanging around their necks—so they can change from a 400mm telephoto to a wide-angle lens in an instant. If they didn't do this, while they were changing lenses, the guy next to them would be getting "the shot" (which winds up on the cover of the magazine). If you want to compete with the big boys, you'll be hanging more than one camera body around your neck so you're ready to catch the shot with a moment's notice. I told you this digital sports photography thing was expensive.

Set Your White Balance for Indoor Sports

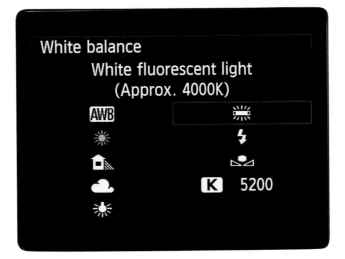

If you're going to be shooting sports indoors, you can count on your photos having a yellow or green tint, caused by the indoor lighting used at most indoor events. You can save yourself a lot of Photoshop editing down the road if you change your white balance to either Fluorescent or Tungsten/Incandescent now, in the camera. (Set it at Fluorescent and do a test shot, then take a look at your test shot in your LCD monitor. If the overall color looks too yellow or green, then try Tungsten/Indcandescent. See the Canon menu above.) By doing this, you're offsetting the yellow or green tint you would have had, which will keep you from pulling your hair out later. If you're shooting in RAW format, you can always reset the white balance later in your RAW processing software. But by setting the correct white balance in the camera, at least you'll see your photos in the proper color temperature when you view them in the LCD monitor on the back of your camera.

DON'T USE COLOR FILTERS

Your first thought might be to add a screw-on color balance filter to your lens to offset the indoor color cast, but don't do it. When you're shooting sports, you're already going to be challenged by lower than ideal lighting situations, and adding a filter takes away even more light. You're better off using a custom white balance setting because it only affects the color of light, not the amount.

Shoot at a 1/1000 Sec. Shutter Speed or Faster

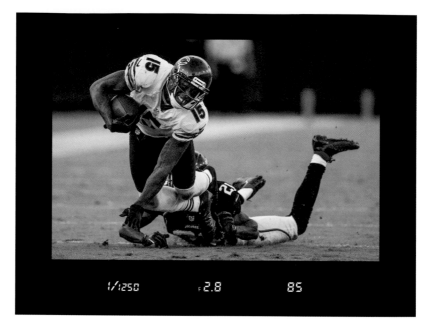

With sports photography, most of the time you're going to want to freeze the action of the athletes (or cars, or motorcycles), and to do that, ideally, you'll need a shutter speed of around 1/1000 of a second or faster (any slower than that and you'll probably have at least some blur. Although I've shot sports as low as 1/640 of a second and wound up with some sharp shots, they're not all sharp, so 1/1000 of a second is our goal). If you're shooting outside on a sunny day, this is no problem—just set your camera to aperture priority mode, use the lowest f-stop your camera will allow (ideally, f/2.8, if your lens will let you go that low, but if not, try for f/4 or f/5.6—lower is better), and you'll probably have shutter speeds of more than 1/4000 of a second or higher. If it's a partly cloudy day, you may drop down to 1/2000, and that's okay, too, as long as you stay above 1/1000. This all sounds too easy, right? Switch to aperture priority mode on your camera, use the lowest f-stop you can, and if you're shooting outside on a sunny day, hitting 1/1000 of a second is no problem. There's gotta be a catch, right? Nope. Well, there's just one thing: the key phrase is "outside on a sunny day." As long as that describes where you're shooting, there is no catch. However, when you shoot at night, or indoors in an arena, a domed stadium, or gym, that's when things get really sticky (see the next page).

Shooting at Night or Indoors?
Raise Your ISO!

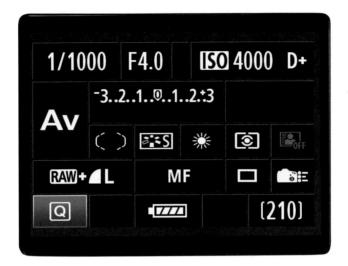

The biggest challenge of shooting sports happens when you shoot at night, or if you shoot indoors in an arena, gym, or a domed stadium. That's because, without that bright sunlight, your shutter speed will drop like a rock. There's really only one way around this— you'll have to raise your ISO like crazy to get your shutter speed back up to 1/1000 of a second to freeze sports action. So, why do we worry so much about raising the ISO? Well, it's because the higher you raise your ISO, the more noise (grain) you'll see in your photos. Today's high-end sports cameras (like the Canon EOS-1D X and the Nikon D4) have very low noise, even at very high ISOs, but it's still sometimes visible. But, really, there's nothing we can do about it—the only way to get our shutter speed up at night or indoors is to raise our ISO until it raises our shutter speed enough. This is why "fast lenses" (like an f/2.8 or f/4) are so helpful—the faster the lens you have, the less you'll have to raise your ISO (and the less noise you'll have). So, how much of a difference does a fast lens really make? Well, if I'm shooting in an NFL football stadium at night with really bright stadium lighting, and I set my f-stop to f/4, I have to set my ISO around 4,000 to get my shutter speed up to 1/1000 of a second to freeze the action. If I have an f/2.8 lens instead, I can usually set it at just 1,600 ISO (much less noise). That one stop makes that big a difference (but man do they charge you a bundle for that one extra stop of light). So, our plan when shooting at night or indoors is to shoot at our widest aperture (lowest number f-stop possible for our lens) and then increase our ISO until we hit a 1/1000 of a second shutter speed. You will see some noise, but seeing some noise beats having a blurry photo every single time.

Getting Burned by Indoor Lighting

If you're shooting indoors at an arena or outdoors under the lights, you already know you're going to have to raise your ISO quite a bit to be able to freeze the action (see the previous page), but there's another area where you're likely to get burned under these lights: most stadiums and arenas don't have consistent light throughout the field of play. For example, it's not uncommon for the center of the field to be much brighter than either end of the field, or for one end of the court to be darker than the other. The reason why you want to keep an eye out for this is because when parts of the playing field are darker than others, your shutter speed will drop in those parts of the field, and that might mean blurry shots in the most important parts of the playing field (think about it—the scoring doesn't happen in the middle of the field for most sports, it usually happens at the ends). So, what you'll have to do is keep an eye on your shutter speed when shooting in those areas, and if you see your shutter speed drop below 1/1000 of a second, you'll need to raise your ISO while the action is happening in that area, and then lower it back down when they move to better-lit areas of the field. If it sounds like kind of a pain in the butt to have to keep an eye on this all night, you're absolutely right.

Shoot Wide Open

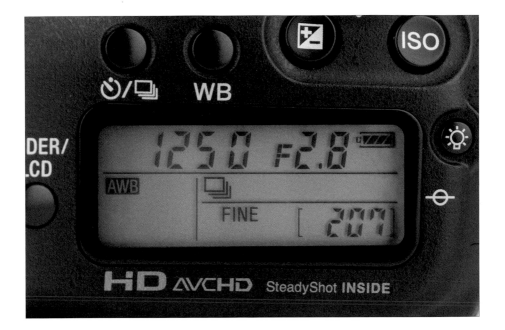

By shooting wide open, I mean shoot as close to your wide open aperture as possible (so if you have an f/2.8 lens, shoot at f/2.8 or one stop up). This will pay off in two ways:

(1) This will blur the background, creating a more dramatic, dynamic, and uncluttered photo of your subject. Busy backgrounds are a problem when shooting sports, and shooting with a telephoto lens at such a wide open aperture gives you a very shallow depth of field (meaning your subject in the foreground is in focus, while the background is out of focus).

(2) You'll be able to shoot at faster shutter speeds, which will greatly help when shooting indoors under artificial low-light situations.

Shooting in Burst Mode

Nikon

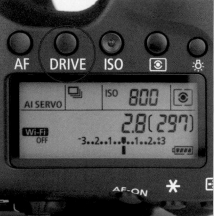

Canon

Much of the shooting you'll be doing in sports photography will require you to take bursts of shots (four or more shots per second) in order to make sure you get the shot while a play is in motion. So, you'll need to set your camera to shoot multiple shots while you hold down the shutter button (this is called burst mode on some digital cameras). By default, most cameras shoot one frame at a time, so you'll have to switch this burst mode on.

Nikon: Switch the camera's mode to continuous (where holding down the shutter release takes multiple photos) by first pressing the Menu button, choosing the Custom Settings menu, and then choosing Continuous High-Speed (to choose either 10 fps or 11 fps). Then, press the release mode dial lock release button on the top left of the camera and turn the release mode dial to CH.

Canon: Press the Drive or AF•Drive button, then rotate the quick control dial until you see an icon that looks like a stack of photos on the top LCD panel.

Now, you can simply hold down the shutter button to fire multiple shots.

RAW or JPEG for Sports Shooters?

Because of the fact that much of sports photography is taken in burst mode (see the previous page) and the fact that you only have so much memory space in your camera's multiple-shot buffer, the larger the photos you take, the quicker that buffer will become full. When it's full, you're done shootin' (well, at least until it has time to write the shots to your memory card, which empties the buffer again). That's why many pro sports photographers choose to shoot in JPEG format rather than RAW. It's because JPEG files are considerably smaller in file size so more of them fit in the buffer (plus, since they're smaller, they write to your memory card faster, so you can effectively shoot more uninterrupted shots in JPEG format vs. RAW format). Now, there are some purists who feel so strongly about shooting in RAW for every occasion (including shots of their kid's birthday party at Chuck E. Cheese) that reading about anyone advocating any file format other than RAW sends them scrambling into a tower with a high-powered rifle to pick off pedestrians. To them, I just say, "Remember, RAW is a file format, not a religion." (By the way, I know a popular *Sports Illustrated* magazine shooter who now sets his cameras to shoot RAW+JPEG, which captures both file formats at the same time. Just thought you'd like to know.)

Pan to Show Motion

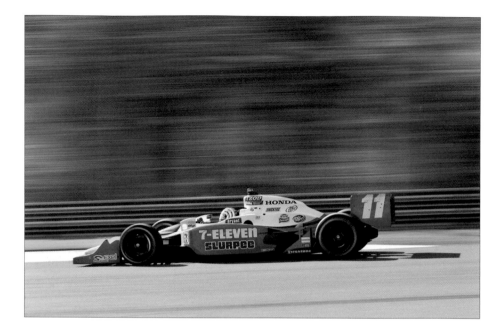

For this entire chapter we've been talking about using super-fast shutter speeds to freeze the motion of sporting events, but there are times when it's more dramatic to emphasize the motion and let parts of the photo become intentionally blurry from movement. There are three keys to this technique:

(1) **Use a slow shutter speed**—ideally, either 1/30 of a second or 1/60 of a second. So, switch to shutter priority mode (using the mode dial on the top of your digital camera) and set the shutter speed accordingly.

(2) **Pan right along with your subject**—following them with your camera. Believe it or not, it's the camera's motion that creates the blurring background, because you're trying to move (pan) right along with the athlete so they remain sharp while every-thing around them appears blurred.

(3) **Use continuous shooting (burst) mode** for your best chance to capture a sharp shot—capturing multiple shots per second really pays off here.

One important thing to remember: Don't stop panning when the athlete leaves your frame—continue panning for a couple of seconds afterwards to get a smooth release.

Pre-Focus to Get the Shot

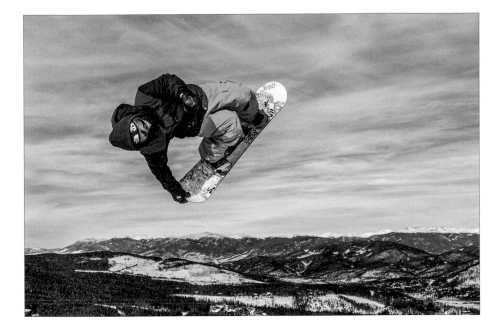

If you're covering an event where you have a pretty good idea where the action is going to happen (for example, you're covering baseball and you know the runner on second base is headed to third, or you're covering snowboarding and you know approximately where the snowboarder is going to land), pre-focus on that spot, so when it happens, all you have to do is press the shutter button. You can start by leaving auto focus on, and then focus on the spot where you expect the action to occur, then switch your lens to manual focus and leave the focus alone (it's set). Now you can pretty much relax and watch the event unfold. When the runner (jumper, skier, etc.) gets near your pre-focused point, just aim back to that area and fire—knowing the focus is locked onto that point. No waiting for auto focus to either get, or miss, the focus. You're good to go—just fire away.

Shoot Vertically for More Impact

Much of pro sports photography is shot vertically because it's easier to fill the frame with your subject (plus, it's ideal for magazine covers, ads, etc.). Just turn the camera sideways, get in tight (with your long lens) and make the magic happen (so to speak). This particularly holds true if you're shooting a single athlete, rather than two or more, where a horizontal shot might work best, but when it comes to shooting a single subject, your best bet is to go vertical. That being said, if you want to really cover your bases (like the way I worked that sports metaphor in there), shoot both as much as possible. As my tech editor Bill Fortney says, "The editor will always ask for the orientation you didn't shoot."

WELL, THERE IS AN EXCEPTION TO THIS "SHOOT VERTICALLY" THING

Today, much of the sports photography you see appears on the Internet, right (on sports websites, team homepages, Facebook, Twitter, etc.)? Wide images look better on the web because they wind up much larger (with more impact) in a web browser than tall shots. Plus, if you shoot wide, you can usually crop pretty easily to make it a tall shot, but it's really hard to crop a tall, vertical shot and make it a wide shot for the web. Which one's right for you? Ask yourself, "Where will these images be seen?" If it's just on the Internet, I'd shoot wide. If there's a chance it's going in print, vertical might get you the cover!

Don't Be Afraid to Crop Your Photos

In general, I hate cropping, and if I have to crop a photo after I've taken it, it kind of makes me feel like I've failed at my most basic job as a photographer—deciding what to include in the photo (how the photo is composed). So, it makes me really mad if I have to crop and I do it very rarely, except for sports, where I crop all the time and feel no remorse whatsoever. I have to. All sports photographers (especially the pros) do. It's because, for most sports, the play often moves away from you in a split-second—a basketball player steals a pass, turns, and runs down the court; a quarterback throws a pass to a receiver 70 yards down the field from you; a baseball player hits a ball deep into the outfield. Even with a 400mm lens, outfielders look tiny in your frame, so we have to crop in tight after the fact (in Photoshop, Elements, Lightroom, etc.) to create dynamic-looking images. It's a part of sports photography—the tight crop, and the tighter the better! If you're reading this and thinking, "Oh, so that's how those sports shooters get those super-up-close shots that look so great!" The answer is "Yes!" and now you can do it, too! Also, the shorter the lens you have, the more you'll be doing it (you'll crop a lot less if you have a 400mm lens than you will if you only have a 200mm lens). This is another reason why having a high-megapixel camera is a big benefit to a sports photographer—you can crop the image in tight and still have plenty of resolution for print or for the web. One more thing: when you're cropping your image and you think to yourself, "Man, that's really a tight crop!" that's your cue to crop it even tighter!

You Need Two Eyes and a Ball

When you're shooting athletes, what's the most important thing to capture? Generally, it's their face. It's their facial expressions that tell the story, and it's their faces that people want to see, but if you really want to take it to the next level, try to include the ball in the shot, as well (if it's a sport that uses a ball, anyway. No sense in including a ball in a Formula One racing shot). There's an old adage used by sports photo editors (the folks who decide which images wind up in a sports magazine) that goes, "Give me two eyes and a ball." If you've got those two, you've got a shot that tells a story and that's going to capture the imagination of your viewer. So, keep that floating around in the back of your mind while you're shooting the game—"I need to see two eyes and a ball."

Don't Always Focus on the Winner

In sports photography (and in sports in general), it's only natural to follow the winner. If someone scores a critical point, you'll be capturing shots of the athlete that made the big score, right? If a team wins, you'll be shooting shots of the winning team celebrating. But if you follow that tradition of covering only the winner, you might miss some of the most dramatic shots with the most powerful story-telling angle, which are the expressions and reactions of the loser or the losing team. This is especially important if you just missed the action play—quickly switch to the reaction of the guy who missed the ball, or didn't block the shot, or missed the goal, etc. Sometimes their reactions are more fascinating than those of the person who makes the shot. Next time, try catching the expression of the golfer who missed the putt (or the golfer who lost because her opponent just sank a 40-footer), and see if it doesn't elicit as much or more emotion as a shot of the winner.

Composing for Sports

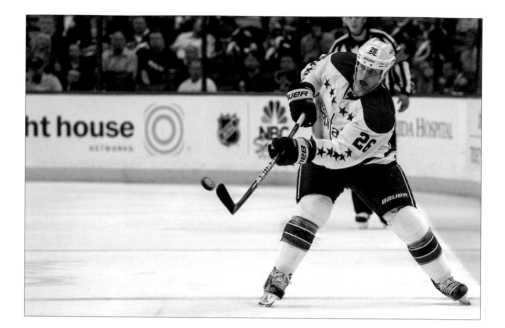

When composing your sports images, give your athlete somewhere to go. Don't compose the shot so your athlete is running out of the frame, compose it so there's room in front of the athlete to move to continue his visual story, so the athlete doesn't look boxed in. It's an uncomfortable look for sports, so when you're composing, be sure to leave some running room (i.e., for a shot of an athlete running left, compose the shot with him on the far-right side of the frame. That way, he visually has room to run). This simple compositional trick will make a big difference on the impact of the final image.

The Pros Know the Game

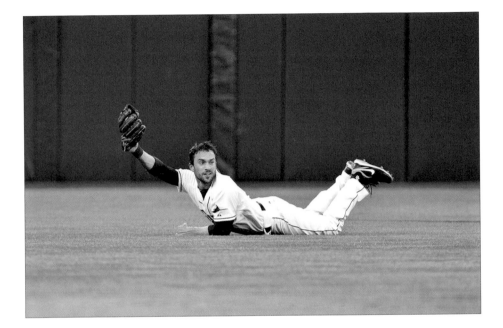

If you know the game you're shooting (for example, if you're a baseball fanatic and you're shooting a baseball game), you're going to get better shots than the next guy because you're going to know where the next play is likely to unfold. This is a huge advantage in sports shooting, and being able to anticipate when and where the big moment will unfold can make all the difference in getting "the shot." The key is you have to watch the game while you're shooting, so you can see the play unfolding and be ready to aim where you feel the action will take place. You won't always be right, but you'll be right enough that you'll get the shot more often than not. So, what if you're assigned to shoot a game you don't know well? Go online and watch some videos, go to the newsstand and buy some magazines on the topic, and study how the pros that cover that sport are shooting it—find out who the stars are in that sport and make sure you follow them (after all, the stars are most likely to be involved in the big plays, right?). It basically comes down to this: if you know the game, you're putting yourself in the best position to get "the shot." If you don't know the game, the only way you'll get "the shot" is by sheer luck. That's not a good career strategy.

Chapter Six
Shooting People Like a Pro
Tips for Making People Look Their Very Best

Now, the subhead above says this chapter is how to make people look their very best, and that is kind of misleading because it's really about making your photos of people look better. If you've got some really ugly looking people in your photos, there's not much you or I can do to help these poor souls. They've been hit with the ugly stick, and they don't make a digital camera that will make these people, who didn't have a date for the prom, suddenly look like Mila Kunis or Channing Tatum (who, not coincidentally, were chosen as the Sexiest Woman Alive by *Esquire* magazine and Sexiest Man Alive by *People* magazine, just in case you cared). By the way, although I did not make last year's cut, if you read my bio at the beginning of this book, you learned that I was among *People* magazine's top 50 sexiest picks back in 2004. This surprises many people, including my wife, as she has no recollection of this whatsoever, but I'm actually thankful for that because she has also completely erased any memory of my brief but highly publicized affair with Angelina Jolie while we were filming the movie *Taking Lives* in Toronto. But I digress. Now this chapter isn't so much about studio portrait techniques, because if you're shooting in a studio, then you're a professional photographer and, honestly, this chapter (and this book for that matter) really isn't for you. This is really for getting better outdoor, or candid, or posed shots that are supposed to look candid, but really aren't, but you can tell they are because they're posed. Are you taking all this down?

The Best Lens for Portrait Photography

There are not many aspects of photography that have a specific focal length you should try to shoot with, but luckily portrait photography is one of them because there's kind of a "sweet spot" that pros generally choose, and that's anywhere between an 85mm focal length and a 105mm range (these are pretty much thought of as "classic" portrait focal lengths). The main reason these focal lengths are popular is that they are literally flattering to your subjects. At lengths 85mm and over, these lenses provide a really flattering perspective and compression that makes people look great (by the way, you can go farther than 105mm. In fact, my go-to portrait lens is my 70–200mm, and I normally shoot somewhere between 150mm and 200mm). Although this is the kind of topic people love to argue endlessly about in online photography forums, I can tell you that most pros I know shoot portraits with an 85mm telephoto lens or longer. By the way, another benefit of shooting with a longer focal length like this is that you don't wind up being right in your subject's face with your lens—the telephoto lens puts some breathing room between you and their face—and if your subject is more comfortable, that usually translates into better-looking images. (*Note:* Nikon, Canon, and Sony all make zoom lenses that fall somewhere in this portrait focal range, as do Sigma and Tamron, so you'll have plenty to choose from in that sweet spot of around 85mm to 105mm, up to 200mm. Also, don't forget, you can buy a 24–105mm, a 24–120mm, or a 70–200mm. Just don't shoot portraits in those lower ranges—use the long end of the zoom, starting at around 85mm and going up from there.)

Which Aperture to Use

One thing I love about portrait photography is that a lot of the decisions are made for you (like which lens/focal length to use), so you can focus on the harder parts of portrait photography—ensuring that you have great light and capturing the personality of your subject. So, now that you know which lens to use, believe it or not (and this is very rare), there is a special aperture (f-stop) that seems to work best for most portrait photography. When it comes to portraits, f/11 is the ticket because it provides great sharpness and depth on the face (and isn't that what portraits are all about?), which gives you a great overall look for most portrait photography (now, I say "most" because there are some artistic reasons why you might want to try a different aperture if you're trying to get a special effect, but for the most part you can choose aperture priority mode, set your aperture at f/11, and then worry about the really important stuff—the lighting, capturing your subject's personality, how much to bill your client, etc.). Okay, as always, there's an exception to every rule, so see page 118 for when f/11 wouldn't be your first choice.

Using Seamless Backgrounds

Backgrounds provide quite a challenge for portrait photographers because they generally get in the way of the portrait photographer's goal—capturing the personality, the drama, the soul (if you will) of the person they're shooting. That's why so many portrait photographers shoot their subjects on as plain a background as possible. In the studio, perhaps the least expensive option is to use a seamless background—these are very inexpensive because they're made of paper. That's right, it's just a big giant roll of paper, and a standard size (53"x36') will only run you about $22. That ain't bad for a professional studio background (you can find these backgrounds at your local camera store). Some photographers tape it to the wall, others nail it to the wall, but the best option is probably to buy an inexpensive stand that holds the roll up for you (you can get a decent one for around $70). Now, which colors should you use? For starters, stick with black (for dramatic portraits) or white (for everything else). The nice thing about a white seamless background is that it usually appears as a shade of gray. To make it really appear white like the one above, you'll have to aim one or more lights at the background or the light from your flashes will fall off, giving you a gray backround. Gray is not a bad background color (in fact, it's very popular), but if you're really going for white, make sure to position one or two lights behind your subject, aiming at the background itself. If you go with a black seamless background, you may need an extra light to backlight your subject (especially if they have dark hair), so they stand out against the black.

Using Canvas or Muslin Backgrounds

SCOTT KELBY AND ©ISTOCKPHOTO/SHUTTERWORX

Canvas or muslin backgrounds aren't quite as cheap—I mean as inexpensive—as seamless rolls, but they're inexpensive enough that you should consider using one as a formal background, as well (a decent canvas background only runs around $140). These backgrounds are seamless too, and I'd recommend buying one (at least to start) that's kind of neutral, like one that's mostly gray or mostly brown. These backgrounds add texture to your photo without distracting from the subject, and they're very popular for use in everything from formal business portraits to engagement photos. Again, an inexpensive stand will pay for itself in no time (they start at around $70), and you'll be amazed at how quickly you can change the look of your background by repositioning your lighting.

The Right Background Outdoors

When shooting portraits outdoors, you're not going to be able to use a muslin background or seamless paper (did I even have to say that?), and because of that you have to think about your background even more. The background rule for shooting portraits outdoors is to keep the background as simple as possible. The simpler the background, the stronger your portrait will be, so position your subject where the least possible amount of activity is going on behind them. Here's where you might want to break the f/11 rule, so you can throw the background out of focus by using an aperture like f/2.8 or f/4 with the portrait focal length you like best. Remember, when it comes to portrait backgrounds outdoors, less is more.

THE BACKGROUND LIGHTING RULE

When it comes to backgrounds, there's another simple rule you can follow that will keep you out of trouble. When you're choosing a simple background to shoot on, make sure your background is no brighter than your subject (in fact, darker is better because a dark subject on a bright background rarely works).

Where to Focus

Over the years, there have been conflicting thoughts as to where the optimal place is to focus your camera when shooting portraits (the cheek, the tip of the nose, the hairline, etc.). Luckily, today the consensus is fairly clear (you'll still find some cheek holdouts here and there, but don't let them throw you): focus directly on the subject's eyes. By shooting at f/11 and focusing on the eyes, this will give you a nice level of sharpness throughout the face (and most importantly, the eyes will be tack sharp, and in portraits that is absolutely critical).

Where to Position Your Camera

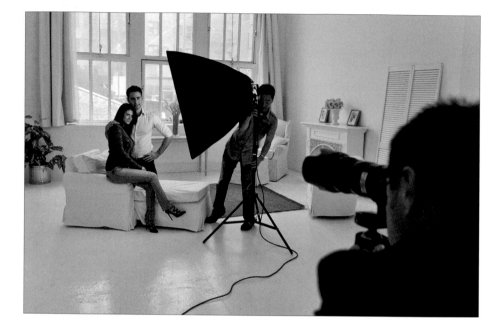

Portraits generally look best when you position your camera at the subject's eye level, so set your tripod up so you're shooting level with their eyes. This is particularly important when shooting children—don't shoot down on children (just like you don't shoot down on flowers), or you'll wind up with some very disappointing shots. So, with kids, you're either going to raise them up to your eye level (on a tall seat) or you're going to lower your tripod down to their eye level and shoot on your knees (I know—the indignities we have to suffer for our craft and all that…). Also, now that you're at the right height, about how far back should you position your tripod from your subject? Your focal length will pretty much dictate that for you, but if you're about 6 to 10 feet from your subject, depending on your lens, you'll be in good shape.

Positioning Your Subject in the Frame

If you're shooting portraits, especially candid portraits or editorial style shots, there's a rule that many pros use about where to position the subject's eyes in the frame— position them 1/3 of the way down from the top of the frame. This is another one of those tricks that gives your portraits more visual interest, and it's easy enough to do since you just compose the shot so your subject's eyes are 1/3 of the way down from the top.

Tip for Framing Portraits

If you're looking for another tip for great portrait shots, try zooming in close so your subject's face nearly fills the entire frame. Also try zooming in close enough so that either the top of their hair, or even the top of their head, gets cut off and extends outside of the frame. This is a very popular look in professional headshots, and you see it all the time in magazines, in ads, and on the web, so don't be afraid to cut off their hair or the top of their head—it can make for a more dynamic portrait.

Getting Great Light Outdoors

Although there's plenty of light for shooting portraits outdoors in the middle of the day, most of that light is very direct and will wind up casting hard, unflattering shadows on your subject's face (not to mention that your subject will usually be squinting, sweating, or both). So, how do you get great outdoor portraits at two o'clock in the afternoon? It's easy—move your subject into the shade, where the light is softer, and the shadows are less prominent and much softer. Now, don't move into a cave—just move to a shady area near the direct sunlight (typical places include under a large tree, under the overhang of a building or house, on the porch of a house, under an umbrella, etc.). Just find a place you'd normally go to get out of the sun on a hot day, and you're ready to get portraits where your subject isn't squinting, and the light is soft and flattering. The photos above perfectly demonstrate the advantage of doing this. The shot on the left was taken in direct sunlight and the shot on the right, of the same model in a similar pose, was taken one minute later less than 30 feet away but in open shade. Notice how much softer and warmer the light is, how vibrant the color is, and how much better the same model looks. All I did was move her into the shade. It makes that big a difference.

Getting Great Light Indoors

What's the pros' trick for getting great portrait light indoors without setting up some extensive studio lighting? Use the best light ever created—natural light. This is such wonderful light that many pros insist on using nothing but natural light for their portraits. To take advantage of this wonderful light source, just position your subject beside a window in your house, office, studio, etc., that doesn't get direct light. The most ideal window light is a north-facing window, but any window getting nice, soft, non-direct sunlight will work. If the window is dirty, that's even better because it helps diffuse the light and makes it even softer. If the only window you have gets direct light, try using sheers (thin curtains that are almost see-through—you find these in hotel rooms quite often, and they make great light diffusers). You can position your subject standing or sitting, but make sure your subject is getting side light from the window—not harsh direct light. The soft shadows on the other side of the face will enhance the portrait and give it depth and interest.

DON'T FORGET THE SHOWER CURTAIN TRICK

That's it—don't forget the frosted shower curtain trick you learned in Chapter 2. It can work wonderfully well here too, and although your subject may think you're a little lame for pinning up a frosted shower curtain, the people who look at their portrait will only think, "What soft, magical lighting—your photographer must be a genius" (or something along those lines).

Taking Great Photos of Newborn Babies

By now you've probably heard how hard it is to photograph babies. That may be true, but newborn babies usually have a distinct advantage—they're asleep. That's right, newborns spend most of their days sleeping, so getting great shots of them is easier than you'd think, but you have to put them in the right setting or everyone who looks at the photos will say something along the lines of, "Aw, too bad she was asleep." Generally, people like babies to be wide awake and smiling in photos, but there's a very popular brand of newborn photography where the baby and mom (or dad) are sharing a quiet moment, and it really sets the stage for a touching portrait. I saw this first-hand when David Ziser (the world-class wedding and portrait photographer) spent one evening photographing my newborn daughter, Kira. Now, David had a huge advantage because my daughter just happened to be the cutest little baby in the whole wide world, but he did stack the deck in his favor with a simple, but extremely effective, technique—he had my wife and I both wear long-sleeved black turtleneck shirts (you can find these at Target). Then, he photographed Kira as my wife held her in her arms (I took a turn as well). David shot very tight (zoomed in), so what you basically got was a sweet little baby resting peacefully in her mother's (and father's) arms. You can use a diffused flash (more on this in Chapter 3), or you can use soft natural light from a side window.

Great Sunset Portraits

Everyone wants to shoot portraits at sunset because the sky is so gorgeous, but the problem generally is that (a) your subject either comes out as a silhouette because the sunset is behind them, or (b) you use a bright flash so your subject looks washed out. Here's how to get great portraits at sunset without washing out your subject: Start by turning off your flash and aim at the sky. Then hold your shutter button halfway down to take an exposure reading from the sky, and while still holding the shutter button halfway down (or you can turn on the exposure lock button on your digital camera), recompose the shot by aiming at your subject, but now turn the flash on (with the power of the flash way down low—maybe 1/4 power or less) and just that small amount of light from your flash is what you use to reveal your subject. This way, your subject gets fill flash, but the sky behind them still looks great. It's an old trick, but it's still around because it works so well.

Better Natural-Light Portraits with a Reflector

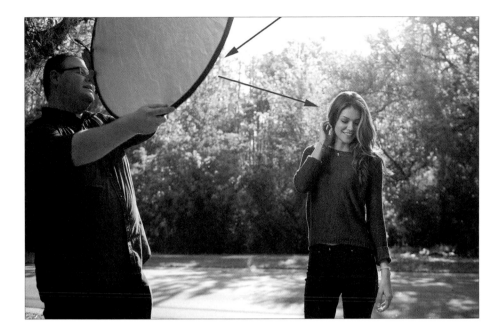

If you want better-looking outdoor portraits, get a reflector. It does just what it sounds like—it lets you reflect light back onto your subject—and one reason why this is so handy is that sunlight isn't always where you'd like it when you're shooting a portrait, so you use a reflector to bounce some of that sunlight over onto your subject, right where you need it. Reflectors are great because: (1) They're cheap. I use a Westcott 30" 5-in-1 circular collapsible reflector (it lets you have gold, silver, white, black, and a translucent light diffuser [for shooting in harsh direct light—you put it between the sun and your subject to soften and diffuse the light]) and they sell for around $30 (told you they were cheap). (2) That collapsible part is important as they fold into a small, flat circle. (3) They're very lightweight, so they're easy to take with you just about anywhere. (4) You'll be amazed at how this one $30 accessory can improve your portraits, either to provide fill light (like when your subjects are backlit [their backs are to the sun], so they're virtually a silhouette—you can bounce some of that sunlight back onto them almost like you're using a light), or when you just want to fill in some dark shadows on one side of your subject's face. The white side of the reflector is probably what you'll wind up using most, as it's the most subtle (and doesn't wind up blinding your subject or, at the very least, making them squint). The silver side is usually used inside a studio or when you need really "punchy" reflected light outdoors (it reflects a lot more light than the white side). The gold side is only for outdoor portraits and works best later in the day because it changes the color of the light it reflects to a very warm sunset-like gold.

Aiming Your Reflector

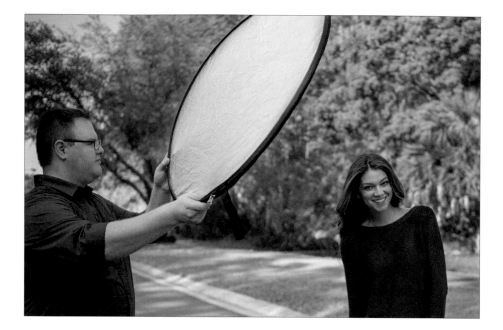

If you've ever watched somebody aim a reflector at their subject, they usually hold it down low and bounce the sunlight from above back onto their subject. That works fine if you're just trying to fill in some shadows, but if your reflector is providing most of the light (your subject is in the shade), then you're "uplighting" your subject (kind of like they do in monster movies to make the monster look more menacing, which probably isn't the look you're going for, unless of course you're lighting your mother-in-law. Not my mother-in-law, mind you, as she is a saint, but ya know, other mothers-in-law). Anyway, people generally look best when lit from above, so the person holding your reflector will need to hold it up high and bounce the light back onto your subject from up there, which is definitely more flattering. (Did I mention that it helps to have a friend hold your reflector? It does. Otherwise, it'll just be sitting there on the ground. Luckily, they do sell reflector stands if you don't have any friends, but if that's the case, reflecting light might not be your biggest concern right now. But I digress.) Have your friend hold the reflector up high and then have them slowly tip it down until you see it starting to light your subject's face. You'll have to direct your friend how far to tip it (ideally, you'd like it aiming down at your subject at a 45° angle), but luckily, while they're moving it, you can see the light move so this won't be too hard to figure out. When it looks good, have them hold it there while you make the shot. Simple enough.

Use a Reflector When the Lighting Is Flat

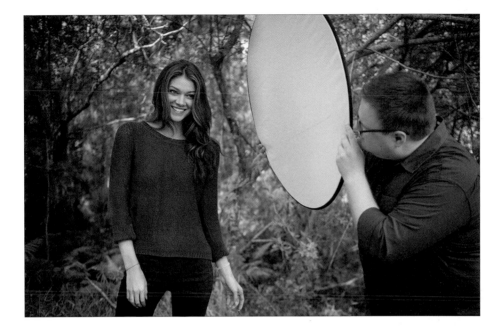

Another time you'll want to reach for your reflector is on a cloudy day because the light tends to be kind of flat (meaning, there are no shadows on one side of your subject's face. It's not horrible light—like harsh, direct sunlight—but it's not great light either, because great light generally has some direction to it). So, on a cloudy day, or if someone is in the shade, we use the reflector to redirect some sunlight onto one side of their face, so it creates a soft shadow on the other side. In this case, your friend holding the reflector will hold the reflector up high to catch the sun, then they'll stand, not in front of your subject, but to either the left or right of them, bouncing the light onto the side of their face and spilling a little bit over onto their cheek on the other side.

THE CLOSER THE REFLECTOR, THE SOFTER THE LIGHT

If your subject is standing in the shade and you want to bounce sunlight onto them, you'll want to know that if the reflector is close to them, the light will be nice and soft. But if the person holding your reflector has to stand 25 or 30 feet away to find some sunlight to bounce back onto your subject, when that light reaches your subject, it's going to be pretty harsh and unflattering. So, ideally, you'd position your subject so they're still standing in the shade, but fairly close to a sunny area. That way, your friend holding the reflector will be fairly close nearby so you'll get softer, better-quality reflected light.

SHUTTER SPEED: 1/1600 SEC F-STOP: F/2.8 ISO: 200 FOCAL LENGTH: 300mm | PHOTOGRAPHER: SCOTT KELBY

Chapter Seven
Avoiding Problems Like a Pro
How to Avoid Digital Headaches

Pros are out shooting every day. And when I say out, if they're studio photographers they're actually usually shooting indoors, so in that case, of course I mean they're out shooting in the studio. Stick with me here, will ya? Anyway, these pros are out shooting every day, while most of the rest of us only get to shoot when our wives let us. I mean, we only get to shoot on certain occasions (like when our wives are out of town), so although we run across digital problems when we're shooting, since we won't have to deal with them again until our wives fly to Minnesota to visit their parents, we just let them slide. The pros don't because they have to deal with these things every day (meaning their in-laws live in the same town they do), so the way they keep from having migraine headaches the size of the Shuttle's booster rockets is by figuring out clever ways to deal with them on the spot. So, this chapter is kind of a shortcut because you're going to get the benefits of years of other people's headaches, but you're going to get to fix them right now, sidestepping one of the real downsides of shooting digital, and that primarily is having to shoot your cousin Earl's wedding (see, you should have listened to your wife when she told you not to get that long lens). Now, you may have noticed that I've been referring to wives as if all photographers were men, and clearly that's not the case. It's just that I am a man (a masculine, mannish, manly man) and therefore it would be silly for me to say, "My husband didn't want me to go shooting that day," when you know darn well he wouldn't mind. Wait—that's not what I meant.

Pro Tips to Avoid White Balance Problems

White balance problems often happen when you shoot indoors under fluorescent, incandescent, or just "them regular ol' light bulbs." Of course, you don't generally find out about them until you open the photos later on your computer and all the shots have either a yellowish, or greenish, or blueish color cast. By default, your camera is set to Auto White Balance, which works pretty well outdoors, but generally doesn't work worth a darn indoors. The pros use three methods to avoid white balance problems when they shoot: (1) They go into the camera and choose a preset white balance setting that matches the lighting they're shooting in (it's easier than you think—just go to your camera's white balance section, and choose either Incandescent [for regular indoor lighting] or Fluorescent [for typical office lighting]). You can choose preset white balance settings for outdoor shots as well, and you'll get more realistic colors there, too. (2) They create a custom white balance. Luckily, your camera will do most of the work for you if you just put a neutral gray card (you can find these at any camera store or B&H Photo) about 8 to 10 inches in front of your lens, and zoom in/out so the card fills your frame. Then, go to your camera's custom white balance menu and set it up to measure what it sees to create a custom white balance (it's easier than it sounds—just take a peek in your camera's manual). And, (3) they shoot in RAW format, so they don't worry about white balance, because they can choose the white balance after the fact, either in Adobe Photoshop's Camera Raw or in their RAW processing software (if they don't use Photoshop's RAW processor). This is just one advantage of shooting in RAW (see Chapter 10 for more on why RAW rocks).

Cold Weather Shooting Means Extra Batteries

Another thing the pros have learned is that digital camera batteries don't last nearly as long in cold weather. So if you're going out shooting in the snow, you'd better bring at least one or two backup batteries for your camera or it could turn into a very short shoot.

EXTRA BATTERIES ARE A SHOOT SAVER

I go out of my way to avoid using flash (I'm one of those natural light freaks), so my batteries last a good long time, and I seldom have to change batteries during a shoot. However, I have at least one backup battery for both of my cameras, and although I don't use them that often, when I have needed them, they've been a shoot saver big time. If there's a must-have accessory, it's an extra battery.

Don't Change Lenses in Dusty Weather

If you're shooting outdoors, take a tip from the pros and don't change lenses if you're in a dusty environment. That's the last thing you want getting down inside your digital camera, and although sometimes you can't see the dust swirling around you, your camera's sensors will see it, and then so will you (when you open the photos on your computer). If you must change lenses, try to go back to your car, or some indoor location, and switch lenses there. Remember, it doesn't take a whole lotta dust to make your camera really miserable—it's worth the extra effort to either plan carefully for shoots in desert or sandy conditions and go with just one lens, or to keep your car nearby so you can go inside, shut the door, and change the lens without fear of fouling your gear.

PROTECT YOUR GEAR TIP

You can buy protective gear for your camera for shooting in harsh or rainy weather conditions. But, if you find yourself in that kind of situation without that protection, you can do what my buddy Bill Fortney does and take a clear plastic shower cap from the hotel you're staying at, and use it to cover your camera and lens. It balls up right in your pocket, and it does a better job than you'd think.

Apply for Permits to Shoot with Your Tripod

©ISTOCKPHOTO/BEANO5

Many indoor locations (including museums, aquariums, public buildings, etc.) don't allow you to shoot on a tripod, even though these locations generally have very low "museum-like" lighting. However, in some cases, you can apply for a free permit to shoot on a tripod—such as the one shown above from the Indianapolis Museum of Art—you just have to ask in advance. I've had a number of instances where, by asking in advance, they would let me come in before or after hours to shoot when nobody's there (alleviating their fear that someone might trip on my tripod and sue them). Sometimes government buildings or museums will let you apply for a permit so you can shoot during their regular open hours, but often they'll have you come before or after hours, which I actually prefer. So, usually it's just me and a security guard shooting at five o'clock in the morning or nine o'clock at night, but at least I've got a stable shooting platform, I'm getting sharp shots because I'm on a tripod, and I don't have to worry about anyone tripping over my tripod, shooting their flash while I'm trying to shoot, or rushing me to get out of the way.

Be Careful What You Shoot

©ISTOCKPHOTO/JONATHAN HARPER

Especially since September 11th in the U.S., people can sometimes get freaky when they see someone shooting photos outside their building (which is common in downtown areas), and they're particularly touchy outside state and federal buildings. Recently, a photographer I know was shooting in a downtown area, and when he pulled his eye away from his viewfinder he was surrounded by three security guards. He didn't realize the building he was shooting was a federal building (it just looked like a fascinating old building to him), and the guards wanted to confiscate his camera's memory card. Luckily, he was able to convince the guards to let him just delete the photos from his card right in front of them, but if he hadn't, the police would have been involved within minutes (it was a federal building, after all). However, building security for corporations can be very aggressive as well (I've heard stories there, too), so just take a little care when shooting in downtown areas and be prepared to delete shots off your card if necessary. Also, as a general rule, in the U.S. and in other countries, you're taking your chances any time you shoot government buildings, airports, military bases, terrorist training camps, nuclear missile silos, Russian sub bases, etc.

A Tip for Shooting on an Incline

If you find yourself shooting on an incline with your tripod, here's a tip that can save your camera from instant death. Let's say you're shooting on a rock or on the side of a hill. Your tripod has three legs—place only one facing you. That way, if the camera starts to tip back, the single leg acts like an anchor and keeps it from falling. If the two-legged side is facing you, with the single leg on the rock or hillside, your camera will topple right over.

The Other Reason Pros Use a Lens Hood

The lens hood that comes with most good-quality lenses these days is designed to reduce or eliminate the lens flare that can creep into your lens when shooting outdoors in daylight, but pros keep a lens hood on even indoors (basically they keep it on all the time) for another reason—it protects the lens. Think about it—the glass end of your lens is pretty much flush to the end of the lens barrel, and if it comes in contact with anything that's not really, really soft, it can get scratched, cracked, or just fingerprinted or dirty. However, when you put a lens hood on the end, it puts a buffer between the glass and the scary world around it. It can save your lens if you drop it or knock it into someone or something.

Keeping Your Lens Out of Trouble

If you're going to be using good-quality lenses with your digital camera, then I highly recommend buying a UV filter for each lens. Although the UV part doesn't do all that much (it filters out UV rays to some extent, which makes your photos look better to some small extent), the real reason to use one is to protect your lens (specifically, the glass on your lens, which can get scratched easily or break if you drop it). Although this "buy a UV filter/don't buy one" controversy is heavily debated on the web, I can tell you from personal experience it saved one of my lenses from certain death. I was out on location and, while changing lenses, I somehow lost my grip and my lens crashed to the ground, glass first. My filter was severely damaged, but once I unscrewed it and took a look at my lens, it was totally unscathed. The filter took all the damage, and it's much cheaper to buy a new filter than it is to replace an expensive lens. So, while a UV filter might not do all that much for your photos, it does a lot for your peace of mind.

Limit Your LCD Time to Save Battery Life

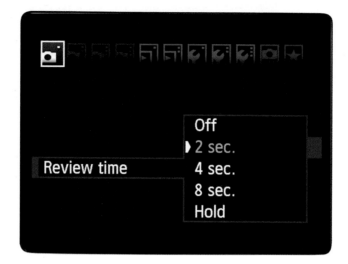

One of the biggest drains on battery life is the color LCD monitor on the back of your digital camera. Although it's a very important part of digital photography, using it too often can really drain your battery, but here's something that can help—lower the number of seconds that your LCD displays right after you take the shot. After all, if you need to see a shot you just took again, you can just press the playback button on the back of your camera and it will reappear. Also, limit your chimping (admiring your photos on the LCD monitor or showing them off to others while making "Oooh! Oooh!" sounds).

Bracket If You're Not Sure About Exposure

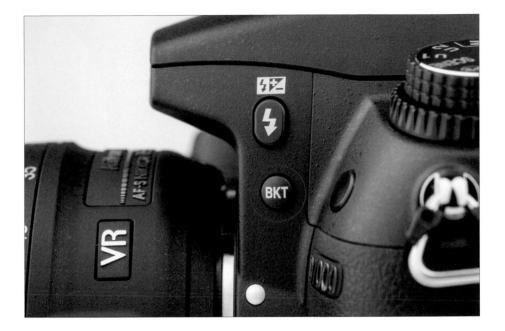

In a tricky lighting situation, or a situation where you've just got to get the correct expo-sure for the shot, the pros make use of the camera's built-in exposure bracketing feature. This basically sets up your camera to shoot multiple versions (as many as five, if you like) of your current scene using different exposures (some lighter, some darker) with the idea that one of them will be just right. It starts by using the suggested exposure read-ing taken by your camera (which your camera believes is the correct exposure, by the way, but it can sometimes be fooled in tricky lighting situations), then it creates another image that is slightly underexposed, and another slightly overexposed (so you've brack-eted both ends of the original exposure). This greatly increases your odds of getting the perfect exposure, and since digital film is free—hey, why not, right? You turn on bracket-ing right on the camera itself. For Nikon digital cameras, depending on the model, the bracketing button may be to the left of the viewfinder below the pop-up flash or on the release mode dial (it says "BKT" on the button). On Canons (like the 60D or the Rebel T4i), you have to turn on bracketing from the menu itself.

BRACKETING TIP

If you're shooting in RAW, bracketing becomes much less important because you have so much control after the fact (in your RAW conversion software), and because you can make as many copies, with different exposures, as you'd like.

Avoid Red Eye

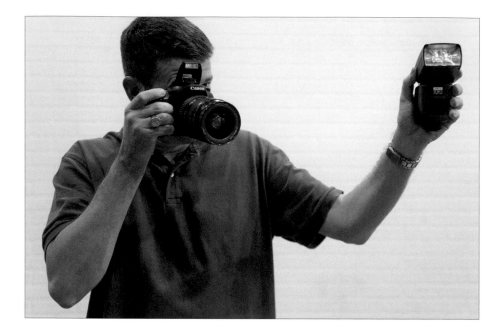

Without going into all the technical (and physiological) reasons why people in our photos often get "red eye" when we use a flash, let's just look at how to avoid it. The main culprit is your camera's pop-up flash, which sits right above your lens and is an almost automatic recipe for red eye. The easy fix (the one the pros use anyway) is to either get that flash (ideally) off the camera and hold it a couple of feet away from the lens, or at the very least up much higher away from the lens, to reduce the chance for red eye. Another method is to bounce your flash off the ceiling, which is a great cure for red eye. Of course, all of these require you to have a separate external flash unit (and not just your camera's built-in pop-up flash). If you can't spring for an external flash, there are a few other popular strategies when you have no choice but to use your built-in pop-up flash: (1) Turn on some room lights, if possible. It lets your subject's pupils contract, and that causes less red eye than shooting in complete darkness. (2) If your camera has a red-eye reduction mode (where it sends a preemptive flash, which causes your subject's pupils to quickly contract, before it fires the main flash), that sometimes reduces red eye. (3) Ask your subject to look slightly away from the lens and that will certainly help, plus (4) moving your camera closer to your subject can also help reduce the dreaded red eye.

Remove Red Eye

KIM DOTY

Okay, let's say you forgot to try one of the strategies on the previous page and you wind up with an important photo that has red eye. Luckily, it's easier than ever to get rid of red eye. Whether you're using Photoshop, Lightroom, or Elements (the consumer version of Photoshop), you can use the Red Eye or Red Eye Correction tool to quickly get rid of red eye. Here's how they work: open the photo in Photoshop (or Lightroom, or Elements), then get the Red Eye tool, and simply click directly on the red area in one of the eyes. That's it—it does the rest. Then do the other eye. Not too shabby, eh? If clicking directly on the red part of the eye is too hard (the person is standing kind of far away so their eyes are kind of a small target), then just take the tool and click-and-drag to create a rectangle or oval around the whole eye area, and when you release the mouse button, it will do its thing. Either way you do it, that red eye is going to be gone in seconds. Just another reason why I love Photoshop.

Chapter Eight
Taking Advantage of Digital Like a Pro

It's More Than Just a Replacement for Film

I added this chapter to the book for a very important reason—I constantly run into people who treat their digital camera like a film camera that comes with free film. These people (freaks) don't realize that digital is much more than just a new type of "free-film camera" and digital cameras offer advantages that we (they, them, us, etc.) never had in film cameras. So, that's what I tried to do in this chapter—show how the pros take advantage of digital cameras to get the most out of their investment. Now, these pros have to squeeze every advantage out of their cameras for two reasons: (1) They have to monetize the results. They paid a lot of money for these tools for their business, and they have to have a verifiable means of tracking their ROI (return on investment). And (2) they have to be able to make enough money to pay both alimony and child support, because their spouses left them shortly after they went digital, because now they spend all their free time playing around with their photos in Adobe Photoshop. Hey, it's an easy trap to fall into, and I've been known to spend an hour or two in Photoshop myself. But that doesn't mean I've turned my back on my wife and child. I mean, wife and two children. My two boys. I mean, my son and daughter, right? Little what's-her-name? And of course, my son Gerald. Er, Jordan. That's it—Jordan. Great little boy, too. What's he now, six? Sixteen! No kidding, he's 16 already? Boy, they sure do grow up fast.

Level the Playing Field: Press That Button

Will digital photography really get you better photos? Absolutely. There are two huge advantages digital brings (if you take advantage of them), so I'm covering both of them on these first two pages. The first is that film is free. In the days of traditional film cameras, every time I pressed the shutter button, I heard in my head, "22¢." Each time I clicked off a shot, it cost me around 22¢. So whenever I considered taking a shot, I would consciously (or subconsciously) think, "Is this shot worth 22¢?" Of course, I wouldn't know for days (when the film came back from the processing lab), but it always made me pause. Now I can push the shutter button again and again and again, and in my head I just see a smiley face instead. Why? Because I'm insane. But besides that, it's because once you've bought your memory card, film is free. This really levels the playing field with professional photographers, because this has always been a huge advantage they had over the amateurs. The pros had a budget for film, so if they were shooting a portrait, they'd shoot literally hundreds of photos to get "the shot." Amateurs would shoot, maybe, a roll of 24. Maybe 36. So, here's a pro photographer shooting hundreds of shots vs. an amateur shooting 36. Who had the best chance of getting the shot? Exactly. Now, jump ahead to digital. It's portrait time—the pro will shoot hundreds of shots, right? Now, so can you, and it doesn't cost you a dime. When you shoot "with wild abandon" (as my friend Vincent Versace always says), you level the playing field. Your chances of getting "the shot" go way, way up, so fire away.

The LCD Monitor "Gotcha!"

Normal

Zoomed in to 100%

The second thing that levels the playing field is that, with the LCD monitor on the back of your camera, you can see if you "got the shot." And by "got the shot," I mean you can tell if your subject blinked when the photo was taken, if your flash actually fired, that sort of thing (I'm not trying to trivialize them—these are huge advantages), but there's a big potential "gotcha" that gets a lot of photographers. It happens because the LCD monitor is so small, it can also fool you. Everything looks in focus on a tiny 3" monitor (think of it this way: even the screen on your cell phone is bigger than this!). When you open that photo later on your computer, you might find out that the key shot from your shoot is out of focus (or your camera focused on the wrong object, so the background is in sharp focus, but your subject is blurry). This actually happens quite often because (all together now) everything looks in focus on an LCD monitor. So, you absolutely *must* zoom in and check your focus regularly during your shoot. If not, you're setting yourself up for a nasty surprise when you download the photos later (see page 17 for how to zoom in).

THE LCD MONITOR CHALLENGE

Another way the LCD monitor will make you a better photographer is through instant creative feedback. If you take your shot, look at the LCD, and what you see disappoints you, then it challenges you to come up with something better. It makes you work the shot, try new angles, get more creative, and experiment until you finally see on the monitor what you set out to capture in the first place.

Edit as You Shoot to Get More Keepers

One of the tricks the pros use to keep an efficient workflow, and to keep from unnecessarily filling up their memory cards, is to edit out the bad shots as they go. If they take a shot and look on the LCD monitor and see that it's grossly underexposed, overexposed, has tons of blinkies, is clearly out of focus, or is just plain badly composed, they delete it right there on the spot. If you do this as well, later, when you download your photos onto your computer, you're only looking at shots that actually have a chance of being a keeper. Plus, you can take more shots per card, because the bad ones have been erased to make room for more potential good shots.

THE HIDDEN "EDIT AS YOU GO" ADVANTAGE

You may think this is silly (at first), but if you edit out all the really bad shots, when you finally do download and start looking at them, you'll feel better as a photographer. That's because you'll be looking at a better group of photos from the very start. The really bad shots have already been deleted, so when you start looking at the day's take, you'll think to yourself, "Hey, these aren't too bad."

Take Advantage of the Blinkies

I know I mentioned this earlier, but it bears repeating. Turning on your highlight warning (or highlight alert, the strobe-like flashing you see on your LCD monitor which shows the parts of your photo that are totally blown out and have no detail) and looking for the "blinkies" will yield you more keepers—no doubt. So, what do you do when you see the blinkies? Use your camera's exposure compensation control to back down the exposure 1/3 stop and shoot the same photo again. If you still see the blinkies, take it down another 1/3 stop and shoot it again. Keep shooting until the blinkies go away. *Note:* Some things will always have blinkies—like the sun—and that's okay. What you want to be concerned about is specifically "blinkies that matter" (blinkies in parts of the photo that you care about). A reflection of the sun on the chrome bumper of a car is an okay situation to let blinkies live. However, blinkies blinking on the forehead of your subject is not acceptable. Also, when looking at the LCD monitor, keep an eye on the overall exposure of the photo—don't let it get way underexposed just to stop a tiny blinky somewhere. Here's how to adjust using exposure compensation:

Nikon: Press the exposure compensation button just behind the shutter button, then move the command dial to the left until it reads –1/3 in the viewfinder readout.

Canon: Turn the mode dial to any creative zone mode except manual, press the shutter button down halfway, then set the exposure compensation by turning the quick control dial on the back of the camera.

The Viewfinder "Border Patrol" Trap

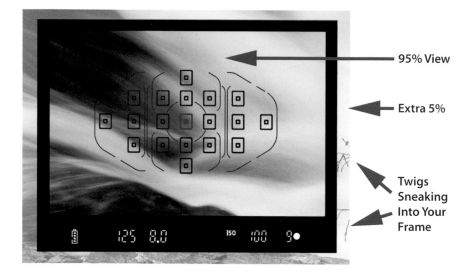

One of the most common mistakes new photographers make is that they don't pay much attention to what's happening around the edges of their image (they're focused on the subject right smack dab in the middle of the frame) and all kinds of stuff creeps in from the sides that can ruin the entire image (things like tree branches, leaves, an old shoe [*an old shoe?*], or some other distracting thingy). We call the act of policing those oh-so-important edge areas "Border Patrol" (you're patrolling the borders for things that shouldn't be there). Anyway, this stuff that's sneaking in on the edges to ruin their shot may not be all their fault. Well, it's not all their fault (notice how I'm spinning this so it's not about you? See? I care). That's because the viewfinder on most digital cameras doesn't actually give you the full 100% of what the camera is capturing. That's right— very often you're only seeing 95% or less of what the camera's sensor is actually seeing (in fact, it's so rare that you see the full 100% image through the viewfinder that when you find a camera that does give you the full-image view, they list that as a feature). So, how do you deal with this? Two ways: (1) Always check the LCD screen on the back of your camera because it actually does show you the full view in most cases. That way, you can see right then, while you can still retake the shot, if something snuck into the edges of your frame. And, (2) now that you're aware that you are in charge of "Border Patrol" for your images, you'll be scanning the edges of your view before you press the shutter button, and that alone makes a big difference.

No Penalty Fee for Experimenting

In the days of traditional film, the only people who could really afford to experiment were pros (or wealthy amateurs), because both the film and processing cost money, and experimenting was just that—taking a chance with money. Now, with digital, not only can you see the results of your experiment instantly (on your LCD monitor), but you can see the full-size results on your computer, and best of all—it doesn't cost a dime. Got a crazy idea? Try it. Want to shoot a subject from a really wild angle? Do it. Want to try something that's never been done before? Go for it. Now there's nothing holding you back from trying something new (except, of course, the intense humiliation that comes with experiencing utter and complete failure, but there's nothing digital can do to help you deal with that. Well, not yet anyway).

Don't Cram Too Much on One Card

One thing a lot of pros do to help avoid disaster is to not try to cram all their photos on one huge memory card, especially when shooting for a paying client. Here's why: Let's say you're shooting a wedding and you want to capture everything on one 64-GB card, so you don't have to switch cards. That's cool, as long as the card doesn't go bad (but sadly my friend, cards do go bad—not often, but it happens. It's a sobering fact of digital photography, but remember that traditional film can go bad as well—there is no "never fails" film). So, if you get back to your studio and find that your 64-gig card took a fatal dive, every photo from that wedding may be gone forever. You might as well just sit by the phone and wait for their lawyer to call. That's why many pros avoid the huge-capacity cards, and instead of using one huge 64-GB card, they use four 16-GB cards. That way, if the unthinkable happens, they only lose one card, and just one set of photos. With any luck, you can save the job with the 48 GB of photos you have on the other three cards, and avoid a really harrowing conversation with "the attorney representing the bride and groom."

SHOOTING RAW? LEAVE A LITTLE ROOM ON THAT MEMORY CARD

A word of warning: If you're shooting in RAW format, don't use up every shot on your memory card (leave one or two unshot) because you could potentially corrupt the entire card and lose all your shots. It happens because some RAW shots take more room on the card than others, but your camera calculates how many shots are left based on an average size, not actual size. So, don't chance it—leave one or two unshot.

Take Advantage of Poster-Sized Printing

You don't have to have a large-format printer to get large-format prints, because today there are loads of professional, reputable online color labs that will print stunning, full-color, poster-sized prints (16x20", 20x30", etc.) and even color correct them for you, for much less than you'd think. You just upload an image, pick your size, and they print it and ship it right to you (I use Mpix [www.mpix.com], and if I get my image uploaded to them by 11:00 a.m., I have the large print in my hands the next morning). For a 20x30" poster-sized print, it runs around $25. Send one of these to your client after an important shoot and it will blow their mind! By the way, the process is so much easier than most people think—you literally just drag-and-drop the file—and once you print one, you'll be totally hooked (and so will your clients).

WHERE TO "GO BIG!"

Here are a couple of services that I use for large-format prints:

- **Mpix** (www.mpix.com)—Been using them for years. I swear by them.
- **Artistic Photo Canvas** (artisticphotocanvas.com)—I use them for large prints on canvas.

You're Probably Going to Lose Your Lens Hood

It's the one thing that falls off your camera more than all the other parts combined. I have no idea why camera manufacturers have been able to pull off mini-miracles where you can make great photos literally in just candlelight and shoot 14 frames per second, with HD video built right in, but the engineering feat of designing a lens hood that doesn't fall off two or three times during a shoot (or walking around a city while on vacation) is simply out of their reach. So, to keep you from pondering this maddening thought at the worst possible time (or losing your lens hood altogether, as I have. Twice. By the way, the replacement was $47), do this instead: buy a cheap roll of gaffer's tape (it's black tape that's good and sticky, but you can peel it off cleanly and it doesn't mess up your camera's finish). Tear off a few small strips and apply them directly to the lens hood itself. Then, when you're out shooting, tear off two short, thin pieces and use them to secure your lens hood to the lens itself. Since I've been doing this, it hasn't fallen off once. You don't know how nice this is until it doesn't happen any more. You can order gaffer's tape online from dozens of places—from B&H Photo to Amazon to www.tapejungle.com.

Is It Better to Underexpose or Overexpose?

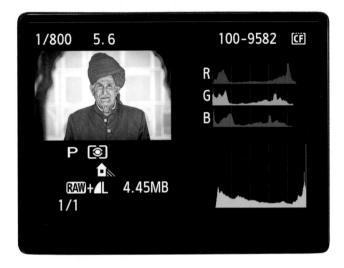

There have been some theories bouncing around a few of the photography forums on the web that claim that you should underexpose by a stop for digital photography. First off, let me say this: your goal (my goal, our common goal) is to get the proper exposure. That's our goal. Always. But if that's not possible, if given a choice between overexposing (a photo that's a bit too light) and underexposing (a photo that's a bit too dark), go with overexposing—you'll have less noise. That's because noise is most prevalent in the shadows, and if you have to lighten an underexposed photo, in Photoshop (see tip below) you're lightening (increasing) the noise in the photo. That's why it's better to shoot lighter (overexposed), because darkening a photo doesn't increase noise the way lightening it does. So, if you'd rather have one than the other—overexpose (but again, our goal is to do neither. That's why we bought these fancy cameras with their highly advanced metering systems).

WHAT TO USE PHOTOSHOP FOR

If you're shooting in RAW, then you're going to use Photoshop to process your RAW photos, but once you leave Camera Raw and you're in the regular part of Photoshop, the idea is to use Photoshop to finish your photos—not fix them. You want to spend your Photoshop time being creative and having fun, not fixing things you should have done correctly in the camera.

Keep from Accidentally Erasing Memory Cards

This is a small tip, but one that can save your hide when you're out shooting in the field. If you keep your spare memory cards in a card holder (and for the sake of your cards, I hope you do), there's a simple routine the pros use to keep track of which cards are full and which cards are empty and available for quick use. They turn the full cards backward in the case (with the labels facing inward), so they can instantly tell which cards are available for use (the ones with the labels visible) and which ones are full. The next time you're shooting in a fast-paced environment (like a wedding shoot or a sporting event), you'll be glad you adopted this system.

Which Brand of Camera Should You Buy?

A lot of folks struggle with this one, especially when they're moving from a point-and-shoot camera to a DSLR. Which brand should you buy? Canon? Sony? Nikon? Pentax? Olympus? This choice is made tougher by the fact that they all make great DSLRs. All of them. However, I have two great ways to make sure you choose the right one (and although they may sound a bit silly, they work better for matching you to your camera than an on-line dating service does for finding your soul mate). Method #1: Choose the camera brand your photography buddy uses. That's right—if they use Canon gear, you should use Canon gear, too, because it will make your life infinitely easier, less stressful, and you'll learn your camera faster. Here's why: (a) now you have someone to call when you can't figure something out; (b) they can show you how to use your camera long after you've left the camera store and chances are they've already run into, and solved, all the roadblocks you're about to run into; and lastly, (c) you can swap (borrow) lenses, filters, flashes, batteries, the whole nine yards. When you're out on a shoot with friends, there's nothing worse than asking, "Anybody got a spare battery?" and everybody does, but not for your brand. Trust me, buy what your friends use. It just makes life easier. Method #2: Go to a real camera store and hold each of the brands you're considering in your hands. Fire a few shots on each, navigate through the menus, change the f-stop, change the shutter speed, and load a memory card. One of those is just going to feel "right" in your hands (just like each guitar has its own feel, or each golf club—one will just feel right). That's the one.

Chapter Nine
Taking Travel & City
Life Shots Like a Pro
Tips for Travel Photography

Ya know what there's not a whole lot of? Professional travel photographers. Ya know why? It's because there are not a whole lot of travel magazines. I mean there's *Condé Nast Traveler*, and *National Geographic Traveler* (one of my personal favorites), and *Travel + Leisure*, and well...I'm sure there are a couple more, but the thing is, there's not like a whole bunch of them. But just because the market's tight for jobs in the professional travel photographer market, that doesn't mean we don't want to take travel and city life shots like we're trying to compete, right? Well, that's what this chapter is all about—tips on beating the living crap out of a couple of those pro travel photographers, so they're in the hospital for a while so we can snag some of their assignments. It's the law of the jungle, and shooting in the jungle sounds like fun, except for the fact that some smug pro travel photographer already has the gig. Or did he just fall (was pushed?) off the side of a mountain in Trinidad and all his expensive gear went right along with him? What a shame. I wonder who'll cover that assignment to shoot the sand dunes in Namibia? Hey, what the heck—I'll do it (see, that's the spirit behind this chapter—jumping in and taking over when one of your photographic comrades has a series of unexplained accidents while shooting on location). Hey look, I'm obviously kidding here, and I'm not actually recommending on any level that you learn the techniques in this chapter so you'll be ready for a last-minute pro assignment, but hey—accidents do happen, right?

How to Be Ready for "The Shot"

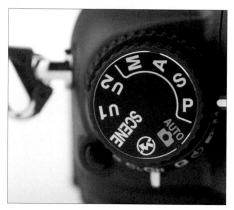

Nikon

Canon

When you're shooting urban (city) or travel photography, you're looking for "the shot." My buddy Dave calls it "the money shot." You know, that shot where you turn the corner and something fascinating, amazing, or [insert your own adjective here] happens and you just happen to be there with a camera to record it. It happened to me in Barcelona when I walked by an alley and saw a man sitting in the dead center of the alley, facing the alley wall, reading a book. It was an incredibly compelling photo (so much so that many people have asked me if it was posed). So, how do you stay ready to catch a photo that just appears on the scene (or maybe drives by in a car)? You shoot in a mode that lets you concentrate on one thing—getting the shot. That's right, when you're walking the city streets, you shoot in program mode. I know, I know, this goes against all sacred rules of professional photography, except the one that says getting the shot is more important than the mode you shoot it in. So, switch your digital camera's mode dial to program(med) mode (which sets both the aperture and shutter speed for you, without popping up the annoying on-camera flash every two seconds like auto mode does) and get the shot. Now, if you get to a scene that isn't changing for a few minutes, you can always switch back to aperture priority (or manual) mode and take creative control of your shot, but for quickly getting the shot as you roam through the city, there's no more practical mode than program. *Note:* Nikon's program mode has a feature called Flexible Program Mode, which lets you change either the shutter speed or aperture setting while the camera automatically changes the opposite setting to keep the same exposure. If you don't touch either dial, it does all the work for you. Sweet!

Shoot Kids and Old People. It Can't Miss

The next time you pick up a travel magazine, take a look at what's in the photos they publish. I can save you the trouble. Their travel photos have two main people themes: old people and children. Now, when I say old people, I don't mean people in their late 50s. I mean really old people, and by that I specifically mean old, wrinkly, craggy-looking women whose skin looks like shoe leather, and old, hobbly, crusty men with canes, wearing hats that haven't been washed since the Korean War. As for kids, the younger the better (but skip the babies). As long as you shoot them on uncomplicated, simple backgrounds, kids make incredibly compelling additions to your urban and travel pics (that's why the magazines love them). Also, if you get either age group to pose for you, make sure you spend some time talking with them before you start shooting—it can go a long way toward loosening them up, which will give you more natural looking poses and expressions (plus, they'll probably let you shoot longer after you've built up a little rapport).

WHAT NOT TO SHOOT

Okay, so kids and old people are "in." What's out? Crowd shots. They're just about useless (you won't even put 'em in your own travel album). Shoot an empty street first thing in the morning, or shoot two people together, but skip the crowds.

Hire a Model (It's Cheaper Than You'd Think)

LOCATION: EIFFEL TOWER, PARIS, FRANCE

How do the pros get those amazing shots of people in exotic locales? One of their tricks is to hire a local model (especially if they're shooting to sell the photos to a stock photo agency). Now, before you turn the page because you think hiring a model is out of your budget, it's usually cheaper than you'd think (well, unless you were thinking it's really, really cheap). Here's a real world example: I hired a professional model recently for a shoot out in New Mexico, and the going rate was $15 per hour, plus I had to provide her prints from the shoot for her portfolio. Some models new to the business will work for free in exchange for you making prints for their portfolio (the term for this in the business is TFP, which stands for "Time For Prints," [they are trading their time for your prints]), so ask your prospective model if they do TFP. If they look at you and ask, "Does that mean Tampa Free Press?" you should probably find another model. Two worldwide resources for finding working models online: www.modelmayhem.com and www.onemodelplace.com.

GET THAT MODEL RELEASE!

If you've hired a model, make absolutely certain that you get your model to sign a model release, which enables you to use those shots for commercial work. You can find some sample model releases online (I believe the PPA [Professional Photographers of America] has downloadable release forms available for its members), and having one could make all the difference in the world.

What Time to Shoot

LOCATION: GRAND CANAL, VENICE, ITALY

Many pros prefer to shoot urban and travel shots at dawn for a couple of reasons: (1) The light is perfect. That's right, the same golden, magical light that looks great for landscape shots looks great for shooting in the city, too. And (2) the streets are usually empty, so there's little distraction for your architecture shots, cathedral shots, or shots of charming little streets and alleys. You only have a limited time to shoot before the sun gets too light in the sky (and the lighting turns harsh) and the streets start to fill with traffic, so get set up before sunup and, of course, shoot on a tripod. Another great time to shoot is at dusk. The lighting will once again be golden, and the only major downside is that the streets won't be empty. There are still some decent opportunities to shoot urban and people shots during the day, because cities often have lots of open shade (sometimes courtesy of the tall buildings in downtown areas). So unlike the landscape photographer, you can often get away with shooting all day, especially if it's an overcast or cloudy day (remember, if the sky is gray, try to avoid including much sky in your photos). Afternoon is a perfect time to shoot charming doorways (in the shade), windows, kids playing in the park—pretty much anything you can find in decent open shade. So, to recap: The best time is probably morning. Second best is dusk, but you can still get away with shooting in open shade during the day, and there's often plenty of it, so fire away (so to speak).

Look for Bold, Vivid Colors

LOCATION: HAVANA, CUBA

One of the things to keep an eye out for when you're shooting urban and travel shots is the bold, vivid colors of the city. You'll often find brilliantly colored walls, doors (shots with a bold-color wall with a contrasting colored door), shops, signs, cars, and bikes. One of my favorite urban shots was of a bright red Vespa scooter parked directly behind a bright yellow Lotus sports car. It almost looked set up for me, and I took dozens of shots of it because the colors were just so vivid, and so perfectly matched. Keep your eyes peeled for brightly painted walls (especially wonderful if you find someone working in front of the wall, or waiting patiently for a bus with the colorful wall in the background, or a bright yellow car parked in front of a bright blue wall). If you're looking for these colorful combinations while you're out exploring, you'll be surprised at how often they'll reveal themselves to you. By the way, I know I'm beating a dead horse here, but these colors will look richer and have more depth in (you guessed it) great light, which generally occurs (you know it) around dawn and dusk. Just remember, the next best thing to those two is open shade.

Shooting Travel? Visit 500px.com First

If you're looking to find the shots everybody else misses (in other words, you don't want shots that are too touristy), before you leave on your trip visit 500px.com, click on Photos in the top left, and in their search field, type in the city or location where you're headed on your trip. You will find absolutely amazing shots, and often a fairly detailed description of where that scene is. (By the way, 500px is a site for serious photographers and a lot of the work there is really amazing, and shot in really amazing places, so it's my go-to resource for researching where to shoot when I'm going to take a trip.)

Don't Try to Capture It All: Shoot the Details

LOCATION: FORBIDDEN CITY, BEIJING, CHINA

I've heard a lot of photographers complain about the results of their urban shooting, and much of the time it's because they try to capture too much. What I mean by that is that they try to capture the entirety of a majestic building or the grandeur of a magnificent cathedral, but even with an ultra-wide-angle lens this is very, very hard to pull off. That's why the pros shoot details instead. For example, instead of shooting to capture the entire cathedral at Notre Dame in Paris, instead capture details that suggest the whole—shoot the doors, a window, a spire, a gargoyle, the pigeons gathered on the steps, or an interesting architectural element of the church, rather than trying to capture the entire structure at once. Let your photo suggest the height, or suggest the craftsmanship, and the mind's eye will fill in the blanks. By shooting just the details, you can engage in some very compelling storytelling, where a piece is often stronger than the whole. After all, if you want a photo of the entire cathedral, you can just buy one from the dozen or so gift shops just steps away. Instead, show your impression, your view, and your take on Notre Dame. Give this a try the next time you're out shooting in a city and see if you're not infinitely more pleased with your results.

The Best Shot May Be Just Three Feet Away

My good friend Bill Fortney said it best, "The biggest impediment to photographers getting great shots is the fact that they don't move. The best shot, the best view, and the best angle is sometimes just 3 feet from where they're standing, but they just don't move—they walk up, set up, and start shooting." It's so true (that's why I also made reference to this non-moving phenomenon in the landscape chapter). Once you find that fascinating detail, that vividly colored wall, that unique scene—walk around. Be on the lookout for other more interesting views of your subject and shoot it from there as well. Besides just moving left and right, you can present a different view by simply changing your shooting height: stand on a chair, squat down, lie on the ground and shoot up, climb up a flight of stairs and shoot down on the scene, etc. Remember, the best shot of your entire trip may be waiting there just 3 feet to your left (or 3 feet up). *Note:* The shot shown above is proof of this concept. It was taken in Morocco. Well, Disney's version of it anyway (at Disney's Epcot Center in Florida). If you were to walk 3 feet to the left (which is the shot I saw first), you'd see an outdoor courtyard full of park visitors eating dinner. But when I stepped 3 feet to the right, it hid the baskets of food and Coca-Cola cups and gave me this more authentic-looking view. By the way, that orange light through the open window is coming from a Disney gift shop. Another few feet to the right, and you'd see some stuffed Mickey Mouse dolls.

Shoot the Signs. You'll Thank Yourself Later

LOCATION: LE PETIT-BÉ, SAINT MALO, FRANCE

Want to save yourself from a lot of headaches? When you're out shooting a cathedral, or a stadium, or a building, etc., take one extra shot—shoot the sign. That's right, later on you may be scrambling to find out the name of that amazing church you shot, and without a lot of research, you may be out of luck. That is, unless you took a shot of the sign that has the name of the church (or building, bridge, etc.). This has saved me on more than one occasion, and if you ever wind up selling the photos, you will absolutely need this info (stock agencies generally won't accept "Pretty Church in Cologne" as a saleable name for an image). Shoot the sign and you'll thank yourself later.

Showing Movement in the City

LOCATION: PARIS, FRANCE

If you want to show the hustle and bustle of a busy city, there's a simple trick that will do just that—slow down your shutter speed and let the people and traffic create motion trails within your image. It's easy (as long as you've got a tripod, which is absolutely required for this effect)—just switch your camera's mode to shutter priority and set the shutter speed at either 1/16, 1/8, or 1/4 of a second (you can go longer if you have low enough light that it doesn't blow the highlights out in your photo). Then press the shutter button, stand back, and in less than a second the motion of the city will reveal itself as the buildings, statues, lights, and signs stay still, but everything else has motion trails around it. If you're shooting at night, you can really have a blast with motion. Try to find a high vantage point (like from a hotel room window, or on a bridge, etc.) where you have a good view of traffic. Then put your camera on a tripod (again, an absolute must for this effect to work), go to shutter priority mode, set your exposure to 30 seconds, and take a shot. Thirty seconds later, you'll see long laser-like streaks of red lines (taillights and brake lights) and white lines (from the headlights), and you'll have an amazingly cool image that most folks won't get.

For Maximum Impact, Look for Simplicity

The single thing that probably kills more properly exposed city life photographs than anything else is clutter—all the distracting background items, foreground items, and just general stuff that gets in the way. So, one of the big secrets to creating powerful and dramatic urban and travel shots is to strive for simplicity. Look for simplicity in your backgrounds, in your people shots, in your architectural elements, in every aspect— the simpler the surroundings, the more powerful the impact. Go out shooting with that very goal in mind. Look for the absence of distraction. Look for the absence of clutter and noise, watch for distracting elements that sneak into the top and sides of your frame, and create some photos that have great impact, not because of what they have, but because of what they don't have—lots of junk.

The Monopod Scam

Now, a lot of places simply won't let you set up a tripod indoors (for example, try to set up a tripod in someplace like Grand Central Station. You can count the seconds before security arrives). However, here's the weird thing: while many places have a strict policy on tripods, they don't have a policy on monopods (a one-legged version of a tripod, often used for long-lens sports photography. Although they're not quite as stable as a good tripod, they're way more stable than hand-holding). So, the scam is this: if they say anything to you about shooting on a monopod, you can always counter with, "Hey, this isn't a tripod." It often stops them dead in their tracks. One reason they let you get away with a monopod is simply because they don't take up much space, and since there are no extended legs, there's nothing really for anyone to trip on (a concern for many building interiors, museums, etc.). So, if you know the indoor environment you're planning to shoot doesn't allow tripods, see if you can pull the old monopod scam. My guess is— you'll float right by 'em.

What to Do When It Has Been "Shot to Death"

So, you're standing in front of the Eiffel Tower (or the Lincoln Memorial, or the Golden Gate Bridge, etc.—any touristy landmark that's been shot to death). You know you have to shoot it (if you go to Paris and don't come back with at least one shot of the Eiffel Tower, friends and family members may beat you within an inch of your life with their bare hands), but you know it has been shot to death. There are a million postcards with the shot you're about to take. So what do you do to show your touristy landmark in a different way? Of course, the obvious thing (you'll find in every photography book) is to shoot it from a different angle. Frankly, I'd like to see an angle of the Eiffel Tower that hasn't been shot. But since, in many cases, that angle just doesn't exist, what do you do next? Try this: Shoot the landmark in weather it's not normally seen in. That's right— shoot it when nobody else would want to shoot it. Shoot it in a storm, shoot it when it's covered in snow, shoot it when a storm is clearing, shoot it when the sky is just plain weird. Since the landmark doesn't change, shoot it when its surroundings are changing to get that shot that you just don't see every day. Here's another idea: try shooting it from a difficult place to shoot from (in other words, shoot it from some view or vantage point that would be too much bother for most folks to consider. Find that "pain in the butt" viewpoint, and chances are you'll pretty much be shooting it there alone). Hey, it's worth a shot. (Get it? Worth a shot? Ah, forget it.)

Including the Moon and Keeping Detail

SCOTT KELBY AND ©ISTOCKPHOTO/DAVID LENTZ

This sounds like it would be easy—a nighttime scene with a crisp detailed moon in the sky in the background, but most people wind up with a totally overexposed bright white circle, rather than the detailed moon shot they were hoping for. That's because it's just about impossible to get both the nighttime scene (which takes a long exposure) and a detailed shot of the moon (which takes a very short exposure because it's actually quite bright) in the same shot. So, what photographers have been doing for years is creating multiple exposures (two images captured in the same frame). Now, there are some digital cameras today that let you create double exposures, but it's just as easy to take two sepa-rate photos—one of the nighttime scene (a barn, in this case), one of the moon—and combine them later in Photoshop. First, start with your nighttime scene. Use a wide-angle lens (maybe an 18mm or 24mm), put your camera on a tripod (an absolute must), set your camera to aperture priority mode, choose f/11 as your f-stop, and your camera will choose the shutter speed for you (which may be as little as 20 or 30 seconds or as long as several minutes, depending on how dark the scene is), then take the nighttime scene shot. Now switch to your longest telephoto (or zoom) lens (ideally 200mm or more). Switch to full manual mode, and set your aperture to f/11 and your shutter speed to 1/250 of a second. Zoom in as tight as you can get on the moon, so there's nothing but black sky and moon in your shot (this is critical—no clouds, buildings, etc.), then take the shot. Now add the moon to your nighttime scene in Photoshop (visit **kelbytraining.com/books/moon** to see my step-by-step Photoshop tutorial on how to do this).

Shooting Fireworks

©ISTOCKPHOTO/MISTIKAS

This is another one that throws a lot of people (one of my best friends, who didn't get a single crisp fireworks shot on the Fourth of July, made me include this tip just for him and the thousands of other digital shooters that share his pain). For starters, you'll need to shoot fireworks with your camera on a tripod, because you're going to need a slow enough shutter speed to capture the falling light trails, which is what you're really after. Also, this is where using a cable release really pays off, because you'll need to see the rocket's trajectory to know when to push the shutter button—if you're looking in the viewfinder instead, it will be more of a hit or miss proposition. Next, use a zoom lens (ideally a 200mm or more) so you can get in tight and capture just the fireworks themselves. If you want fireworks and the background (like fireworks over Cinderella's Castle at Disney World), then use a wider lens. Now, I recommend shooting in full manual mode, because you just set two settings and you're good to go: (1) set the shutter speed to 4 seconds, and (2) set the aperture to f/11. Fire a test shot and look in the LCD monitor to see if you like the results. If it overexposes, lower the shutter speed to 3 seconds, then check the results again. *Tip:* If your camera has bulb mode (where the shutter stays open as long as you hold the shutter release button down), this works great—hold the shutter button down when the rocket bursts, then release when the light trails start to fade. (By the way, most Canon and Nikon digital SLRs have bulb mode.) The rest is timing—because now you've got the exposure and sharpness covered.

If You Have a Laptop, Take It With You

You know what will drive you crazy on vacation? Visiting some amazing location, taking what you know are some really awesome shots, and then having to wait nine days until you get home to start editing and sharing the images. If you take your laptop, you have an editing studio with you wherever you go, and the other bonus is that you have a place to back up each day's shoots. What I generally do is back up my images onto my laptop after I return to my hotel after a day of shooting, and then I connect an inexpensive hard drive and copy those backups to another drive (now I have two copies of my photos from that day, so now I can erase my memory cards and go back out shooting tomorrow, knowing that I have two copies of my images, in two separate locations). After dinner, I usually open those images from the day and do a little bit of editing, so I can email them to friends or post them on Facebook, Twitter, etc. Lastly, I take one extra step: I upload only my final images (in JPEG format) to Dropbox (or any cloud-based service you like). That way, no matter what happens, my final images are safely stored off-site. One more thing: What if you either don't have a laptop or don't feel it's practical to bring one? In that case, bring a tablet and download Snapseed from Nik Software (now owned by Google). It's absolutely amazing for editing images, it's perfect for travel photos, and did I mention it's free? Well, it is, and it's awesome! Anyway, there are three morals to this story: (1) If you think it will drive you a little nuts to wait until you return from your trip to edit and/or share your images, bring your laptop. (2) If you can't go that route, bring a tablet and get Snapseed. (3) Back up your images on-site and, ideally, off-site, as well. You'll thank me.

Want a Rooftop Shot of the City? Try This

LOCATION: PARIS, FRANCE

If you walk into an office building or high-rise hotel and ask them if it's okay if you shoot some photographs from their roof, what are the chances they'll say, "Sure, no problem"? Pretty slim, right? It's because they really have nothing to gain from letting some stranger up on their roof (it's all downside for them, right?). Yet, you see shots from rooftops and from rooftop lounges or restaurants quite often, so what's the trick? The trick is this: when you book your hotel accommodations for your trip, try to find a high-rise hotel with a great view, and now you're no longer "some stranger." You're a hotel guest, and they have plenty to gain from making you happy (after all, that's their job). Start with the concierge. Tell them you're a serious photographer (not a commercial photographer—that might close the door for good) and that you'd love to take a shot from their [rooftop bar when it's closed, roof of the hotel, maybe the balcony of the Presidential Suite if it's available]. The concierge genuinely wants to help (and they might get a nice tip from you, right?), so they'll often bend over backward to get you access to some high vista where you can make your shot. If that doesn't work, introduce yourself to the hotel manager (who also wants to make you happy) as one of his "guests." If he can't let you on the roof, ask if there is some other high view in the hotel that might make a great city shot (the concierge may have already tipped you off as to what to ask for), but the bottom line is this: they want to say, "Yes" because you're a guest. If you're just a stranger walking in off the street asking for favors, they want to say no, and seem to have little trouble doing so.

Getting "Nearly Tourist-Free" Shots

LOCATION: PARIS OPERA HOUSE, PARIS, FRANCE

When you look at the photo above, taken during the middle of the day at the Paris Opera House while it was very busy, you might be wondering what the trick is to get a shot like this where you have very few tourists in the scene (well, if you look closely, down at the far end of the hall, there are a few tourists, but not enough to "kill" the shot). The trick is actually very easy, but it's kind of a pain to actually do it. The trick is patience. That's right—I stood there for 10 or so minutes hoping that there would be a break in the seemingly non-stop parade of tourists walking down the beautiful hall, and worse yet, walking directly in front of me, because immediately to my left was an open door to the balcony overlooking the busy street below (I took a few shots from that same balcony a little later, but the light was harsh and ugly, so they're pretty much hidden from public view until the end of time). Anyway, I just stood there, back a few feet, waiting for my chance and, sure enough, my patience paid off and suddenly I had about a 20-second opportunity where no one was walking in front of me, and no one was in the middle or front of the hall. So, I quickly fired off a few shots and got the one you see above. I actually use this trick quite a bit (see page 217 where I did this in Disneyland and it worked like a charm).

SHUTTER SPEED: 1/250 SEC F-STOP: F/2.8 ISO: 1000 FOCAL LENGTH: 14MM PHOTOGRAPHER: SCOTT KELBY

Chapter Ten
How to Print Like a Pro and Other Cool Stuff
After All, It's All About the Print!

This is a great chapter to read if you're a doctor, because you're going to want a great printer, and you're going to want big prints (at least 13x19", right?), and that means you're probably going to need to spend some money, and nobody spends money like doctors. Ya know why? It's because people always get sick or get hurt. Why just the other day this photographer was in Trinidad shooting and the next thing you know he tumbles down this hillside and winds up in the hospital (I know that last sentence made it sound like he finally stopped tumbling when he hit the wall of the hospital, but that was misleading—he actually was stopped by hitting a large llama grazing at the bottom of the hill, but luckily it was a pretty sharp llama, and she was able to summon an ambulance for him, but not before the llama put all his camera gear on eBay. Hey, I said she was pretty sharp). Anyway, who do you think is going to show up at the hospital to help this unfortunate accident victim? That's right—a doctor. And is this doctor going to fix this photographer for free? I doubt it. The doctor is going to get paid handsomely from the insurance carrier that covers the travel photographer. So what's this doctor going to do with the money? He's going to go on eBay and get a great deal on some camera gear. He'll probably save thousands. Now, what's he going to do with the savings? Buy a 13x19" printer. See, this is the wonder of market-driven economies and why we should all sell our camera equipment and go to medical school, because within a few years we'll all be able to buy some really nice gear.

The Advantages of Shooting in RAW

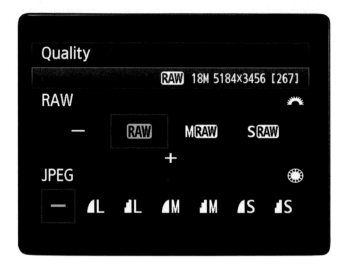

Most professionals today agree that RAW gives you three big advantages over JPEG-quality images: (1) It provides the highest possible image quality—RAW photos are not compressed (JPEG files are compressed to a smaller file size by throwing away some of the original data). (2) RAW files are a higher quality in general, and have a larger dynamic range, so they're more forgiving if you have to adjust the file because you didn't nail the proper exposure. (3) When you shoot in JPEG, your camera applies sharpening, contrast, color correction, and all sorts of stuff (called "processing") to make your images look good. When you switch your camera to shoot in RAW, it turns all that stuff (sharpening, contrast, and so on) off and you get the raw, unprocessed image just as the camera took it. Now you get to process the image yourself, adding contrast and sharpening and all that stuff (usually in Camera Raw [a part of Photoshop], or in Lightroom, or Apple's Aperture, or whichever RAW processor you choose). The idea is that you can process your images better than your camera's built-in automation (and I agree), but you can experiment without ever damaging the original RAW file.

THE DOWNSIDES OF SHOOTING IN RAW

There are really only two: (1) RAW files are larger in size, so you'll fit about 1/2 as many (or less) on your memory card, and (2) since RAW files don't have any sharpening or contrast or other in-camera stuff applied, they don't look as good as JPEG images do straight out of the camera.

How to Process RAW Photos in Photoshop

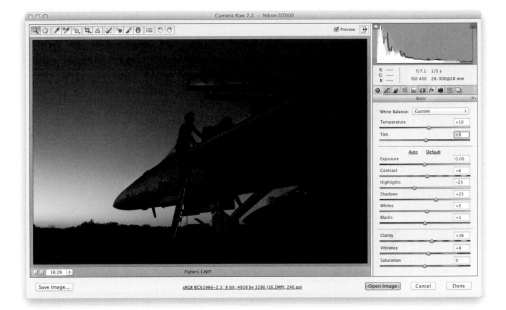

Adobe Photoshop (and Photoshop Elements) includes a RAW processor called Adobe Camera Raw (or ACR, for short). If you shoot in the RAW format, when you double-click on a RAW image on your computer, it will open that image in Camera Raw (if you use Lightroom instead, Camera Raw is built-in there, too—it's the Develop module. The same sliders and controls as ACR, in the same order, too!). Camera Raw lets you adjust everything from your image's white balance to exposure (and even fix lens problems) very quickly and easily. This is all done before you enter regular Photoshop for retouching and finishing touches. And, best of all, changes you make in Camera Raw never change your original RAW photo, so you can experiment and create new images anytime from your original RAW file (think of it as your digital negative). You can also process RAW files in Apple's Aperture, or even iPhoto.

WHERE TO LEARN MORE ABOUT RAW

If you want to learn more about processing your RAW photos (and you don't mind me subtly mentioning three of my bestselling books ever), try these: *The Adobe Photoshop Book for Digital Photographers*, where I did an entire section on processing RAW images step by step. If you use Photoshop Elements, try *The Photoshop Elements Book for Digital Photographers* (which I co-authored with Matt Kloskowski). Or, if you use Lightroom instead, I've still got ya covered with *The Adobe Photoshop Lightroom Book for Digital Photographers*. See how subtle that was? No? Oh, come on, that was totally subtle (wink).

Compare Your LCD to Your Computer Monitor

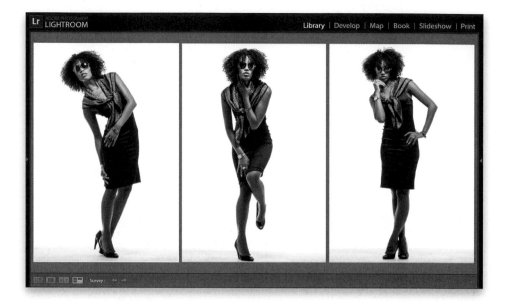

Once you're done with your latest photo shoot, go ahead and download the images from your memory card onto your computer and open them in whatever software package you use to view and organize your photos (I use Lightroom, which is a software application from Adobe specially designed from the ground up just for photographers. You can download a free 30-day trial version at adobe.com/lightroom). Now, once you've got your photos open on your computer, grab your camera and start comparing how the photos on your camera's LCD monitor look compared to the photos you're now seeing on your computer screen. Is it a pretty close match? Is your camera's LCD darker or lighter than what you see onscreen? This will give you a quick idea of how close your digital camera's LCD monitor is to what the image will look like once its on your computer (where you'll ultimately be editing your photos). This can be a big help when you're out shooting. For example, if you learn that your LCD makes everything look cooler (bluer) than it is on your computer screen, then you know you don't have to worry about adding a warming filter to your lens to warm up your photos—they're actually already warm enough. If the LCD is brighter than your computer screen, most cameras these days let you lower the brightness of the LCD screen, so it more closely matches how it will look when you edit your images on your computer. Try this and you'll be amazed at how knowing how "true" your LCD actually is can help you and your photography.

Organizing Your Photos with Lightroom

Although I use Photoshop for all the serious retouching and high-end tweaking of my photographic work, I use Lightroom for managing and organizing my thousands of digital photos, processing my RAW photos, creating onscreen slide shows, printing out multi-photo layouts, and even creating custom photo books. It is available for both Macintosh and Windows users, and only costs a fraction of what Photoshop costs (currently $149). Now, it certainly doesn't replace Photoshop, because it doesn't really allow for much serious retouching (like removing wrinkles, or reshaping facial features, or any one of a hundred things we can do in Photoshop to make people look their very best), nor does it create the amazing special effects, or photo composites, or layer adjustments, or the myriad of other things that only Photoshop can do, but then Lightroom isn't supposed to do all those things. Its strength is organizing, viewing, and editing RAW, JPEG, and TIFF files, and printing them, and it does that pretty brilliantly I might add. If you get serious about this whole digital photography thing (and if you bought this book, you're getting serious), I recommend you check out Lightroom—especially because if you actually go and buy it, I get a cash kickback from Adobe. I'm kidding of course, but I wish I weren't.

How Many More Megapixels Do You Need?

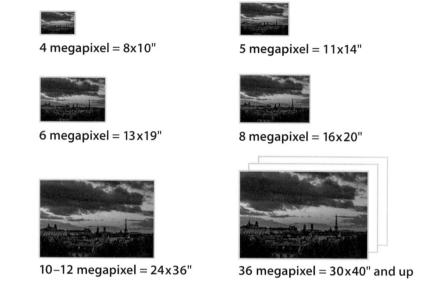

4 megapixel = 8x10"

5 megapixel = 11x14"

6 megapixel = 13x19"

8 megapixel = 16x20"

10–12 megapixel = 24x36"

36 megapixel = 30x40" and up

There's a ton of confusion (also known as marketing hype) around megapixels, and many people believe that megapixels have to do with image quality—the higher the number of megapixels, the better the quality, right? Unfortunately, that's not true. So, if you were using that as an excuse to buy a new camera, that's not going to float with me (although your spouse may buy that line). Here's what megapixels really mean: how large can I print my final photograph? That's it. If you're not going to print anything larger than 8x10", then a 5-megapixel camera is absolutely all you need. In fact, it's really more than you need, but I don't think you can even find a DSLR that's only 5 megapixels anymore (heck, our cell phone cameras are more than 5 megapixels these days). Anyway, if you want to routinely print 13x19" color prints, then you only need a 6-megapixel camera, so if yours is more megapixels (and you know, and I know, it is), then you're already set (I know, this is hard to swallow after years of thinking you needed more megapixels). So, what are today's 36-megapixel and up cameras for? Suckers. (Okay, not really, but you knew I was going to say that.) Actually, those high-megapixel cameras are for pros who need to print giant-sized images (think 30x40" and larger). If that's not you, then a 6-megapixel camera is all most people will really ever need, so put away your checkbook. Hey, don't blame me. I'm trying to save you some money, so you can buy some decent lenses and a fancy tripod.

Printing Lab-Quality 8x10s

SCOTT KELBY AND EPSON AMERICA INC.

At some point, after putting all these techniques to use, you're going to want prints, and today many pro photographers create their own prints. Personally, I only use Epson printers, and about every other pro I know uses Epson printers as well, because they've become the standard for professional quality color and black-and-white inkjet printing. Now, before I start making recommendations as to which Epson printer to buy, I want you to know up front that the only reason I'm telling you this is because it's exactly what I'd tell any friend who asked. I don't get a kickback or cut from Epson. They have no idea I'm telling you this, so if you tell them, "Hey, Scott said I should buy an Epson," they'll say something along the lines of, "Scott who?" I personally have three Epson printers, and I love them dearly for three main reasons:

(1) They work pretty flawlessly most of the time, but if I do run into a bump along the way, they have live 24-hour tech support, which is actually quite good.

(2) They not only sell the printers, but the paper as well, and I love their paper.

(3) The output is absolutely stunning. The quality prints that come out of my Epson printers still amaze me

For printing borderless 4x6s, 5x7s, and 8x10s, try the Epson Artisan 50 Inkjet Printer. The street price is around $150 (if that sounds pretty cheap, it is, but don't get too excited— you'll make up for it buying ink and photo-quality paper).

Printing Lab-Quality 13x19s

SCOTT KELBY AND EPSON AMERICA INC.

A popular print size with serious photographers is the 13x19" large print, and the Epson Stylus Photo R3000 is the king of this realm (it's the update to my beloved R2880—Epson tweaks their printers every year or so with the latest technology). Its color output is really stunning, but where the R3000 really kills is when you make black-and-white prints (it has a built-in advanced black and white mode). You'll lose your mind. Plus, the R3000 uses Epson's UltraChrome K3 archival-quality inks, so your prints are going to last longer than you will by a long shot. Of course, besides the 13x19" prints, it also does all of the smaller sizes, and you can print to roll paper, as well (for printing lots of prints on an overnight run—ideal for small studios). This is as in love with a printer as I've ever become. It costs around $790, which, for what it does, is a bargain.

Printing 17x22s—The Pros' Choice

SCOTT KELBY AND EPSON AMERICA INC.

Pros who sell their prints know that the bigger the print, the bigger the paycheck, and maybe that's why so many favor Epson's Stylus Pro 3880 large-print format printer, which makes prints on cut sheets up to 17x22" (or 17" by whatever if you use roll paper). For years, I've been a little miffed that Epson doesn't make a cut sheet in the classic 16x20" size, so I bought my 16x20 sheets from Red River Paper. I've finally gotten over it and now I just print on 17x22s, which fit digital file dimensions better anyway. Now that my rant is out of the way, this is one seriously killer printer (I think it's the best one Epson's ever made), and better yet, I just checked B&H Photo and they had it for $899, which is an insanely low price for a printer like this. If you're ready for a pro-quality photo printer, this is the one!

Which Paper Should You Print On?

If you're getting an Epson printer, then you definitely want to print on Epson paper. Epson paper not only works best on Epson printers, sometimes it's the only paper that will work (for example, one time when I was in a bind, I tried some HP paper. It didn't work at all—the paper went through the printer and ink came out, but it looked like… well, let's just say it didn't work and leave it at that). So, which papers do I recommend? Here they are:

Epson Velvet Fine Art Paper: This is a cotton paper with a matte coating that looks like watercolor paper and has a wonderful texture that gives your photos almost a painted feel. Clients love the feel of this paper and it's usually the first thing they notice.

Epson Ultra Premium Photo Paper Luster: This is probably my all-around favorite paper (and a favorite with many pros) because, although it definitely has a sheen to it, it does so without being overly glossy. It's that perfect paper between glossy and matte.

Epson Exhibition Fiber Paper: This is real pro-quality, high-end paper, with a true pro-quality look and a pro-quality price to match. This is about as good as it gets—use it for prints you're going to hang in a gallery or sell.

All of these papers are available directly from Epson.com, but I also often find these at my local Staples or Office Depot in sizes up to 13x19".

What Determines Which Paper You Use?

PREMIUM LUSTER

VELVET FINE ART

So, how do you know which paper to use? Believe it or not, there's an easy way—the paper you choose to print on is determined by one thing: the subject matter of your photo.

For example, if you're printing things of a softer nature, like flowers, birds, landscapes, waterfalls, or any type of image where you want a softer feel, try a textured paper like Epson's Velvet Fine Art Paper (provided you are printing to an Epson printer), which works wonderfully well for these types of images. This is your choice any time you want that "artsy" feel to your photography, and it also works well when your photo isn't tack sharp. Try it for black-and-white photography, too (especially on Epson's R3000), when you want extra texture and depth.

For serious portrait work, architecture, city life, travel, and finely detailed landscape shots, try Epson's Ultra Premium Photo Paper Luster. Anything with lots of detail looks great on this paper, and it really makes your colors vivid. So, when the shot has lots of detail and sharpness, lots of color, and you need it to "pop," this is the ticket for sharp, crisp prints.

Epson's Exhibition Fiber Paper is a great choice for landscape or cityscape black-and-white photos on the R3000 or the 3880 (this paper was designed expressly for printers that use Epson's Ultrachrome K3 inks), and it's one of the few fiber papers that print both color and black-and-white prints equally as well. When you see one of your landscape shots printed on this paper, you'll momentarily black out. I am not kidding.

Getting Your Monitor to Match Your Printer

Color management (the art of getting your color inkjet prints to match what you see on your monitor) has gotten dramatically easier in recent years, but the key to getting a color management system to work is getting your monitor color calibrated. A few years ago, this was a costly and time-consuming process usually only undertaken by paid consultants, but now anybody can do it because (1) it's very affordable now, and (2) it pretty much does all the calibrating work automatically while you just sit there and munch on a donut (you don't have to eat a donut, but it doesn't hurt). I use Datacolor's Spyder4ELITE hardware color calibrator, because it's absolutely simple to use, it's affordable, and a lot of the pros I know have moved over to it. It sells for around $249, and that's pretty much all that stands in the way of having your monitor match your prints. Well, that and downloading the free color profiles for the paper you're printing on (more on that on the next page).

Download the Color Profiles for Your Paper

If you buy Epson papers (or any of the major name-brand professional inkjet papers), you'll definitely want to go to Epson's (or your paper manufacturer's) website, go to their downloads page for your particular inkjet printer, and download their free color profiles for the exact paper you'll be printing to. Once you install these free color profiles (they install with just a double-click), when you go to Photoshop (or Lightroom, or Elements) to print your photo, you can choose the exact printer and paper combination you'll be printing to. This gives you the best possible results (and color fidelity) for your particular paper and printer. The pros do this every time and it makes a huge difference in the quality of their prints.

TIP FOR MORE PREDICTABLE COLOR

Your printer has a color management system, and Photoshop has one, too. Having two color management systems going at the same time is a guaranteed recipe for bad color. So, if you're printing from Photoshop, you should definitely turn off the color management system for your printer and use Photoshop's instead (in other words, let Photoshop determine the right colors).

Selling Your Photos as "Stock" Online

Selling photos to a stock agency is a dream of many photographers (pros included), but generally only the best of the best get this opportunity. Until now. Now you can start selling royalty-free stock photography today thanks to iStockphoto, which is a community of photographers all around the world who sell their photos online as stock (which means you give the rights to other people to buy, download, and use your photos in brochures, ads, wetbsites, flyers, and other collateral material graphic designers and web designers create for their clients). The great thing is anybody that follows their guidelines can upload their own photos and start selling them right away as part of iStockphoto's huge database of images. Now, you only get paid on how many people actually buy your photo, and since prices vary based on a buyer's subscription, and you get from 15%–25% (depending on how many people download your image), you're going to need to move a lot of photos to make this a business. But let me tell you this, there are photographers who make their living (and their Porsche payments) strictly from what they sell on iStockphoto.com, because iStockphoto is used by about a bazillion people around the world. Needless to say, the better quality your work is, and the more popular the subjects are, the more your images will get downloaded. How popular is iStockphoto? Well, Getty Images, one of the world's leading and most respected providers of high-quality stock images, bought them out—if that gives you any idea.

A Quick Peek at My Gear

For those interested in what kind of photo gear I use, here's a quick look: my main camera is a Nikon D4 and my backup camera body is a Nikon D3S. My go-to lens (if I have to have just one) is a Nikon 70–200mm f/2.8 VR II zoom lens (I use it for everything from portraits to my second lens when shooting sports).

For travel, I like to use just one lens (less is more for travel), and that's a Nikon 28–300mm f/3.5–f/5.6 VR lens. For landscapes, it's a Nikon 14–24mm f/2.8 super-wide-angle lens. I also use a Sigma 15mm f/2.8 fisheye lens for when I want an extreme-wide-angle for special effects type shots. You can't use it every day, but use it sparingly and it's really effective. I have a few other lenses (like a Nikon 85mm f/1.4 and a Nikon 24–70mm f/2.8), but those are the ones I use day-in/day-out (for sports, I have some long glass: a Nikon 300mm f/2.8 VR II, a Nikon 400mm f/2.8 VR II, and a Nikon 200-400mm f/4 VR).

I use two Nikon SB-910 hot shoe flashes and a Nikon TC-14E II 1.4x teleconverter to make my long lenses even longer. I use a collapsible Hoodman HoodLoupe, so I can see my LCD screen clearly when I'm shooting outside, and two Gitzo tripods (one for travel; one for everything else) with a BH-55 (and a smaller BH-40) Really Right Stuff ballhead (the mother of all ballheads, if you ask me). I have Lexar 600x and 1000x CompactFlash memory cards (you can never have enough), and I move all this gear in a Think Tank Photo Airport International V 2.0 Rolling Camera Bag (it's awesome!). You can see all my latest gear, with photos and links, at scottkelby.com/gear.

There Are Three Other Books in This Series

I hope this book has ignited your passion to learn more about photography, and if that's the case, I want to let you know that the book you're holding is Part 1 of what is (so far) a four-part series. I didn't plan it that way, but so many folks wrote me and asked, "When are you doing a part 2?" that I did Part 2. It did really well, so my publisher asked, "When are you doing a part 3?" and then I emailed myself a note asking, "When are you doing a part 4?" I am now concerned that I might send myself a tweet asking, "Will there be a part 5?" Probably, but only when I come up with enough kick-butt tips to fill an entire book—sometime in the year 2525, if man is still alive. (Okay, did anyone catch that vague reference to the song "In the Year 2525?" You did? Nice! Okay, bonus question: What's the name of the artists? Don't feel bad; nobody knows this one. It's by Zager and Evans.) Anyway, each part builds on the previous book, so you started with the right one by starting here with Part 1. You should read Part 2 next—don't jump ahead to Part 3 or Part 4. Here's what's in the other books in this series:

Part 2: It includes chapters on hot-shoe flash, studio lighting basics, shooting macro, more on everything from travel to landscapes to portraits, and more photo recipes.

Part 3: There are chapters on shooting outdoors, composition, product photography, lenses, and lots more on portraits, hot-shoe and studio flash, and sports.

Part 4: Lots more on lighting, chapters on shooting HDR and shooting DSLR video, plus more travel, portraits, shooting with natural light, sports, and lots more.

I hope you'll continue your photographic journey with me through this series. There's always the possibility the jokes will get better in Parts 2, 3 & 4 (Spoiler Alert: They don't).

Learn More with Me Each Week on *The Grid*

Every Wednesday at 4:00 p.m. EST, I co-host (with photographer and Photoshop Guy Matt Kloskowski) a free, weekly photography talk show called *The Grid*. We talk about the week's hot topics in the photography community, and once a month we do a very popular episode called "Blind Photo Critiques," where you can send us five images for critique on the show. They're called "Blind Photo Critiques" because we don't reveal your name on-air, so we can be really honest and helpful to the person sending in the images. If you want "a hug," post your images on Flickr, and people will line up to tell you you've reinvented a photography genre, even if it's just a photo of your cat, Mr. Whiskers, playing with an empty juice box. Here, we actually tell you the truth (good or bad) and do it in a way that helps people learn about photography. Photographers from around the world tell us they learn a tremendous amount from it (in fact, the Light Stalking website included us in their list of "5 Incredible Online Communities to Get Genuine Feedback on Your Photography"). We also have famous in-studio guests, like Joe McNally, Cliff Mautner, Joel Grimes, Moose Peterson, Glyn Dewis, Lindsay Adler, Dave Black, and more. It's fast-paced, informative, sometimes controversial, often enlightening, and always a lot of laughs and fun. It airs live at **kelbytv.com/thegrid**, and we take your questions live on-air during the show. See you on *The Grid*!

WANT TO LEARN EVEN MORE?

I also produce a free weekly show called *Photography Tips and Tricks* ("Photo TNT" for short), hosted by RC Concepcion and Larry Becker. It's packed full of short little quick tips to help you make better photos—kinda like this book. You can catch it live (or we rebroadcast episodes free starting the next day) over at **kelbytv.com/photographytnt/**.

Chapter Eleven
Ten Things I Wish Someone Had Told Me
When I First Started Out in Photography

So, why don't pro photographers tell you about these things when you're "on the way up"? It's actually very simple, but you need to know the back story to understand how, historically, this has all worked. For as long as I can remember, there has been a "Secret Society of Photographers Who Have Taken a Blood Oath to Never Share Their Hard-Earned Secrets with Outsiders" (known as the SSOPWHTABOTNSTH-ESWO, for short), and this cartel of working pros (supposedly funded by an "unofficial" government agency, or Pentax) controls the flow of information, much like the ICANN controls the distribution of top-level web domains. Anyway, the sacred brothers (as they're called) of the SSOPWHTABOTNSTH-ESWO controlled the flow of photographic techniques for many years by only sharing them with other sacred brothers during a ritualistic "sharing of the mastery" ceremony held once at year in a hidden cave (which some claim is in Dunwoody, Georgia, just outside Atlanta). Anyway, what finally broke this chain of religious-like secrecy was actually a clerical error—a typo, if you will. When they were updating their official letterhead and business cards back in 2006, an intern working on the design apparently typed in their name as "SSOPWHTABOTTH-ESWO," accidentally leaving off two critical letters, "NS," which was the "Never Share" part of their name. As things tend to go in secret societies like this, the members felt this was actually an edict from the governing body (the Parliamentary Order of Professionals, a group which regular members are forbidden to ever refer to by their acronym), and so members began to share these once secret techniques openly and freely, and that's how we got to where we are today. Or, it could be that those pros are just afraid that if other people learn this stuff they'll wind up losing wedding jobs to them. It's hard to say.

#1: Buying a More Expensive Camera Doesn't Necessarily Mean Better Photos

If you bought a new DSLR camera in the past year or two, even an entry-level model, it already takes better quality photos right out of the box than the high-end pro models did just a few years ago. The quality of the sensors in today's entry-level digital cameras is truly amazing and, whether it's a Nikon, Canon, Sony, Pentax, etc., they all make great quality photos. For example, if you went out at dawn to a beautiful landscape location, set up a tripod, and took 10 shots with an entry-level camera, like the Canon Rebel T4i (I found a body online for $499), then took the same shots, in the same location, with the high-end Canon 5D Mark III (around $2,600), printed all 20 images, and mixed them up, you wouldn't be able to tell which camera took which images. They'd be that close in quality. So, if they both take such great shots, why would anyone ever need a high-end pro camera? Well, it's *not* because they take better photos; it's because they have more features. It's kinda like buying a car. You can buy a Toyota Camry from around $22,000 up to around $30,000. They're all Camrys (great cars), but you buy the $30K model because it has more features—heated seats, a back-up camera, a bigger engine, a security system, more speakers, and so on. But, when you're on the highway going 60 mph, the results are the same. So, how can you get better photos out of the camera you already have? Learn your camera inside and out—all the features, all the menus, and what all the buttons do. That way, using your camera becomes automatic and you can stop worrying about all the buttons and dials and start focusing on making great pictures, which is really about two things: what you aim your camera at and how you aim it.

#2: You Need to Sharpen After the Fact

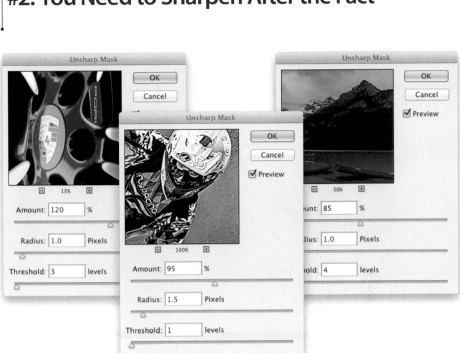

There are lots of things you can do to help really sharpen photos, and obviously I thought it was so important that I started this book with a whole chapter just about sharpness. But, if there is one single trick that really takes a sharp shot to one that's tack sharp, it's sharpening after the fact on your computer. It doesn't matter whether you use Photoshop, Photoshop Elements (the "light" version of Photoshop that really isn't very light), Apple's Aperture, or Adobe's Lightroom, you need to sharpen every single photo to get the look the pros have. Think about this: with all the money we spend on tripods, and cable releases, and really sharp lenses, the reality is that as long as the shot is pretty sharp coming out of the camera, the $99 you spend on a program like Photoshop Elements will have the most impact on you getting a truly sharp photo (heck, I just did a quick Google search and found Elements for $65—that's a small price to pay to have all your photos from here on out jump to the next level of sharpness). By the way, whether you buy Photoshop Elements for $65 or the full version of Photoshop for around $700, the sharpen filter we use, called the Unsharp Mask filter, works exactly the same in both. To use it, go under the Filter menu, under Sharpen, and choose Unsharp Mask. Back on page 18 in Chapter 1, I gave you the settings I use day-in, day-out for people, cityscapes, urban photography, or travel, general everyday use, super-sharpening (for sports photos, landscapes, stuff with lots of details), and for images I've already made smaller and lower resolution, so I can post them on the web. Try them out and see if this sharpening doesn't make as big of a, or bigger, difference than all the rest.

#3: The Pros Take Lots of Bad Photos

You just don't see them, because one of the traits of a real pro is that they only show their very best work. I know a lot of folks think that these pros walk up to a scene, take one amazing shot, and then walk away and do it again someplace else—every time they press the shutter button, they create yet another amazing shot. I can tell you, for certain, that's just not how it works (if it was that way, the photographer's workday would be all of five minutes long, right?). I've worked and taught alongside some of the most famous pho-tographers in the world today and they'd be the first ones to tell you that it often takes hundreds of shots of the same subject to come away with that one amazing shot (the only one that anyone will see). But, when we shoot, we see *all* our shots (the good ones and bad ones), so we start to compare *all* our shots to the pros' highlight reels, and it bums us out. Remember: we're not judged as photographers by the bad shots we take; we're judged by the ones we share. Take a cue from the pros—only share your best shots and just know that pros simply don't nail every shot. So, don't compare all your shots to the pros' cream of the crop. By the way, if I shoot 200 or 300 shots and I come away with five or six really good ones in there, I'm thrilled. Sometimes I get a few more than that; sometimes I literally walk away with none, which is disappointing, but it happens. If that happens to you, don't let it get you down—chances are that at the next shoot you'll make up for it. One more thing: every once in a while something amazing happens right in front of us and we raise our camera, shoot, and capture something magical. It happens to both amateurs and pros and it's called "getting lucky." Thankfully, it happens more often than you'd think.

#4: Learn Exposure Compensation

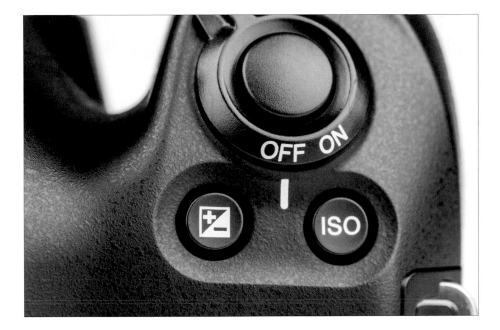

If you take a shot and you look at it on the back of your camera and it just looks awful (it's way too dark, way too bright, your subject is in shadows, etc.), do you know exactly which controls on your camera will fix it? If not, the next most important thing for you to learn is exposure compensation. I cover it back on page 74, but a lot of people will skip over that page because the phrase "exposure compensation" doesn't mean anything to them at that point. I wish it had a better name, because I think it's probably one of the most important camera techniques to learn when you're starting out. It helps you overcome two big problems: (1) your camera's built-in light meter is really good, but sometimes it's wrong and you know it's wrong, but you're not sure how to fix it; and (2) it helps you retain the detail in your photos, primarily in the brightest parts of your image. If you and I were out shooting and you asked me what one thing you needed to understand about your camera itself to really take better shots, learning exposure compensation would be it. Learning this is what will turn more of your messed up shots into prints you'll want to hang on your wall. Turn to page 74 right now and learn it. You can always come back to this chapter later (yes, it's that important).

#5: Don't Worry About Manual Mode

Good news: you can be a great photographer, and make amazing images, and live a long, happy life all without ever having to learn to shoot in manual mode. I know a lot of new photographers worry that the reason their photos don't look like they want them to is because they're not shooting in manual mode. But, trust me, manual mode isn't some magical mode that transforms everyday photos into gallery pieces—it's just another shooting mode on your camera like the rest. And, ultimately, what makes magical photos is, say it with me, "what you aim your camera at and how you aim it." It's not which mode you shoot in. I think the reason some of us get sucked into thinking it's the magical unicorn of modes is that you'll sometimes read in an online forum some photographer bragging that he "only shoots in manual mode" (like he's earned some special honor). But, again, trust me, it's just another exposure mode on your camera, so you can scratch that one off your worry list. Now, I don't want you to think that I'm saying you shouldn't learn manual mode, or that manual mode is bad (I actually recommend it for shooting in a photo studio with strobes), but I don't want you to think it's this big hill that one day you're going to have to climb to get to photography nirvana. In the list of things we have to worry about in our quest to become better photographers, you can move this one way, way down your list.

#6: Today You Should Probably Shoot Wide

Where do most of our images wind up being seen today? On the web, right? I mean, we still make some prints from time to time (you do make prints, right?), but really, in today's world, you'd have to admit that for most of us, the web is where most folks will see our images. If that's the case for you, then I hope you take this advice I got a few years ago: shoot wide. By wide I mean shoot horizontal (landscape) shots rather than tall, vertical shots. Here are two reasons why: (1) The bigger your images appear, the more impact they have, right? Right! So, when you shoot tall shots and put them on the web, they usually wind up looking like small thumbnails because that's the way most websites, portfolio sites, and social media sites are designed. Your image will have a lot of empty space on either side of it, and in the middle, there's your little picture. However, if you shoot wide, you'll be able to make your images much larger on the web and they'll have that much more impact. (2) It's usually much easier to crop a wide image so it looks like a tall image, than it is to try to crop a tall image so it looks like a wide image (give it a try and you'll instantly see what I mean). So, I know there's an old saying that goes, "When do you shoot a tall image? Right after you've shot a wide version of it," but there's a reason that's an "old" saying. It used to apply because all our images used to be prints, and they all had the same impact because you could just rotate the print. Today, things have changed and we need to change our thinking (and our shooting strategy), too!

#7: Nothing Has Impact Like a Print

If you want to really make an impression on people, make a print. I know it sounds simple, but a printed piece, especially today, is one of the most powerful, impactful things you can do for your photography, and the bigger the print, the more powerful the impact (I personally think the impact size starts at 13x19", but if you can go bigger, like 17x22", it really adds impact. This is a case where bigger is better). So, why do prints have such an impact these days? (1) Prints are real. The rest of the time we're looking at images inside a glass screen on a computer. We can't hold them. We can't touch them. They're "inside" a box of some sort. When you make a print, your image is no longer a bunch of 1s and 0s and a bunch of digital code. It's real. (2) When you make a print, watch the person's hands right after you hand them the print. They start feeling the paper. Touch is one of our five senses, and when you add touch to your visual sense, your image con- nects with the viewer on a different level. (3) There is a certain legitimacy to having prints of your work. It says something about you, about how serious you take your work, and it's an investment in your photographic journey. (4) Prints open doors. If you want to shoot in a particular location (let's say it's a restaurant interior), and you take a large print in to show the restaurant owner the type of work you do, my guess is they'll welcome you to shoot in their restaurant. It tacitly says, "I'm legit—it's okay to let me do this." Believe me, it works wonders. Lastly, (5) prints make an amazing gift. Think of it this way: How much impact does it have when you email an image to a friend? Now, make a nice print, sign it, roll it in a tube, and mail it to them the old fashioned way. You'll be amazed at the reaction you get. There's power in the print. Try it once, and you'll see.

#8: Ignore Your Histogram

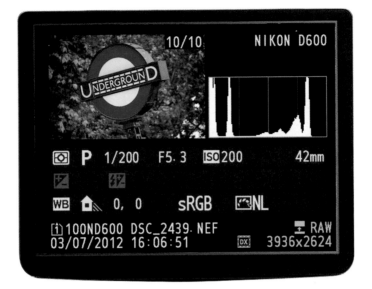

I know that headline above just made someone's head explode, but remember, these are things I'd tell a personal friend (and things I wish somebody had told me), and one of those things would be to ignore the histogram on the back of your camera. I know that people desperately want a tangible, technical measure of the age-old question, "Is this a good photo?" But, I can promise you the answer isn't found there. I remember being one of the guest speakers at a photography workshop and, during my presentation, the subject of histograms came up. Standing in the back of the room were some of the other instructors (literally, some of the best in the business—Joe McNally, Vincent Versace, Laurie Excell, and Moose Peterson). I mentioned I didn't use histograms, and then I asked those famous photography instructors if they ever used the histogram on the back of their camera. They yelled back: "Nope," "Never," "Not me," and "Not a chance!" What is it that these pros know that so many people arguing endlessly on the web don't know? They know that great photos don't come from looking at a graph. They know that great photos aren't about the technical stuff (even though so many photographers desperately wish that it was, because people can learn technical stuff—it's much harder to develop an "eye" and a heart for photography). Getting a good exposure with today's digital cameras just isn't that hard. In fact, it's simple, because today's cameras are so advanced that you almost have to work hard to get a bad exposure. So, stop worrying about the graph and start worrying about what you aim your camera at, and how you aim it. That's where great photos come from.

#9: Figure Out What Type of Photographer You Are

You should try shooting all sorts of stuff—from food to landscapes, from portraits to sports, from products to travel, and everything in between. When you're just starting out, shoot everything! And once you've done that, sit down and figure out what kind of photographer you really want to be and work on that. The first step is to take a good look at the stuff you've been shooting and ask yourself, "Which one of these do I seem to have a knack for?" Or, "Which shots have people told me I have a knack for?" Chances are there is something you shot that you particularly felt you had a knack for—you just kind of knew what to do. Okay, that's step one (and it might be more than one thing—you might feel like you have a knack for travel, sports, and natural light portraits, and that's okay). The next step is to ask yourself, "Which one of these do I really enjoy shooting?" This is really important, because this is what you should be focusing on. There's no sense in getting really good at product photography when what you really want to be is a natural light portrait photographer. But, few photographers, even more experienced ones, really sit down and think this through—they just shoot what comes their way. And, while they may wind up being competent at shooting a lot of different things, I'm guessing being *competent* isn't your goal (it's like getting a C+ in class). Finding out who you are as a photographer allows you to focus your learning, your energy, and your time in the right direction. When you start to get good at what you really enjoy, this is when the magic happens.

#10: Do What It Takes to Get the Photos You Want

Look, somebody has to tell you this (I wish it wasn't me, but since we're here together, here goes): great photos aren't around your house. One day, they might be, but chances are, you're going to have to venture out, perhaps quite far, to make the type of photos you want to make. For example, if you decide you want to take great landscape photos, chances are (unless you live in Page, Arizona, or Moab, Utah), you're not going to be able to make great landscape photos in the city where you live. You're going to have to go someplace where great landscape photos are made. I know that takes time and it costs money, but if you want amazing landscape photos, you'd better start by standing in front of an amazing landscape, preferably at dawn. That's the other part. If you do spend the money and make the trip, don't sleep in and shoot at 9:00 a.m. You need to be in place, ready to shoot, at least 30 minutes before sunrise—more like 4:45 a.m. This is what I mean when I say, "Do what it takes to get the photos you want." When you see amazing landscape photos, someone did just that. They paid for the trip. They learned the settings. They bought (borrowed, or rented) the right equipment. They got up at dawn (maybe two mornings in a row at the same location. Maybe more). They did what it took to get the type of shot they wanted. But shouldn't you practice a lot before you make that trip? That trip is the practice (and this won't be your only practice trip). If you want to shoot people, find interesting looking or extremely photogenic people, and then either learn to light them or find amazing light. If great photos were easy, everybody would have them. Making great photos takes more than a great camera. Do whatever it takes to make the shot or you'll wind up with a lifetime of shots you're disappointed with.

#11: You Need a Portfolio

You're probably thinking, "Wait, this is #11. I thought you said there would be just 10 things?" I know, but 11 things just sounds kind of weenie, so consider this one a bonus thing. Okay, back to the portfolio. It doesn't matter if you have an online one or a printed portfolio. The most important part at this point is that you have one. Why is this so important? It's because you probably have literally thousands of photos on your computer, so what you really have is a big pile of photos that doesn't really tell you much, besides that you've taken a bunch of photos. The reason you need a portfolio of your best work is so you know where you are, right now, as a photographer. When you compile your best photos, you'll get a real sense for where you are on your journey and only then can you decide what you need to learn or do next. Okay, so how many photos should be in your portfolio? Start with just 24 of your best photos and compile them into a portfolio. I don't mean put them in folder on your computer—you need to post them somewhere online (yes, you have to post them). You don't have to pay a bunch, as there are lots of places to get an online portfolio for free or next to nothing (try 500px.com or www.squarespace .com, which are both very cool and affordable). If you don't think you can narrow things down to just 24 images, ask another photographer who you feel can give you an un-biased opinion to help. If you're serious about growing as a photographer, this is an important step (a bigger one than it sounds).

#12: Stop Reading Books About Photography

Now you're thinking, "Really? There's a number 12?" Well, this was going to be a blank page, because of the way books are printed, so I thought I'd toss in another bonus one, and although the headline sounds kind of negative (well, certainly from my book publisher's point of view), it actually isn't. But, let's switch gears for a moment. Have you ever read *Golf Digest* magazine? Terrific magazine, full of great articles on everything from how to improve your swing to "bunker shots made simple." I always learn a thing or two reading *Golf Digest*, which is great because I love golf. I'm just not very good at it. When I play a round with my brother Jeff, I don't score very well. I do hit a few nice drives, sink a nice putt or two, and every once in a while I even make a simple bunker shot. I've taken golf lessons, I have a pretty decent set of clubs, and thanks to *Golf Digest*, I pretty much know what to do, which is why it's so frustrating that when I play a round, I don't do nearly as well as I should. But, at least I know why. I don't practice. Taking lessons, reading *Golf Digest*, and watching the Golf Channel teach me about golf, but it's not practice. I need to take what I've read, watched, and been taught, and actually go practice those techniques. I need to hit the driving range regularly. I need to practice my short game. And, I need to practice actually getting out of bunkers (and not just reading about how to do it). Photography is the same way. If you want to get better, reading will pretty much show you what to do, but that's not doing it. That's reading about it. You need to practice. You need to shoot regularly with the single intent of practicing the things you've read about. I really do appreciate that you bought this book, and I hope it gives you some great ideas about what to work on, but now put down the book. It's practice time.

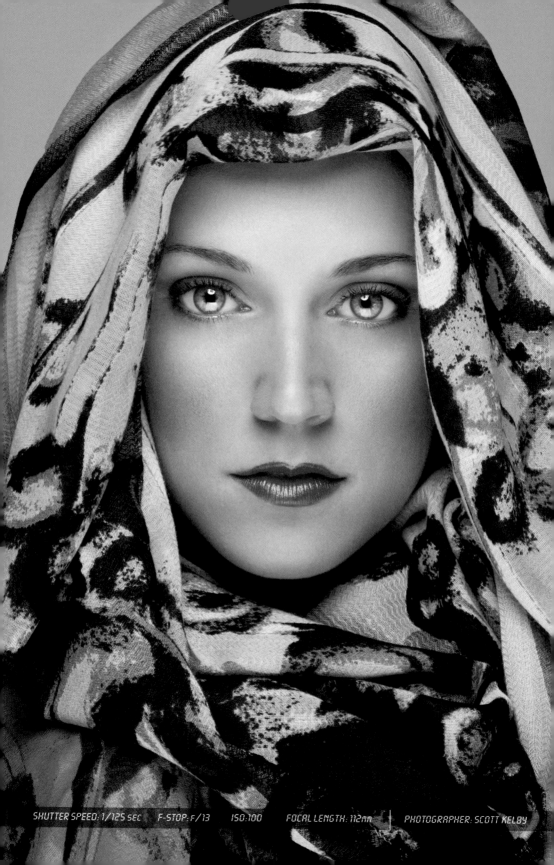

SHUTTER SPEED: 1/125 SEC F-STOP: F/13 ISO:100 FOCAL LENGTH: 112mm PHOTOGRAPHER: SCOTT KELBY

Chapter Twelve

Photo Recipes to Help You Get "The Shot"
The Simple Ingredients That Make It All Come Together

Hey, it's the end of the book, and now is as good a time as any to let you in on a secret. There's really no way in hell we're going to get those really magical shots (like you see in magazines such as *Outdoor Photographer* or *Shutterbug*). That's because when we get out to that prime shooting location at the crack of dawn to hopefully capture one of these once-in-a-lifetime shots, carrying so much gear that our chiropractors are on speed dial, we'll soon find that it's too late—there are already a dozen or so photographers set up there waiting for that magical light, too. Since they were there first, the only spot left on that tiny plateau is behind them, and every shot you take is going to have some, if not all, of their camera gear fully in your frame, ruining any possible chance of you getting "the shot." But this chapter is all about recipes for getting the shot, and I've got a special recipe for this very situation. Just as the golden light appears over the horizon, you quietly slide your foot inside one of their tripod legs, then quickly pull your foot back, toppling over their entire rig, and as their thousands of dollars of gear begins to crash violently to the ground, you deftly press the cable release on your camera and capture that amazing vista as the sound of broken glass echoes off the canyon walls. Ahh, that, my friends, is the magical sound of you getting "the shot." If you hear the faint sound of sobbing in the distance, it all becomes that much sweeter. Enjoy.

The Recipe for Getting This Type of Shot

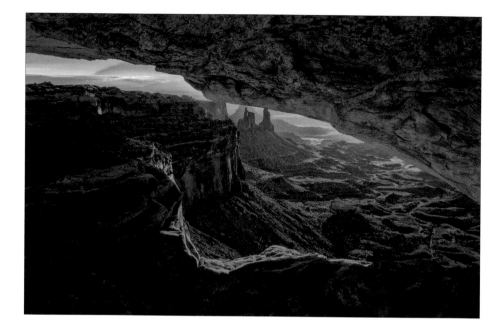

Characteristics of this type of shot: A sweeping landscape with beautiful overall light and some areas lit brighter than others.

(1) This type of beautiful light doesn't happen at 2:00 p.m. You have to get up early and be in place, ready to shoot, 30 minutes before the sun comes up.

(2) To get a big, sweeping feel to your image, you'll want to use a "big, sweeping feel" type of f-stop, something like f/22, which is perfect for landscape shots like this.

(3) Right around sunrise, the light is very low and since you're shooting at a slow f-stop, like f/22, you'll need to be on a tripod, and you'll need a cable release (or wireless shutter release) to reduce the chance of any movement of your camera.

(4) Since you'll be on a tripod, you can shoot at the lowest native ISO for your camera (usually 100 for Canon and Sony cameras, and 200 for most Nikons, although some of the newer ones are 100 ISO, as well. Check the manual for your camera).

(5) For landscape shots like this, use the widest wide-angle lens you have. If you're using a full-frame camera, something like a 14mm or 16mm would be ideal. If you're shooting a cropped-sensor camera, something like a 12mm would be ideal.

(6) For a warmer look overall, set your white balance to Cloudy.

(7) This particular shot was taken right at sunrise, which is why some of the mountains are still in the shade and some have some light peeking through. The red glow on the arch (that's Mesa Arch in Moab, Utah) appears right before and during sunrise.

The Recipe for Getting This Type of Shot

Characteristics of this type of shot: A "beauty style" shot with soft, punchy light that eliminates most shadows on the face.

(1) This is a two-light shoot: The main light is a studio strobe (flash) with a 17" beauty dish attachment that's directly in front of the subject (to soften the punchy light from a beauty dish, put a diffusion sock over it), up about 2 feet above her face, aiming down at her at a 45° angle. (*Note:* If you don't have a beauty dish, you can use a small softbox instead.) The other light is a small 24" square softbox down at her waist level, aiming up at her at a 45° angle.

(2) Position the camera height right at eye level and, to keep everything in focus from front to back, you'll need to use an f-stop that holds details (like f/11) and a long enough lens (like a 200mm) to give nice perspective. You're in the studio, so use the lowest native ISO you can (100 or 200 ISO max).

(3) Position your subject about 8 to 10 feet in front of a white seamless paper background. Don't put any light on the background, and your white seamless paper will be light gray, like you see here.

(4) If you only have one strobe, use that as the main light up top, then have your subject hold a reflector flat at their chest level, as high as possible without being seen in the frame, to reflect the light from the top strobe back up onto their face to reduce any shadows.

The Recipe for Getting This Type of Shot

Characteristics of this type of shot: Still water and interesting shades of blue and pink come together for this travel shot taken in Jaipur, Rajasthan, India.

(1) Soft, beautiful light like this only happens twice a day—at sunrise and sunset— and this shot was taken after sunset. The fact that there is mirror-like water was total luck.

(2) Since this is taken in the low light of dusk, it has to be taken on a tripod with a cable release or the shutter speed will fall so low that the image will be blurry and out of focus.

(3) Since you're shooting on a tripod, you can use the lowest, cleanest ISO for your camera (probably 100 or 200 ISO).

(4) The color comes from experimenting with the camera's white balance setting. Try a different setting (like Fluorescent or Tungsten), take a shot, and then look at the LCD monitor on the back of your camera to see how it looks to you. You're not looking for accuracy here, you're looking to create art—something beautiful—so try different ones out and see which one really creates stunning color.

(5) The other key to getting a shot like this is composition. By putting the palace in the bottom third of the frame (rather than the boring dead center of the image), it creates more visual interest, a more dynamic image, and draws your eye right to the subject.

The Recipe for Getting This Type of Shot

Characteristics of this type of shot: An aggressive-looking car detail shot (only showing part of the car—in this case, the front), lit with soft, even lighting.

(1) This shot is actually much easier than it looks, since it only uses one single light: a studio flash with a long, thin (14x35") softbox called a strip bank. It's surprisingly affordable for the wonderful light it creates (the one I use costs around $175) and since it's long and thin, the light it delivers is long and thin.

(2) The big trick to this is getting the background and sides to fall off to solid black, even though this was taken indoors with lots of lights on. The trick is the f-stop. Shooting at f/22 makes the light fall off (end) very quickly, so the flash only really lights just where you're aiming it.

(3) In this case, I have the light on a boom stand directly over the front of the car, aiming straight down at the hood (you can see a reflection of the softbox right below the Lamborghini logo on the hood).

(4) To get the aggressive look to the image, I am literally lying down on the floor. This really low perspective makes the car look bigger and badder (not that it needs it).

(5) Since I'm using a flash, it will pretty much freeze any minor movement by my camera, so I don't have to worry about setting up a tripod 6" off the ground. I used my elbows to steady my camera nevertheless. The hardest part of all of this is finding a friend with a really cool car. A big thanks to automotive photographer Tim Wallace for teaching me this car detail shooting technique and for letting me share it here with you.

The Recipe for Getting This Type of Shot

Characteristics of this type of shot: Sports photo, freezing the action and keeping the athlete in focus while the background is soft and out of focus.

(1) To get a tight-in shot like this, you'll need a very long lens, ideally a 400mm f/2.8 lens or a 300mm lens with a 1.4x teleconverter to get you in closer. If this seems like a crazy-expensive proposition, turn back to page 92 for a refresher.

(2) To get the out-of-focus background (which you want, as it creates separation of the player from the background), you need to shoot at the widest possible aperture your lens will allow (meaning, shoot at the lowest number your lens will go. Ideally f/2.8, but if your lens won't go that low, then f/4. If your lens will only go down to f/5.6, you're not going to get the type of out-of-focus background and separation you see here, which is why these fast lenses—ones that shoot at f/2.8 or f/4—are ideal for sports). During a game, I shoot in aperture priority mode and I won't change the f-stop even once—it will always be f/2.8 (and the camera will pick the shutter speed for me).

(3) Your shutter speed needs to be at least 1/1000 of a second or faster to freeze action in sports. During a daylight game like this, with you shooting at f/2.8, it will not be a problem (you'll probably see shutter speeds more like 1/4000 or higher). However, if part of the field winds up in shadow later in the day, you might have to raise your ISO to get your shutter speed back up to 1/1000 of a second.

(4) Lastly, to shoot a moving athlete like this and not lose the focus, switch your camera to AI Servo Mode (Canon) or Continuous Focus mode (Nikon and Sony). That way, the focus tracks and moves with your athlete as he/she moves during the action.

The Recipe for Getting This Type of Shot

Characteristics of this type of shot: A nighttime shot of a building lit with neon lights (this is Flo's V8 Cafe in Cars Land at Disney California Adventure Park).

(1) There are just three things you need to make a shot like this: The first is patience. I had to wait quite a while until there was a 5-second break between streaming crowds of tourists walking right in front of the cafe. This also took a lot of patience for my wife and kids (luckily, there was a gift shop nearby).

(2) The second thing you need is a tripod to steady your camera in low light. Unfortunately, I didn't have a tripod with me, so I had to find something to steady my camera because the shutter was going to be open for a couple of seconds (if I handheld that, it would be out of focus for certain). I tried leaning my camera on a garbage can right across the way from Flo's. I also tried setting it on the ground and using a self-timer. I tried setting it on a railing and a few other different locations, but to get the perspective you see here, I actually wound up setting it on the seat of a park bench.

(3) The third thing is to shoot in manual mode. If you shoot in aperture priority mode, it's probably going to overexpose the shot (not always, mind you, but enough times to where when I shoot nighttime shots, I switch to manual mode). Start by taking one shot in program mode, then note the settings it used. Now switch to manual mode, enter those settings as your starting place, and then if the shot looks too bright, raise your f-stop by one stop (like from f/5.6 to f/8) or higher until the sky gets nice and black.

The Recipe for Getting This Type of Shot

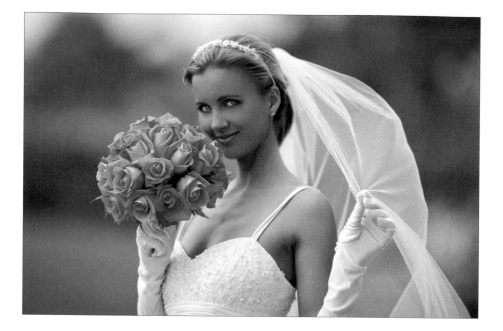

Characteristics of this type of shot: Soft, beautiful light with your background out of focus so there's lots of separation between your subject and the background.

(1) The first step, way before the shoot, is to go to a bridal store and buy a very, very long veil. Years ago, I heard a top pro wedding photographer say, "Give me a really long veil, and I'll give you magic!" So that's the first step (and what I used here).

(2) Put your camera in aperture priority mode so you get to choose the f-stop you want, and in this case you want to shoot with the lowest numbered f-stop your lens will allow (the lower the better, so f/1.8, f/2, or f/2.8 would be ideal). This gives you that out-of-focus background. Well, it pretty much does, but not without the next step.

(3) Use a long lens (like a 200mm lens) and zoom in on your bride. Zooming in (like I did for this shot), combined with the f/2.8 f-stop is what gives you that magical, soft, out-of-focus background. If you shoot at f/2.8, but with a wide-angle lens or zoomed way out, the background will all be in focus and you won't get this look.

(4) Shoot at the cleanest ISO your camera will allow (probably 100 or 200 ISO).

(5) Wait until the sun goes behind a cloud. That way, the cloud acts as a giant softbox and softens and spreads the sunlight so you don't have harsh shadows. Then, try to position your subject so the sunlight that does come through the clouds hits mostly on one side of her face (in this case, the left side in the photo above).

(6) Set the focus on your subject's eye that's closest to the camera, because if her eyes aren't in focus, the shot goes in the trash.

The Recipe for Getting This Type of Shot

Characteristics of this type of shot: A soft beautiful gradient of light wrapping around a classic P-51 Mustang.

(1) Beautiful light like this, with that beautiful gradient of color in the sky, happens only twice a day—at dawn or at dusk—and this shot was taken at dusk, with the plane sitting on the ramp at an airshow.

(2) Since this is taken at dusk in low light, it has to be taken on a tripod with a cable release or the shutter speed will fall so low that the image will be blurry and out of focus.

(3) Since you're shooting on a tripod, you can use the lowest, cleanest ISO for your camera (probably 100 or 200 ISO).

(4) To get the perspective you see here, you'll need to lower the tripod way down (I took this shot with my tripod so low I had to shoot on my knees. Glad I remembered to take gel-filled knee pads with me, since I figured I'd wind up shooting down low like this on the airfield's tarmac). However, the main reason I shot down low like this was to avoid seeing all the distracting stuff behind the plane, like other planes, airshow vendors, and an ugly trailer. By shooting up at the plane, all you see is sky.

(5) To capture as much of the plane as possible, and still be close enough for the shot to have impact, you'll need to shoot with a wide-angle lens (this was shot at 24mm with a 24–105mm f/4 lens). Since you're shooting on a tripod, this lens doesn't have to be a fast lens (in fact, I shot it at f/8, so everything would be in focus).

The Recipe for Getting This Type of Shot

Characteristics of this type of shot: Popular "blown-out" look with tons of light, and the image is converted into a high-contrast black and white.

(1) This is a natural-light shot made by positioning the bride and groom about 6 feet from a window in the church (you move them 6 feet back, so the light is soft and beautiful). The window is yellow stained glass, which means the light from it will be yellow, and if the light is yellow, the bride and groom will look very yellow, so I knew when I was taking the photo that I would have to convert this image to black and white (that's an old trick: if the color looks way off, convert the image to black and white).

(2) Position yourself so you're aiming into the window (if the bride and groom stepped away, I'd have a great shot of the empty window), but then use a long lens to zoom in tight. I used a 70–200mm lens all the way out at 200mm. Notice how tight in I am— the top of his head is cut off, which is perfectly fine (and very common). Zooming in tight like this makes the photo feel more intimate.

(3) The light from the window is so bright the photo is already kind of blown out, but you can make it more blown out in Photoshop (or Elements, or Lightroom) by dragging Camera Raw's (or the Develop module's) Highlights slider way over to the right to accentuate the effect.

(4) Lastly, convert the image to black and white (using one of the programs above). To create the high-contrast look, drag the Camera Raw (Develop module) Contrast slider way over to the right.

The Recipe for Getting This Type of Shot

Characteristics of this type of shot: A food shot, cropping in tight with lots of detail, while the background falls off to being out-of-focus very quickly.

(1) The first step to a shot like this happens before you're seated at your table. Ask to either be seated outside (if possible) or near the window. The reason is the challenge of shooting food—you need light. Nice, natural light looks wonderful for food shots, so if you can sit near a window, or outside, you're halfway there. However, to keep the plates looking white (instead of tinted blue), make sure you change your camera's white balance to Cloudy or Shade (try both and see which one looks better).

(2) The other key to great-looking food shots is to zoom in really tight on the food. For example, if you have an 18–200mm lens, zoom all the way in to 200mm. Don't try to show the whole plate, just show part of it. To do this, you'll probably have to stand up behind your chair for a moment, then shoot from a little lower angle (don't stand up straight and shoot down on your food—crouch down to lower your angle).

(3) To get the soft, out-of-focus background, shoot in aperture priority mode at the lowest number f-stop your lens will allow (in this case, it was only f/5.6, but because I was zoomed in so tight, it still creates that out-of-focus background). If my lens would have gone to f/4 or f/2.8, I could have made it even more shallow and out-of-focus.

(4) To create some energy in food shots like this, I normally tilt the camera to the right or to the left (as seen here).

The Recipe for Getting This Type of Shot

Characteristics of this type of shot: A concert shot with multi-colored lighting.

(1) You can't (and shouldn't) use a flash for concert or event photography, so you don't have to worry about that. One key to a shot like this is to use the lowest possible f-stop your lens will allow (ideally, f/2.8 or f/4) to help separate the musician from the background by making the background go out of focus. In fact, the depth of field here is so shallow that the arm on the left is in focus and the arm on the right is out of focus.

(2) For a close-up shot like this, you'll need a zoom lens to zoom in tight (this was taken with a 70–200mm lens at 200mm).

(3) The real challenge in getting a shot like this is freezing the motion of the musicians on stage, so the shot is in focus. That means keeping an eye on your shutter speed. If it falls below 1/60 of a second, your shot will definitely be out of focus. If you're shooting a big major touring act, most times light will not be a problem, because there will be a ton of it. However, in some cases (like with the shot above), the light is low. Here, there were only four lights total for the whole night, so I had to shoot at (wait for it…wait for it…) 8,000 ISO to get to a shutter speed of just 1/100 of a second. If this happens to you, you'll need to use the noise reduction software in Camera Raw (in Photoshop or Elements, or the Develop module in Lightroom) to reduce the amount of visible noise that you see when shooting at that high an ISO. Go to the Detail tab (panel) and drag the Luminance slider to the right until the noise starts to disappear (stop as soon as it's gone, or your image will get blurry).

The Recipe for Getting This Type of Shot

Characteristics of this type of shot: A "beauty style" shot with soft light against a white background.

(1) Unlike the beauty shot I showed at the beginning of this chapter, this is just a one-light shoot, but it has a lot in common with the first shot—this one is just easier. The one light is a single studio strobe (flash) with a 17" beauty dish attachment that's directly in front of the subject, with a $20 diffusion sock over the front of the beauty dish to soften and diffuse the light. It's positioned about 2 feet above her head, aiming back at her at a 45° angle. (*Note:* If you don't have a beauty dish, you can use a small softbox instead.)

(2) Have your subject (or, ideally, a friend) hold a white reflector up at waist level, tilted back toward your subject to fill in any shadows under her eyes and her face. If you need the light to be brighter, have your subject hold the reflector up a little higher.

(3) Since you're using studio lighting, you'll want to shoot in manual mode so you can set the shutter speed and then forget it. Set it to 1/125 of a second. To keep everything in focus, set your aperture to f/11, and use a long lens (like a 200mm) to give a nice perspective. Also, use the lowest native ISO you can (like 100 or 200 ISO max).

(4) Position your subject fairly close to the white seamless paper background, so your front light spills over onto the background to help make it white (instead of gray). However, you shouldn't see any shadows casting on the background. If you do, move your subject farther away from the background.

The Recipe for Getting This Type of Shot

Characteristics of this type of shot: A travel shot taken with soft light, capturing a moment and capturing it in focus (which is the challenge).

(1) When you're shooting travel photos and you're not in bright, direct sunlight (this shot is taken on an overcast day and the subjects are under a tree), chances are the photo is going to be blurry because your shutter speed falls too low to keep everything in focus.

(2) The trick for having these types of shots in focus is to set your camera to a high ISO (this was shot at 1,600 ISO). By shooting at a high ISO like this, it raises your shutter speed high enough to freeze most movement (from your subjects, or from camera shake on your part). That way, you don't miss a quiet moment like this (by the way, I bought one of the crêpes she's making [in the Luxembourg Gardens in Paris], and it was insane!).

(3) If you look closely at the image, the edges all the way around the photo are darkened, and that is done using the Camera Raw software in either Photoshop or Elements, or the Develop module in Lightroom. You do it by going to the Effects tab (panel), under the Post Crop Vignetting section, and then dragging the Amount slider to the left. The farther you drag it, the more it darkens the edges. By default, it darkens just the outside edges, but if you want it to darken a little farther in toward the center of your photo, drag the Midpoint slider to the left, too.

The Recipe for Getting This Type of Shot

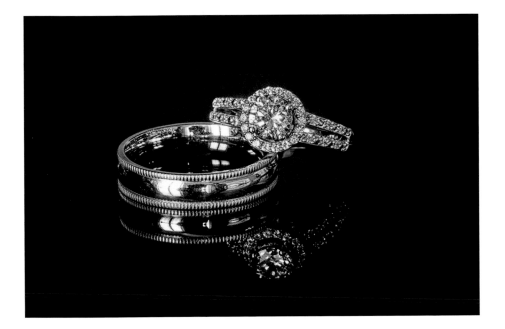

Characteristics of this type of shot: A brightly lit set of wedding rings with a mirror-like reflection.

(1) The trick here is simply to place the rings on a piano, so you get a natural reflection from the black, highly polished wood. If there's not a piano where the wedding reception is being held, try placing them on the hood of a black car (ideally, one that's not out in the direct sun. But, if that's your only choice, have a friend or assistant hold a white handkerchief between the sun and the rings to soften and diffuse the light).

(2) The lighting is just light coming in from a nearby window. In this case, the piano was located about 6 feet from a nearby window, so the light wasn't very bright. To keep the shutter open long enough to make it look like it's perfectly lit, you have to shoot this on a tripod or it would be crazy-blurry.

(3) To have the rings appear this large in the photo and with this much detail, you'll need to use a macro (close-up) lens. That way, you can position your lens really, really close to the rings (just a few inches away)—being that close makes them appear really large (this shot was taken with a 105mm macro).

(4) Because macro lenses have such an incredibly shallow depth of field (which means if you're not really careful, just the front of the first ring will be in focus, and then the other ring, and basically everything else, will be totally out of focus), you need to choose an f-stop that offers as much depth as possible (like f/22). That lets you keep most of the rings in sharp focus.

Index